Graphic Design
BASICS

Creating
Brochures
& Booklets

Val Adkins

NORTH LIGHT BOOKS
CINCINNATI, OHIO

Creating Brochures & Booklets. Copyright © 1994 by Val Adkins. All rights reserved. No part of this book may be reproduced in any form or by any electronic or mechanical means including information storage and retrieval systems without permission in writing from the publisher, except by a reviewer, who may quote brief passages in a review. Published by North Light Books, an imprint of F&W Publications, Inc., 1507 Dana Avenue, Cincinnati, Ohio 45207. (800) 289-0963. First edition.

Printed and bound in Mexico.

This hardcover edition of *Creating Brochures & Booklets* features a "self-jacket" that eliminates the need for a separate dust jacket. It provides sturdy protection for your book while it saves paper, trees and energy.

Other fine North Light Books are available from your local bookstore, art supply store or direct from the publisher.

98 97 96 95 5 4 3 2

Library of Congress Cataloging-in-Publication Data

Adkins, Val.
 Creating brochures & booklets/Val Adkins.—1st ed.
 p.cm.—(Graphic design basics)
 Includes index.
 ISBN 0-89134-517-5
 1. Printing, Practical—Layout. 2. Advertising layout and typography. 3. Pamphlets—Design. 4. Advertising fliers.
I. Title. II. Title: Creating brochures and booklets. III. Series.
Z246.A34 1994
686.2'25—dc20 93-39369
 CIP

Edited by Lynn Haller
Designed by Lori Siebert, Lisa Ballard and Paul Neff

The permissions on page v constitute an extension of this copyright page.

QUANTITY DISCOUNTS AVAILABLE
This and other North Light Books are available at a discount when purchased in bulk. Schools, organizations, corporations and others interested in purchasing bulk quantities of this book should contact the Special Sales Department of F&W Publications at 1-800-289-0963 (8 a.m.-5 p.m. Eastern Time) or write to this department at 1507 Dana Avenue, Cincinnati, OH 45207.

For Margit, who told me I could do it.
For Michael, who smiled and drew.
For Mary, who encouraged me along the path and
insisted I eat regular meals.

A special thanks to my editors, Mary Cropper and Lynn
Haller, who have so patiently and gently led me along
the garden path to authordom, in addition to putting up
with my whining and insanity.

Also, great gratitude to production editor Terri Boemker,
who so graciously made time stand still so I could finish
this project, and to designer Paul Neff, who made me
look so good on paper.

Blessings, too, on all the designers who so generously
allowed me to use their work to illustrate myriad design
principles in this book. And deep appreciation to all of
my delightful clients, without whose projects this book
would probably have been about the mating habits of
the Tibetan yak.

Mil gracias to Martin Rosenberg of Manhattan Graphics
for so generously providing me with Ready-Set-Go! 5.06
and 6, thereby enabling me to continue creating in a
state-of-the-art environment. Huge bundles of thanks to
Carol Gillette for sharing the office, the coffee, and her
vast knowledge.

And finally, a big gracias to all the fine companies who
so kindly gifted me with samples of their wares: Paper
Direct of Lyndhurst, NJ; Idea Art of Nashville, TN;
Queblo of Brentwood, NY; T/Maker Company of
Mountain View, CA.

About the Author

Photo: Margit Malmstrom

Val Adkins has been a desktop designer/publisher, freelance writer and computer junkie since 1985. In that time, she has owned and operated her own design and typography firm, has written a weekly column for a local newspaper, and has published an article and program for a computer magazine. She eventually merged with a printing company in 1992, where she served as printer's devil, as well as attending to all the design and typography needs of her clients. She lives in Meadville, Pennsylvania with her noble German shepherd, Sanctus, and is employed as a staff graphic artist for the Meadville *Tribune*, a Thomson newspaper.

Permissions

Contents

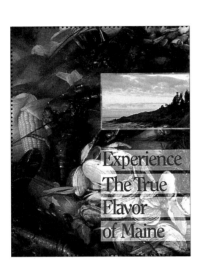

Experience The True Flavor of Maine

Chapter Two: Creating a Brochure or Booklet

This chapter takes you through the process of creating and producing every type of real-life brochure or booklet.

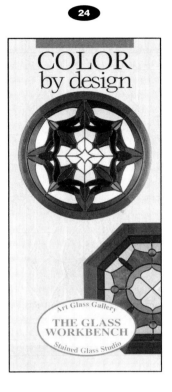

Chapter Three: More Good Ideas

In this chapter, you'll see plenty of examples of brochure and booklet designs of all types that will educate and enlighten you about what you can do with brochures and booklets.

Index

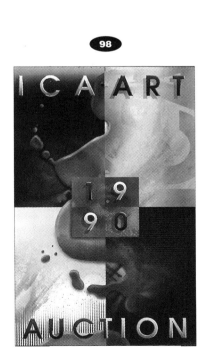

Introduction

When you think of an example of graphic design, chances are you think of a printed piece. And the printed pieces most commonly designed by graphic artists, whatever their level of expertise, are brochures and booklets.

Whether you're just starting out, or whether you're a graphic designer whose ability has been recognized by every committee short of the bestowers of the Nobel Prize, chances are you spend the better part of your time puzzling over two-page spreads or three-panel grids, wondering how you can make the piece you're working on stand out from all the rest.

As anybody with a mailbox knows, the average designer will have a tough time these days cutting through the printed clutter foisted upon every member of society, and designing an attention-getting and memorable printed piece that communicates a message to its recipient.

But of course, you're not average. You want to learn how to do a *good* job designing the printed piece—that's why you bought this book. Congratulations—this desire alone puts you well ahead of the majority of the pack.

And not only do you have the desire to learn, you've gone ahead and picked the perfect book to get you started—if I do say so myself.

This is the book that will give you all the information a beginner needs to know: what a service bureau is, how to incorporate photographs in your brochure, what kinds of folds or bindings you can use, and how to find a good printer.

This is the book that will show you plenty of real-life reasons for coming up with a brochure or booklet, and will show you, step by step, how to do every kind of brochure or booklet you'll probably ever need to do. You'll walk through a number of real-life projects done by a real-life designer (me!), and you'll get to look over my shoulder as I wrestle with—and, I hope, solve—problems common to projects of this type.

This is the book that, finally, will give you plenty of full-color examples of brochures and booklets that have stretched the boundaries of these categories; looking at these examples will give both beginners and more experienced designers ideas for creating great brochures and booklets.

Enjoy!

Chapter One
Before You Begin

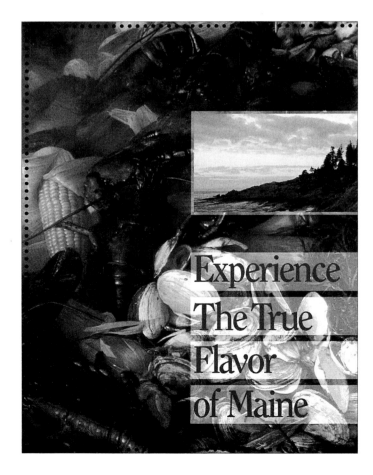

A brochure is a printed piece that is folded into panels. You can create any number of panels, depending on how you fold your paper. Obviously, then, brochures are extremely adaptable because they can be folded in many different ways, on many different sizes of paper. The beauty of this adaptability is that any budget, any purpose and, in fact, any whim can be matched to a printed piece.

A booklet serves the same purposes as a brochure, but is, as the name suggests, a little book. Rather than being folded, it often is bound in one fashion or another.

Plan your piece well, from budget all the way to copy and artwork. The primary ingredient, however, is order. If a piece can't be read in an orderly fashion, don't bother creating it. By and large, people want an easy read. Be sure that all the parts are in order—don't offer suggestions about feeding a German shepherd before the section on choosing a puppy. Remember, first things first. Then you can deal with the middle and the end.

This chapter has everything you need to know to get started creating brochures and booklets.

Why Create a Brochure

Booklets and brochures have almost endless possibilities for usage. Both manufacturing and service-oriented companies use brochures of one type or another to promote a positive image of themselves, as well as their goods and services. For example, a shoe manufacturer could use a brochure to present a new line of running shoes. The same company could also use a printed piece to illustrate the care it takes in manufacturing these shoes to the surgeon general's specifications.

If your mailbox is anything like mine, it gets filled with catalogs on a regular basis. These range from black-and-white pieces printed on pulp paper to beautiful four-color pieces printed on heavy coated stock. No mail-order company can exist without them.

That spectacular local department store needs to keep you apprised of its latest sale, too! And I live near a factory outlet store city—Freeport, Maine, home of L. L. Bean. Their catalogs arrive regularly.

Nonprofit organizations need to get the word out, too. The local soup kitchen wants to let you know that it performs a valuable community service, and that it needs your help and donations in order to stay afloat. Most organizations require funding to remain in existence. Although these groups—such as women's shelters and those that promote education and research regarding various diseases such as cancer, heart disease and AIDS—often receive government and United Way funding, they usually rely on private do-

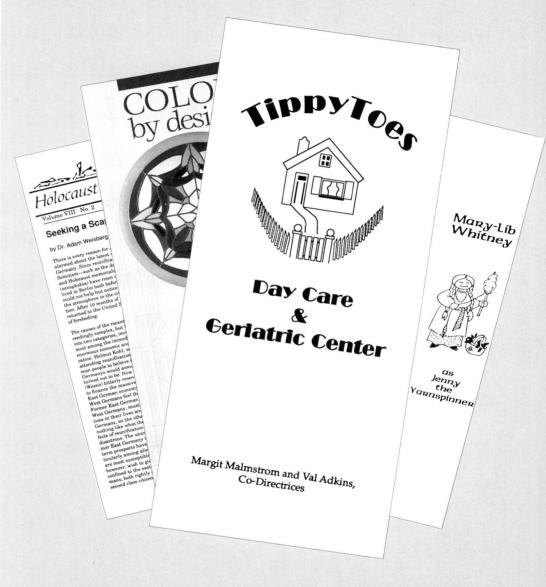

In Chapter Two, you'll find out step by step exactly how to do these brochures and booklets.

or Booklet?

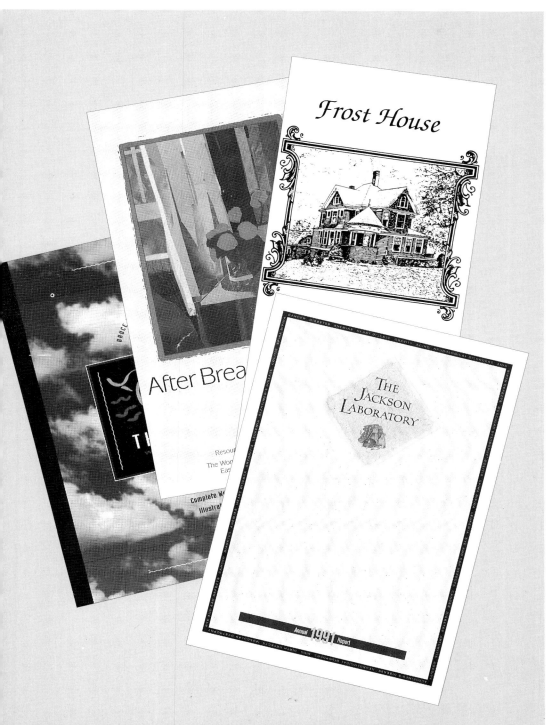

In Chapter Three, you'll get a closer look at these and other beautiful brochures and booklets.

nations, too. And in order to let folks know what they need, they use the printed word.

Newsletters come in booklet form, too. They serve as super networking and marketing resources. Check your telephone and electric bills; it's not at all unusual to find a newsletter enclosed that lets you know what the company is doing ecologically or why they are planning a rate hike.

And can we forget the annual report? Where would we be without that fun- and fact-filled document that is published at least once a year by ever so many publicly owned companies. Granted, they're not exactly light reading, but they are, in most cases, necessary. And they're becoming a more attractive market to target, too, because it's not just the big boys any more. Nonprofit organizations as well as small and newly opened companies all need annual reports. It's a wide-open market out there.

Wouldn't we all be as cheery as Marley's ghost if we didn't have instruction booklets to assist us in assembling those Supersonic Transport Mutant Little Red Wagons for the wee tykes on Christmas Eve? What a joy to have ready assistance enclosed with all those strange whatzits.

The list goes on and on. Look around you at all the printed matter that flows into your life each day. Buy this, donate to that, don't miss the boat, subscribe to the Weekly Blurb, feed the hungry—we all have a message. How you choose to deliver yours is up to you.

Getting the Copy Right

White space is our friend! This is the first thing I tell my students in each new desktop publishing class, lest they make an enemy of this important ally.

What you say and how you say it are paramount. Since space may be limited, be sure to cover important information first. Don't use more words than you must, but use words that will grab your readers' attention. To do this, you'll need to know your audience and write to them.

If a space is filled to capacity with text, chances are good that no one is going to try to decipher it. Conversely, if a space contains only one phrase or sentence, the eye will be drawn right to it. The idea is to create the text to fit the space comfortably—not too much, not too little—but just right.

First of all, you need to decide how much space in your brochure will be allotted to each topic. Then you can choose a typeface and decide on size and leading. The next step is to calculate the number of words required to properly utilize the space. In other words, write to fit the space.

Here's how to calculate the number of words you'll need. Consider a 2"-wide by 4"-deep column. Obviously your lines will be 2" wide—but how many lines will fill your column, and how many words does that come out to? Suppose you are using 10-point Times Roman on 12-point leading. Given the fact that there are 72 points to the inch, you will need 24 lines to fit your space (72 points divided by 12 points equals 1" worth of type or 6 lines). Now,

Eat at Joe's. Eat at Joe's.

Eat at Joe's.

Sometimes you only need to say it once.

Justification is another consideration. Do you want your type to be flush on both the left and right? Or just on the left with a ragged right? Perhaps you'd like it flush right with a ragged left? What about centered? These are all considerations based on your specific project. I wouldn't recommend setting your type flush right just for the heck of it. Balance is a major issue. If you are captioning an illustration on the left, for example, right justification can work very nicely, but for the most part, you will want to use either full justification, that is, flush left and right, or flush left justification.

In short, keep it readable, keep it simple and keep it balanced.

Justification is another consideration. Do you want your type to be flush on both the left and right? Or just on the left with a ragged right? Perhaps you'd like it flush right with a ragged left? What about centered? These are all considerations based on your specific project. I wouldn't recommend setting your type flush right just for the heck of it. Balance is a major issue. If you are captioning an illustration on the left, for example, right justification can work very nicely, but for the most part, you will want to use either full justification, that is, flush left and right, or flush left justification.

In short, keep it readable, keep it simple and keep it balanced.

Justification is another consideration. Do you want your type to be flush on both the left and right? Or just on the left with a ragged right? Perhaps you'd like it flush right with a ragged left? What about centered? These are all considerations based on your specific project. I wouldn't recommend setting your type flush right just for the heck of it. Balance is a major issue. If you are captioning an illustration on the left, for example, right justification can work very nicely, but for the most part, you will want to use either full justification, that is, flush left and right, or flush left justification.

In short, keep it readable, keep it simple and keep it balanced.

Justification is another consideration. Do you want your type to be flush on both the left and right? Or just on the left with a ragged right? Perhaps you'd like it flush right with a ragged left? What about centered? These are all considerations based on your specific project. I wouldn't recommend setting your type flush right just for the heck of it. Balance is a major issue. If you are captioning an illustration on the left, for example, right justification can work very nicely, but for the most part, you will want to use either full justification, that is, flush left and right, or flush left justification.

In short, keep it readable, keep it simple and keep it balanced.

Justification is another consideration. Do you want your type to be flush on both the left and right? Or just on the left with a ragged right? Perhaps you'd like it flush right with a ragged left? What about centered? These are all considerations based on your specific project. I wouldn't recommend setting your type flush right just for the heck of it. Balance is a major issue. If you are captioning an illustration on the left, for example, right justification can work very nicely, but for the most part, you will want to use either full justification, that is, flush left and right, or flush left justification.

In short, keep it readable, keep it simple and keep it b a l a n c e d.

Above, your alignment options: top left, flush left; top right, flush right; bottom left, centered; bottom center, justified; and bottom right, force justified.

begin typing "The quick brown fox jumped over the lazy dog." How many words did it take to fill one line? Six, you say? Okay, now 1 line of type equals 6 words. You need 24 lines of type. Six words times 24 lines equals 144 words. There, now, that was pretty painless, wasn't it?

Be sure to keep your piece more or less consistent. If you use 10-point Times Roman for the first section, don't switch to 14-point Helvetica for the next one. Choose one typeface for headlines and another for body text. Keep them, along with point size and leading, consistent throughout the entire piece.

Suppose you simply can't write enough to fill the allotted space. Don't despair—there are ways around this. You can increase the point size, open up the leading, or both. Perhaps 12-point type with 15-point leading will leave the page looking less naked than 11-point type with 13-point leading. On the other hand, perhaps you've continued singing the praises of your product, service or organization far beyond the limits of the printed page. If this is the case, you'll have to reduce the size of the type and/or close up the leading.

Another option that will aid in either expansion or reduction of text is changing typefaces. Different typefaces take up varying amounts of space. If you need to fill more space, try Bookman or another fat serif font. Times, or any of the condensed or sans serif faces, will help you to get more text in less space.

With a computer it's easy to

Getting the Copy Right

explore any of these options, because you can just block and choose; it truly is magic. Don't be afraid to experiment; most page layout programs will give you the option to undo what you just did with a few simple keystrokes, and even if you don't have that option, you can always save one version before you start experimenting further, so you can easily go back to square one if you create a monster.

A word about case. Never, ever, set an entire article in uppercase type. ALL CAPS looks like you're shouting, and heaven forfend you should shout at a prospective client or donor. Also, we recognize words by their shapes, and setting your text in all caps creates a page full of rectangles. This is not an easy read. If you're WARNING people, or if you're trying to get their ATTENTION, you can make your point with uppercase type. Just don't go overboard with it.

Leading, the space between lines, adds to ease of reading. Adding 2 points of leading to the point size of the type, e.g., 11-point type on 13-point leading, works very well to make type readable. As always, though, keep an eye on proportion; 11-point type on 16-point leading may look elegant, or it may just look like you're trying to fill up space. Let your common, and your aesthetic, sense be your guide.

Don't confuse your readers' eyes. The length of the line matters! If the line is too long, we tend to lose track of where we are and end up reading the same line several times after a few false

If a space is filled to capacity with text, chances are good that no one is going to bother trying to decipher it. Conversely, if a space contains only one phrase or sentence, the eye will be drawn right to it. The idea is to create the text to fit the space comfortably--not too much, not too little--but just right.

First of all, you need to decide how much space in your brochure will be allotted to each topic. Then you can choose a typeface and decide on size and leading. The next step is to calculate the number of words required to properly utilize the space. In other words, write to fit the space.

Suppose you simply can't write enough to fill the allotted space.

If a space is filled to capacity with text, chances are good that no one is going to bother trying to decipher it. Conversely, if a space contains only one phrase or sentence, the eye will be drawn right to it. The idea is to create the text to fit the space comfortably--not too much, not too little--but just right.

First of all, you need to decide how much space in your brochure will be allotted to each topic. Then you can choose a typeface and decide on size and leading. The next step is to calculate the number of words required to properly utilize the space. In other words, write to fit the space.

If a space is filled to capacity with text, chances are good that no one is going to bother trying to decipher it. Conversely, if a space contains only one phrase or sentence, the eye will be drawn right to it. The idea is to create the text to fit the space comfortably--not too much, not too little--but just right.

First of all, you need to decide how much space in your brochure

If a space is filled to capacity with text, chances are good that no one is going to bother trying to decipher it. Conversely, if a space contains only one phrase or sentence, the eye will be drawn right to it. The idea is to create the text to fit the space comfortably--not too much, not too little--but just right.

First of all, you need to decide how

Leading can make a world of difference in your copy. Top left, Times Roman 10/10 leading is tight and looks uninviting, but may be your only recourse if you don't have a lot of room; you're most likely to see something like this in mass-market paperbacks (and badly designed brochures). Top right, Times Roman 10/12 is legible and not too airy; a pragmatic choice for handling a lot of text. Bottom left, Times Roman 10/16 may be too loose a leading for a lot of copy, but has a more artistic look than 10/12, and may be a good choice if your brochure has wide columns of text. Bottom right, Times Roman 10/20 would make it difficult to find the next line in a long, narrow column of text, but may be a good choice for pull quotes, or any other copy that needs emphasis.

OLDS FUNERAL HOME

Morticia Olds, Dir.

Anywhere, USA 555-1234

Olds Funeral Home

Morticia Olds, Dir.

Anywhere, USA 555-1234

Gun for Hire

Cowboy Bob, Prop.
"You point, we shoot"

Anywhere, USA 555-9876

GUN FOR HIRE

Cowboy Bob, Prop.
"You point, we shoot"

Anywhere, USA 555-9876

A typeface that works in one situation might be inappropriate in another.

starts to begin the next line of text. Try to limit your lines to no more than twelve words, and adjust your type size and leading accordingly.

A word about typefaces. As we've stressed all along, you shouldn't make your readers work too hard—they won't read what you've published, and your purpose will be defeated. So use a clear, easily readable face for your body text and avoid script or decorative typefaces. Save the fancy stuff for headers.

Justification is another consideration. Do you want your type to be flush on both the left and right? Perhaps you'd like it flush right with a ragged left? What about centered? These are all considerations based on your specific project. When deciding what to do, balance is also a major issue. If you are captioning an illustration on the left, for example, right justification can work very nicely, but for the most part, you will want to use either full justification—that is, flush left and right—or flush left justification. Force justification—in which every line is justified no matter how short, usually by spreading the extra spacing evenly over the whole line—has traditionally been associated with its use in poorly designed newspapers, but has of late been spotted in logos and other short pieces of text. When properly used, it can have an avant-garde look; as usual, let your eyes be your guide.

In short, keep it readable, keep it simple and keep it balanced.

Illustrations With Impact

As decorations, illustrations can make your printed piece infinitely more interesting. Look at a page with three columns of nothing but text. Now find a page with both text and illustrations. There's really no comparison, is there?

If a picture is truly worth a thousand words, you can save yourself the pain of writer's cramp with several pertinent illustrations. And for those among your intended audience who are visual learners, you'll really make your point clear.

But, you say, you're not an artist. You can't draw. No matter. The world is full of ways to illustrate your booklet or brochure, and you don't even have to lift a drawing pen.

The Dover Clip Art Series is an invaluable source of clip art. This series consists of many reasonably priced booklets, filled with illustrations for every imaginable occasion. You may use these illustrations without permission as long as you don't use more than ten of them in any single project. There are also subscription services available if you will be using great numbers of illustrations. There are subscription services available for electronic usage as well. Each month brings yet another disk, or disks, brimful of illustrations in the format of your choice.

T/Maker, publisher of many disks full of ClickArt, is a fine source of artwork for both the Macintosh and IBM computers. These images can be imported into virtually any page layout program. Images are available in several formats, including bit-mapped and encapsulated PostScript.

Small decorative typographic illustrations such as stars, hearts, circles and squares, to name only a few,

ClickArt Publications © 1984 T/Maker Co.

ClickArt Personal Graphics © 1984, 1989 T/Maker Co.

ClickArt Newsletter Cartoons © 1991 T/Maker Co.

ClickArt Holidays © 1984 T/Maker Co.

ClickArt Business Cartoons © 1990 T/Maker Co.

ClickArt Events & Holiday Cartoons © 1990 T/Maker Co.

ClickArt Business Images © 1987 T/Maker Co.

Some examples of ClickArt, by T/Maker. These illustrations can be great if you need to fill up some room in your newsletter, though they're not as useful for the kind of wild manipulation that more abstract electronic clip art can stand up to.

Dingbat	Keyboard	Dingbat	Keyboard	Dingbat	Keyboard	Dingbat	Keyboard
✻	a	❘	x	✳	U	➜	Op h
✺	b	❙	y	✦	V	❧	Op i
✳	c	✡	z	✳	W	⑦	Op j
❄	d	✜	A	✴	X	➤	Op k
✳	e	✛	B	✺	Y	③	Op l
❈	f	✢	C	✳	Z	⑩	Op m
✳	g	✣	D	✎	0	❞	Op n
✳	h	◆	E	✑	1	❿	Op o
✳	i	◇	F	❧	2	❹	Op p
✳	j	★	G	✓	3	❻	Op q
✳	k	☆	H	✔	4	♣	Op r
●	l	✪	I	✕	5	❦	Op s
○	m	☆	J	✖	6	①	Op u
■	n	✬	K	✗	7	④	Op v
❏	o	✭	L	✘	8	❷	Op w
❐	p	✯	M	✚	9	⑥	Op x
❑	q	✷	N	❴	Op a	⑨	Op y
❒	r	✩	O	❺	Op b	❽	Op z
▲	s	✱	P	❵	Op c	✳	[
▼	t	✲	Q	❶	Op d	✴]
◆	u	❆	R	♠	Op e	‘	{
❖	v	✳	S	⑤	Op f	“	}
◗	w	✳	T	◆	Op g	†	=

A chart of just some of the Zapf Dingbats available. This isn't the only dingbat font, however; other popular ones are Morbats, Carta, and a newcomer, Letraset's DesignFonts. Check with your software dealer to see what's available, and for what price. And, when shopping for such fonts, be sure to bring your laser printer manual with you—while Zapf Dingbats is built into most printers, not all of the other fonts are. Don't make the mistake of shelling out a hundred bucks for a font that only your service bureau will be able to print out properly for you.

are called dingbats. This was a printing term long before Archie Bunker made it popular. Among other things, dingbats can be used to mark the beginning and/or ending of a section of type or to bullet a list. If the right size, you can also line them up in a row, either vertically or horizontally, to create a unique decorative border. There are dingbat fonts, such as Zapf Dingbats, available from Adobe Systems, Inc. In addition, there are lots of images available at no charge that can be downloaded from various bulletin boards or on-line services.

Other small illustrations such as symbols, logos or icons are available as clip art of one kind or another. For instance, you could use a small mark that is descriptive of your business or organization to separate the sections of your booklet.

If you are so inclined, you may want to invest in some technical pens and create your own art, which can be reproduced in your printed piece. Or perhaps you're more comfortable creating computer art; there are several painting and drawing programs available. Adobe I!lustrator, Mac-Paint, Aldus SuperPaint and Corel-DRAW! will give you the opportunity to create your masterpiece electronically.

The type of artwork you use depends on your topic, the type of piece you are producing and, of course, the Budget Ogre. For instance, if you are creating a financial report, a bar graph is a good way to show your company's growth since the last quarter. A pie chart could show the percentage of the donated dollar that actually goes toward feeding the hungry. Line art—that is, plain black-and-white drawings that can be

Illustrations With Impact

used as is, without halftoning—could be used to illustrate the new line of mountain bikes down at the cycle shop. Halftones, or photographs printed with a pattern of dots as opposed to solid application of ink, are an excellent way to illustrate the loving faces of the caregivers at the local hospice or animal shelter.

Rules, borders and backgrounds are good ways to set off important pieces of information. Perhaps the mission statement could have a thin border and/or a screen, or perhaps the warning signs of a disease could be set off with bold rules before and after the list. But remember, don't overdo it; use only what you need to make your point.

If you are blessed with a large budget, you might want to consider color photos to illustrate your piece. Getting these printed is expensive, but their use goes a long way toward creating an extremely attractive brochure, always providing that your photos are of the best quality.

Let's assume that your piece is quite specific to a given operation or service, and that generic clip art just won't do it. You'll need to engage the services of an illustrator or a graphic artist. Or, if photographs are more appropriate for your brochure, a photographer is in order. There are several things to look for here. Is his or her style appropriate for your piece? A photographer who does still life shots in color would not be the perfect choice for photographing, in black and white, the "before" picture for a doggie obedience school brochure. Look at his or her portfolio. Pay attention to the quality of the work. Does the artist consistently

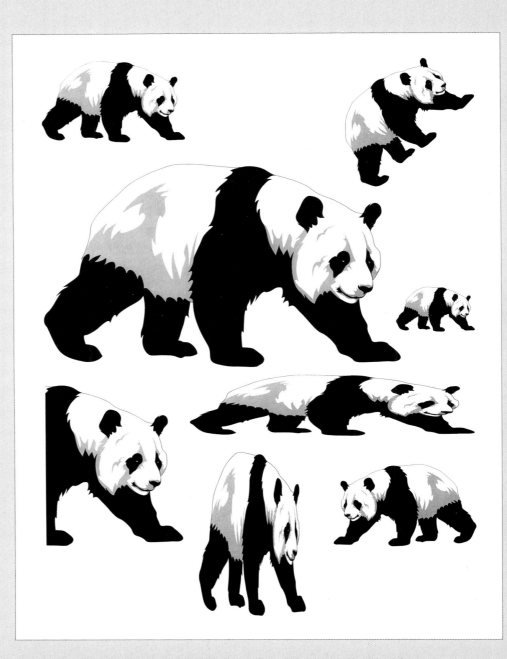

You can use your page layout program to manipulate a piece of clip art in a wide variety of ways.

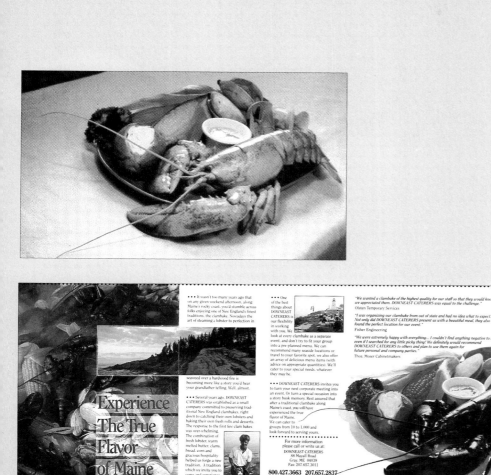

If you're stuck with a photograph that's not quite what you had hoped for, but that you have to make work, there is hope. See what ImageSet Design did with the photograph of the lobster plate on top. By dropping the background and silhouetting the image, and by using some dramatic cropping, they were able to turn this ho-hum photograph into an attractive centerpiece for the brochure on the bottom.

draw figures disproportionately? Do the photographs lack definition and contrast? Keep looking! Talk to colleagues who have employed their services. Do they deliver on time? The bottom line here is that you need to hire someone who can deliver quality work on time and within your budget. Make an informed choice.

One horror that will probably happen at least once in your career is that a client will proudly hand you the photographs that he or she wants you to use. The only problem is that they appear to have been taken by someone who was on drugs. First of all, try to reason with the client. Try explaining that since the quality of the photos is poor, the quality of the reproductions in the printed piece will also be poor. Illustrate this by showing him or her a piece with poor quality photographs. Chances are they'll see the light.

If, however, the client insists on using these dreadful photographs, you still have some options. First, electronic "doctoring" is a possibility here. Having the photographs scanned and corrected can save the day. Do what needs to be done, but, as always, do it within budget. Second, cropping the photographs might rid you of some of the problem parts of the photos, or at least, if your cropping is creative enough, might draw attention away from their inadequacies.

Finally, if all else fails, you can send the client to someone else to get the job done—perhaps a rival in the desktop publishing field, heh, heh.

 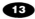

Picking the Perfect Paper

Choosing the paper your piece is to be printed on can be the most enjoyable part of the project, but it can also be a bit overwhelming.

First, there's the question of what color you're going to use. This decision is not as easy as it used to be—over and above the mere colors of the rainbow, you now have the choice of having preprinted four-color stock as well (as shown at right); for more on this issue, see the section on adding color with paper on pages 54 through 57.

After you've made that difficult decision, you'll have to choose your paper stock. When checking out the possibilities here, you'll be looking primarily at four types of paper—bond, coated book, uncoated book and text.

Bond paper is quite versatile because, though it's usually smooth, it comes in a variety of grades, weights, colors and fiber contents. This paper is popular with many folks since it's quite economical and, within this class, there's plenty of variety. For instance, there are bonds that contain 25 percent, 50 percent, 75 percent or 100 percent cotton fiber; these are rich-feeling papers. Then there is what is probably the most common paper of all, good old 20-pound bond. This is the staple (no pun intended) of copy shops everywhere.

Coated book paper has a clay coating that gives it a very smooth finish. This coating keeps the ink from being absorbed into the paper and is available in both glossy and matte finishes.

Uncoated book paper comes with a variety of surfaces, from antique, which is the roughest, to eggshell, which is a little smoother, to machine

Four-color papers such as these (available from Idea Art, Paper Direct or Queblo) allow you to give your brochure an expensive and vibrant look without the cost of a color laser printer or a color separator. If you want to use this kind of paper, though, you should choose the kind you want to use before you design your brochure—using papers such as these requires precise copy placement.

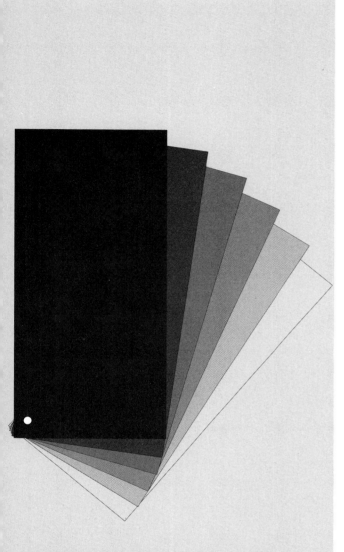

Looking at paper swatch books such as this one will give you some idea of your options when choosing paper.

finish and English finish, which are smoother yet and even less bulky.

Text paper describes a variety of papers used for, among other things, brochures and booklets. These include wove and laid.

There are other papers to be considered as well—kraft, vellum, fleet, etc. Each of these will give a different effect—on your eyes and on your budget.

Cover stock is another possibility. This is a heavier, cardboardy paper that holds up well under quite a lot of handling and that will provide a richer feeling than a lighter paper. It is also available in coated and uncoated form.

Recycled paper versus virgin paper should be considered since this, too, can affect your relationship with a potential client. In this day of ecological awareness, saving our natural resources is of paramount importance. There are those who will go to any lengths to accomplish this end. However, the Budget Ogre is always on the horizon, and since recycled paper is, at least for the present, more expensive, the battle of nature versus finance has to be considered.

When your piece includes photographs, your best choice is a coated paper. The ink won't be as likely to soak in and spread as on uncoated paper. If there is a fair amount of text in addition to photographs, choose a coated paper with a matte finish to reduce glare.

Weight and texture figure heavily here, too. A thin, lightweight paper is not going to make the same impression in the hands of the reader as a more textured paper would. You must, however, match your paper to your project. Trying to raise funds for

a charity by using a deluxe paper is more apt to raise eyebrows than cash. Conversely, luring folks to your posh health spa would be rather difficult if you chose a 50-pound white offset bond paper to make your pitch.

As in any undertaking, there are some things to avoid. For example, don't use a laid finish cover stock for a piece that will be folded—the folds are not attractive. If you are planning a piece that will be printed on both sides, use a paper that is opaque enough to keep the text and/or images from showing through the other side.

Now that you know your basic options, have your printer show you some swatch books so you can check out the look and feel of various paper.

And finally, once you think you've made your decision, try to get an assortment of your chosen paper, and print out or photocopy the brochure onto this paper, and then fold it; how this mockup looks will tell you whether or not you made the right choice, and could save you from making a time-consuming, and costly, mistake.

 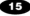

Selecting Services

What you need in the line of services depends, for the most part, on your piece's intended use. For example, it doesn't make a lot of sense to do a four-color slick piece to herald a one-day bargain basement sale on surplus army socks (olive drab) at a single location. On the other hand, if you are announcing a new line of 18 karat gold designer jewelry, you might want to go the whole route.

Obviously, the simplest way to get your piece from concept to print is to do it yourself on the company computer. Assuming that you have page layout software and a laser printer, you can do a fine job in-house. If you want a higher resolution output than your company printer is capable of, you can do the work yourself, and then send the file via disk or modem to the service bureau for output.

I usually don't bother with a service bureau if the piece is for limited use and is to be photocopied, such as a tri-fold promoting a one-time workshop. Three hundred dpi (dots per inch) output is good enough quality for these purposes. However, if the piece is to be used over a period of time, for example, an informational brochure for a service organization, and the printing process will be superior to photocopying, I will then have it output at 1270 dpi on an imagesetter. I use RC (resin coated) paper output if there are going to be several components to assemble in order to create a traditional mechanical. If I've done my entire piece on the computer, I request film output. This saves a step in the printing process—your printer won't have to take a negative of your work to print from; it will already be done for him. Be sure, however, to check with your printer

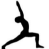

The final brochure you will create in Project 2. The version on top was printed out on a 300 dpi laser printer; the version on the bottom was printed out at 1270 dpi. Comparing the top and bottom makes evident the difference in quality you'll get by going with the highest dpi you can afford.

SERVICE BUREAU ORDER FORM

You can include this sheet or one like it with each job you send to the service bureau for output to make sure you've included all the information for your job.

Date: _____

From: _____ To: _____
_____ _____
_____ _____

Phone: _____ Phone: _____

Project Name/Description _____ Project # _____

Due Date (Date & Time): _____

PO #: _____

Rush Charges okay: ☐ Yes ☐ No

Submission Format: ☐ Floppy ☐ Modem ☐ Optical ☐ Tape ☐ Cartridge ☐ SCSI device ☐ Worm

Page Layout Program Used: _____ Version _____

Xpress Data Files Included ☐ Yes ☐ No

Font(s) Used in Document

Name: _____ Manufacturer: _____
Name: _____ Manufacturer: _____
Name: _____ Manufacturer: _____
Name: _____ Manufacturer: _____

File Name to Image: _____

Number of Pages: _____ Resolution _____ dpi _____

Output Size Excluding Trim Zone: _____

Type of Graphics File: ☐ TIFF ☐ PICT ☐ PICT2 ☐ EPSF ☐ Amiga ILF/ILBN

Type of Graphics File: ☐ TIFF ☐ PICT ☐ PICT2 ☐ EPSF ☐ Amiga ILF/ILBN

Type of Graphics File: ☐ TIFF ☐ PICT ☐ PICT2 ☐ EPSF ☐ Amiga ILF/ILBN

Type of Graphics File: ☐ TIFF ☐ PICT ☐ PICT2 ☐ EPSF ☐ Amiga ILF/ILBN

LineScreen: ☐ 85 ☐ 100 ☐ 110 ☐ 120 ☐ 133 ☐ 150 ☐ 175 ☐ 200

Sizing: ☐ Percent Given ☐ Stat Enclosed

Separations Required: ☐ Spot ☐ Screen Color ☐ Match Color(s) ☐ Process Colors

Proof Required: ☐ Matchprint ☐ Cromalin ☐ Color Keys ☐ Mac-driven Color Copier
☐ Other: _____

Special Instructions: _____

This form (reprinted from *Graphic Designer's Guide to Faster, Better, Easier Design and Production* by Poppy Evans) or one like it should be filled out for each job you give your service bureau, whether or not they require it; it gives them everything they need to know to get your job printed out right.

first to determine his or her specific needs.

What is this mystical place called the service bureau? Simply put, it is a place where electronic magic is worked. It is here that your project, be it a single printed page or a complete booklet, is output on an imagesetter that is capable of very high resolution. Service bureaus are also capable of any or all of the following:

• *Scanning.* This is a way to get line art, gray-scale, or color art or photos, and even text from your sheet of paper into the computer's brain. Once your artwork has been scanned, images can be sharpened, color corrected and halftoned.

• *Laser printing.* 300 dpi output from a black-and-white laser printer (or, if it's a higher grade of service bureau, 1270 dpi).

• *Color laser printing.* 300 or 1270 dpi output from a laser printer capable of four-color printing.

• *Transparencies.* Film output for use with, for example, overhead projectors. Also color slides.

• *High resolution color imaging.* This process includes sharpening images and color correction, as well as color separations and color output.

Check the yellow pages. Learn all you can. The more you know about your local bureaus, the better prepared you will be to serve your clients by making an informed choice.

If you are creating a mechanical with more than one component, e.g., type and a pen-and-ink drawing, you'll need to make the acquaintance of a stat house. Look in the yellow

Selecting Services

pages under "Photo Copying" (as opposed to "Photocopying"). These folks will create a photostat, or PMT (photomechanical transfer), of the art you submit to them, sized to your specifications, which you can then paste up with whatever else is included in your mechanical. Using a stat of line art or simple graphic elements on your mechanical ensures sharper reproduction quality—and leaves your original art untouched. If you are using a photograph, this agency can also produce a properly sized halftone. This is a reproduction of your photo that is composed of a pattern of tiny dots. (If you are curious as to why halftones are necessary, take a look at a plain photocopy of a photograph. It loses something in the translation—like contrast and detail.) After you get this properly sized halftone made, you can paste it up on your mechanical.

A quick note on halftones and copy machines. There are copiers on the market that have the capability to reproduce photographs as halftones. For the budget-minded, there is also a screen that can be placed over the photograph when copying it that will give you a higher quality photocopy of the photograph than a photocopier alone could. Neither of these processes, however, will equal the quality of a camera or a scanner.

For a four-color piece, you'll need color separations—CMYK (cyan, magenta, yellow, black). You have some options. You may choose the conventional way, i.e., having your color photo or artwork photographed four times through four different filters. Or you may choose to have your artwork scanned and separated by computer. This works well, especially if any corrections need to be made to

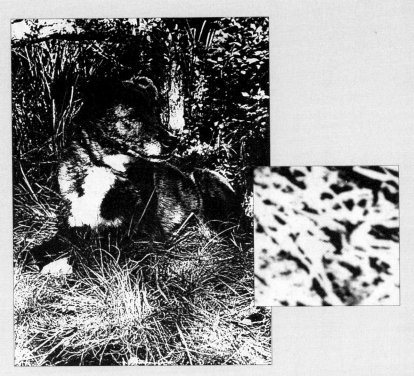

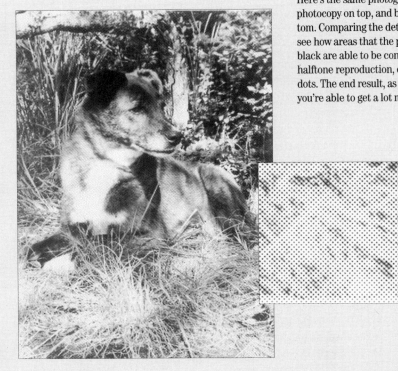

Here's the same photograph, reproduced by photocopy on top, and by halftone on the bottom. Comparing the details of the two, you can see how areas that the photocopy interprets as black are able to be conveyed as gray by halftone reproduction, due to the use of tiny dots. The end result, as you can see here, is that you're able to get a lot more detail this way.

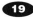

Here's a piece of color art and a stat of the same piece of art. Notice how crisply the stat reproduces in black and white, compared to the original art, which is printed in dark red ink on a tan background. It's a good idea to have a stat made of anything you plan to reproduce in black and white.

the artwork or photography.

Another service you'll need to consider is that of a typographer. This is the person who will put the type on the page and make it lovely—to your specs, of course. Again, check the yellow pages or ask your printer for a recommendation. Ask to see their work. Choose someone who is best able to produce the results you specifically need and can deliver on time.

The bottom line is budget! No matter who you're dealing with—printers, service bureaus, typographers—get quotes in writing. And get at least three. As always, ask to see the work of anyone you're getting a quote from. A quote of $225 from a printer who delivers clear, correct work on time is a lot lower than $150 from a printer who doesn't clean the press properly and is consistently late. Talk to other desktop publishers in your area. An informed choice is the only choice.

Folding, Binding and

You've reached the finish line! It's time to go to the printer. But which one? Ask yourself a few questions. First of all, the big one—how's your budget? As always, get the best you can for the allotted cash. Next, what will the piece be used for? If this is a one-shot deal, such as a sale flyer or charity bazaar announcement, or if the information in this piece is subject to frequent change, then the photocopy shop or quick printer is the place to go. How many copies do you need? If the answer is less than 250, you again need to take a trip to the copy shop or quick printer.

If you need more copies, then a commercial printer is the person you need to see. The offset process used by a commercial printer offers a greater variety of ink color, paper color and paper texture than photocopying does, as well as a finer quality overall. Since the inking is not done directly from the plate but from a rubber blanket, textured papers such as laid or rippletone can be used, as well as smooth papers.

Offset printing allows the designer more latitude as well, since it is conducive to various components and finishes. Text and halftones do very well with this process, along with screens and other tricks of the trade.

Visit the printers in your area—see what they do. Larger houses that specialize in four-color work are not the folks to approach for 500 copies of a one-color sales brochure. Get a feel for the capabilities and competency level of each outfit. And again, look at their work and speak with your colleagues.

When obtaining printing quotes, be thorough in your request. It's not a happy designer who delivers a project

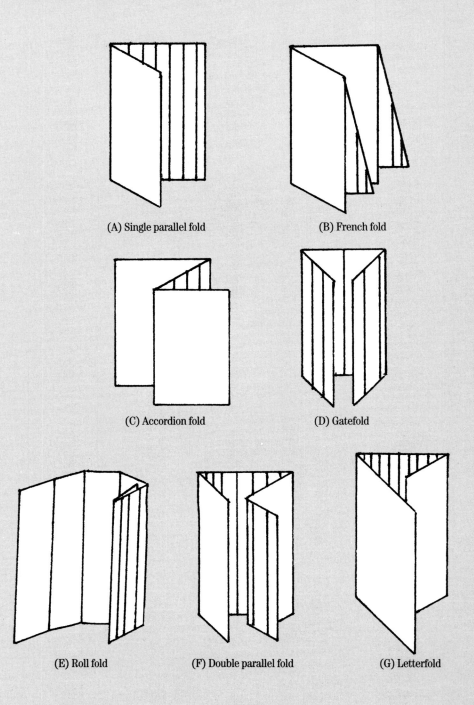

The most common brochure folds.

(A) Single parallel fold

(B) French fold

(C) Accordion fold

(D) Gatefold

(E) Roll fold

(F) Double parallel fold

(G) Letterfold

Printing

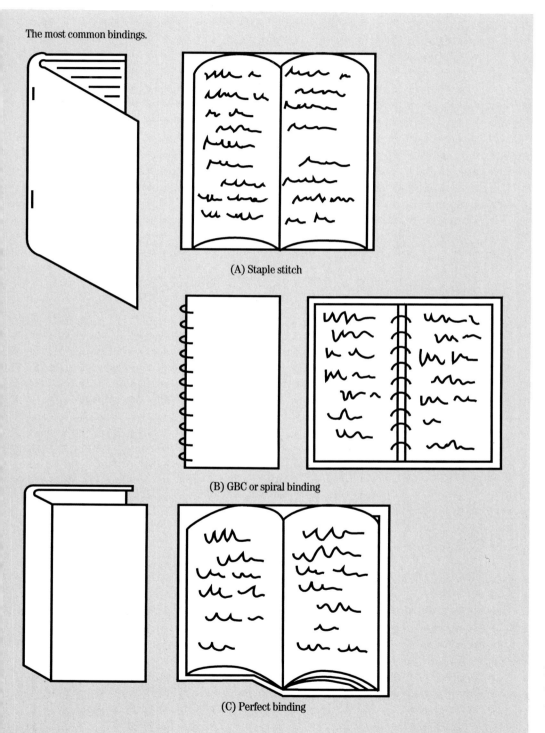

The most common bindings.

(A) Staple stitch

(B) GBC or spiral binding

(C) Perfect binding

to the selected printer, only to discover that those twelve photographs he or she neglected to mention in the bid request will increase the final bill to the tune of $120.

When you're getting your brochure or booklet printed, you'll also need to have it folded or bound. There are many ways to go about this, and you need to learn what your options are before you can make an informed decision about what fold or binding will work best with the piece you have created. Here is a list of some of the options you have.

- *Single parallel fold.* This consists of simply folding the piece in half. It works well for things like church bulletins and menus.

- *French fold.* With this process, the paper is folded in half one way and then folded in half the other, just like the card you sent to Mom on Mother's Day. This works well for large poster-size pieces, among others.

- *Accordion fold.* This zig-zag fold works well if you want to direct the reader's attention to one side of the brochure at a time.

- *Gatefold.* The ends of the piece are folded to meet in the middle, forming a "gate" that opens to—I would hope—a massively exciting piece of information or illustration.

- *Roll or barrel fold.* This one starts at one end of the printed piece and is folded in on itself panel by panel. It is a great way to "unfold" information and create a sense of excitement.

- *Double parallel fold.* With this style, the piece is folded in half and then folded in half again in the same direction, giving a sort of "book"

 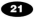

Folding, Binding and Printing

effect, again guiding the reader's eye.

• *Letterfold.* As the name implies, just fold it in thirds like a letter. Many brochures are folded in this manner. This turkey is popular!

• *Staple stitch.* This is a single parallel fold that is then stapled on the spine, forming a booklet.

• *GBC plastic binding.* In this process, a series of small rectangular holes is punched at the left side of the pages and a plastic comb inserted. The first example that comes to my mind (I live in a rural area) is the church fundraising cookbook.

• *Spiral binding.* Yes, this is what you think it is—just like those spiral-bound notebooks you toted around in high school.

• *Perfect binding.* This is the binding used for most paperback books. The pages are glued together and the cover attached. It works well for annual reports.

Don't wait until you need to get your piece printed, though, to consider these options; the best time to think this through is when you are planning your project. Start by looking closely at the piece. You just wouldn't use a French fold for a three-panel brochure, or use a letter fold for a piece measuring 11" x 17". Nor would you bother to GBC bind a piece with only two or three pages.

And while we're on the subject of bindings, number of pages and usage of the booklet are the two greatest dictators of type of binding. For instance, the aforementioned cookbook does best with a GBC binding, since a cookbook is best used when opened

YOUR BUSINESS LOGO

Printing Bid Request

Printing Company: _____

Contact Person: _____

Address: _____

Telephone/Fax: _____

Designer's Name: _____ Date: _____

Project Description: _____ Project Number: _____

Printing Specifications

Quantity to Print: _____

Paper Stock: _____

Number of Sides Printed: _____

# of Colors: _____	PMS Ink #'s: _____	Varnish: _____
Bleeds: _____	Screens: _____	Reverses: _____
Halftones: _____	Film: _____	Separations: _____
Proofs/Blueline: _____	Color Key: _____	Chromalin Proof: _____
Print Size: _____	Score: _____	Fold: _____
Finished Size: _____	Bindery: _____	Emboss: _____
Die Cut: _____	Perforations: _____	Drills: _____
Thermography: _____	Other: _____	
Pack: _____	Mailing: _____	

Mailing Instructions: _____

Delivery Instructions: _____

Date Due: _____

Please return bid by: _____

A form like this one (reprinted from *The Designer's Commonsense Business Book* by Barbara Ganim) should accompany your request for a printing bid; giving your printer all of the information included here will help ensure the accuracy of your printing bid.

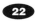

A flow chart of printing process options.

flat. This binding is also an acceptable choice because its casual look won't undercut the booklet's message. On the other hand, perfect binding is a more appropriate choice for an annual report, which requires a much more businesslike appearance, and which will not be referred to as often as a cookbook (making the fact that it will not lie flat when open a moot point). Obviously, if you can't get a staple through the spine of a booklet, you'll have to look into other options. Common sense, as well as the client's wishes, should be your guide.

When you've decided what kind of binding or folding your piece requires, be sure to include that information when you request a bid from your printer, and find out what's available and what it will cost. If you're doing something simple, such as a single parallel fold or a simple staple stitch, your bill shouldn't increase too much. If, however, your piece requires something unusual, then you can expect quite a hike in the bottom line.

And when designing your piece, please remember that folding is usually done on high-speed machines, and that these machines are rather unimaginative and cannot produce paper cranes; if you're designing a piece around an unusual fold or if you've devised an offbeat binding, it behooves you to call your printer and ask if what you want is possible (and if so, what it will cost you) before you invest a lot of time in designing something that can't be done.

If, however, you have your heart set on some kind of folding or binding your printer says can't be done, and if your piece is produced in small enough quantities, or is important enough to you, you can always do it yourself. Hand-folding might be your only recourse if you've designed something really elaborate, and hand-binding booklets in a unique way (some employ ribbons or even twigs) will certainly give your booklet a distinctive look. As always, though, consider what's appropriate for your piece. While hand-binding might work for a booklet featuring the wares of a crafts store, it might undercut the message of a catalog of computer software. Again, common sense should be your guide.

 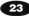

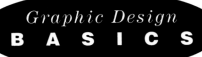
Chapter Two
Creating a Brochure or Booklet

When you begin to design a given brochure or booklet, always remind yourself that, whether you're designing a party invitation or an annual report, your goal is to communicate. And your role, as a graphic designer, is to facilitate communication.

Now, that doesn't mean your whole piece has to be constructed of 16-point Helvetica type and the most prosaic and unmistakable illustrations a clip art book can provide. Remember, if your piece is boring to look at, you won't be able to communicate—because no one will even bother to read it.

However, if you wrap 7-point Zapf Chancery type around a circular photograph of the Pope, you may get the reader's attention, but you won't keep it too long if you make him or her dizzy from spinning the piece around to read it.

The following chapter walks you through a number of projects that I did which, I'd like to think, balance the need to artfully catch the eye of the recipient and the need to put down the message of the brochure in a way easily digestible to its reader. The point is not, of course, to follow my layouts letter by letter, but instead to look over my shoulder and see how you can approach a project with these two concerns in mind—and maybe pick up a few tricks and techniques along the way.

> This chapter
> shows you
> step-by-step how
> to create your own
> brochures and
> booklets.

Project 1: One-Sided Accordion Fold

The Client: Bennett-Springer Insurance Agency.

This piece lists possibilities for insurance coverage for antique dealers. It can be personalized for potential clients by writing their names on the front panel and by using the blank lines inside to provide specific premium amounts and policy limitations for specific businesses. The last panel is the application to ensure that an agent will, indeed, call.

This part of Maine abounds in antique dealers. Since each shop is unique, it is necessary to evaluate each one on its own merit. Perhaps one specializes in Chinese pieces while another carries early twentieth-century American or seventeenth-century French or Italian items. Some inventories are vastly larger than others, as well. There can be no blanket policy that will serve the needs of each and every dealer.

It was a bit difficult to put this piece together, since the client wanted it printed only on one side, and, as we all know, the customer is always right; besides, printing only one side was easier on the client's budget. So a major difficulty of this project was staying within the allotted space. There was so much information that it required a very small point size to buy as much white space as possible and to keep the type from running all over itself.

Step 1. The beginning of this piece is just like any other—the quintessential grid. In this case it consists of four panels with ½" margins. Even though I'm including quite a bit of information in this brochure, I was still able to allow reasonably generous 1" gutters. I use Ready-Set-Go! 5.06 for page layout. Other programs available are Quark XPress, PageMaker and Publish-It!. Of course, there is also good old traditional pasteup, where you farm out the typesetting and create mechanicals by waxing each component of the piece onto a piece of mechanical board. For the latter process, you need steady hands, to be sure; it's easier to be precise in a page layout program, as the screen is continually surrounded by rulers that will aid you in placing the elements of your brochure accurately. A good page layout program also has a specifications screen in which you can specify the exact positions of various objects. It is a very accurate way to place lines, boxes, ovals, text boxes or whatever your heart and client desire. Get to know what your specific program can do for you.

Step 2. The cover was easy to set up. I entered the information, centered it, allowed space for the clip art that the client planned to provide and put the words "Insurance Proposal" into a shaded box (a text box that I drew with a 15 percent black background) to set apart and to emphasize that headline while still sticking with the Helvetica I used on the rest of the cover.

**Antique Dealers
Business Owners
Program**

Insurance Proposal

Prepared for

Prepared by
Bennett-Springer Agency
Route 1 at Mill Lane
East Belfast, Maine 04915
(207) 338-5430

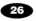

The Assignment: Create a four-panel single-sided brochure with type and simple graphics to be photocopied and folded accordion-style.

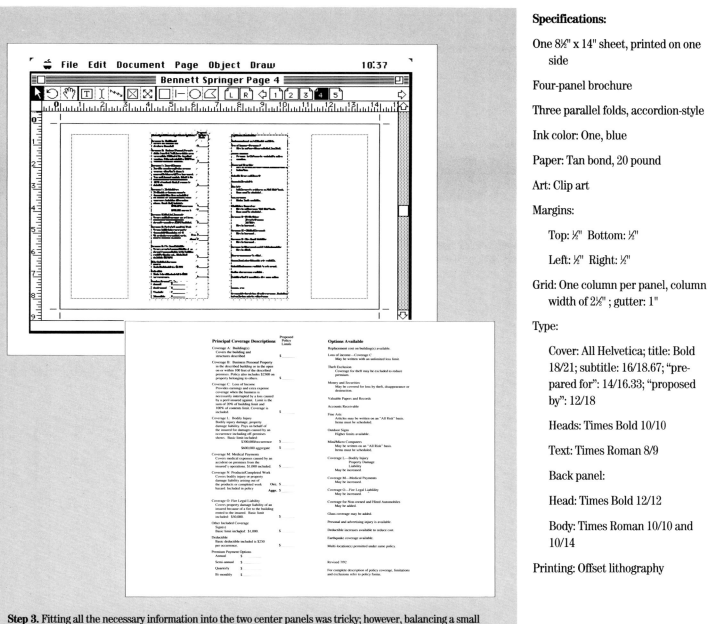

Specifications:

One 8½" x 14" sheet, printed on one side

Four-panel brochure

Three parallel folds, accordion-style

Ink color: One, blue

Paper: Tan bond, 20 pound

Art: Clip art

Margins:

Top: ½" Bottom: ½"

Left: ½" Right: ½"

Grid: One column per panel, column width of 2½" ; gutter: 1"

Type:

Cover: All Helvetica; title: Bold 18/21; subtitle: 16/18.67; "prepared for": 14/16.33; "proposed by": 12/18

Heads: Times Bold 10/10

Text: Times Roman 8/9

Back panel:

Head: Times Bold 12/12

Body: Times Roman 10/10 and 10/14

Printing: Offset lithography

Step 3. Fitting all the necessary information into the two center panels was tricky; however, balancing a small point size with a reasonable amount of white space keeps it quite readable. I used Times here instead of Helvetica to add some variety to the look of the brochure, and to lend a credibility to this important information. When setting up a column of lines, you can use the specifications menu of your page layout program to ensure even placement, or you can draw vertical rules on either side of the column in which you're drawing rules (either by double-clicking on the left- or right-hand column and pulling a ruler line out on either side of the column, or by using nonreproducible ink lines drawn on your boards) to maintain an even look when drawing your lines. I used the line-drawing tool on my page layout program to draw the lines you see here, but you could use ready-made clear tape with lines drawn on it instead. I wouldn't recommend drawing lines yourself with a ruler; even if you have a steady hand, you never know when your ink is going to clump or when you might have to sneeze.

 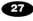

One-Sided Accordion Fold

Business Owners Application

Applicant Name Business Name

Street Address/Mailing (if different)
Street City/Town County State Zip Code

Legal Entity Individual Partnership Corporation
 Joint Venture Other

Prepared Effective Date: From___/___/___ to ___/___/___ Phone ()
 Quote Only

Actual location of business (if more than one location, please list):
 City/Town County State Zip Code

Step 4. The only glitch in the design was the form on the last panel, where I had to overshoot the margins to fit all the information in. The client approved this. To him, the information was more important than the design. (Remember, it's always a good idea to get a feel for what your client's priorities are even before you start working on a piece, so you'll have some idea what to do when a situation like this occurs.) I entered the text where I needed it, then used the rule and rectangle tools of my page layout program to create the rules and boxes you see here. (If you're not using a page layout program, you can use rolls of clear tape with various and sundry graphic elements to get such effects.)

Business Owners Application

Applicant Name ——————————————— Business Name ———

Street Address/Mailing (if different)
Street City/Town County State Zip Code

Legal Entity ☐ Individual ☐ Partnership ☐ Corporation
 ☐ Joint Venture ☐ Other

Prepared Effective Date: From __/__/__ to __/__/__ Phone (_____)
 ☐ Quote Only

Actual location of business (if more than one location, please list):
 City/Town County State Zip Code

Step 5. After I laid out the text horizontally for the form on the back panel, I used the rotation tool to position this box of text properly on the grid. If you don't have the capability to rotate a text box, you could always create the text horizontally, print it out and then wax it onto the mechanical in the desired position.

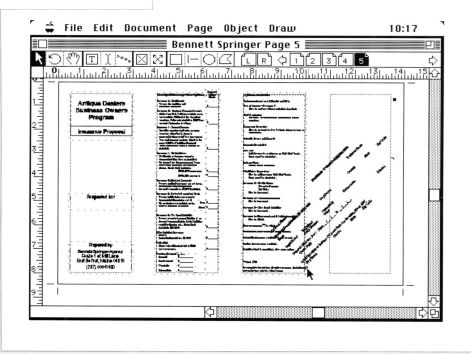

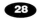

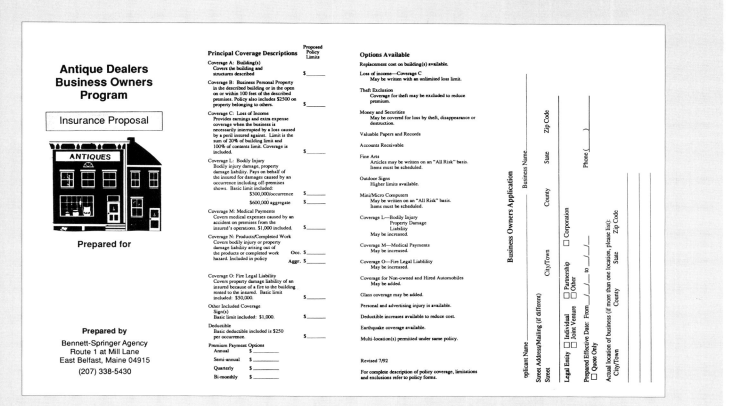

The print shop added the clip art, which was provided by the client, before printing. I recommended the ink and paper colors (blue ink on brown paper) to create a sense of antiquity with a businesslike flavor. The piece that resulted is now ready to hand, or send, to clients. This brochure is flexible enough to use for years. Since specific dollar amounts are not listed in the brochure, updates won't be necessary for a long time.

Project 2: Two-Sided, All-Type Brochure

The Client: A local yoga instructor who offers four sessions of classes a year; dates and information change each session.

Marianna needed a throwaway piece that she could reproduce, with some changes, for each session of her yoga classes. To keep costs to a minimum, she wanted to reproduce it at a local copy shop if she needed more during a session.

This brochure includes three major pieces of information—Marianna's credentials, the class schedule and a description of what Iyengar Yoga is and does (she chose the quote by Iyengar to convey to potential students the importance of nurturing the body in order to nurture the soul—the essence of yoga). Because she mails out brochures in response to requests for information, the brochure will need to work as a self-mailer. The back cover will be left blank for mailing information except for a preprinted return address. When information is requested, it's easy to write in the address or to attach a mailing label and get the dog to lick a stamp.

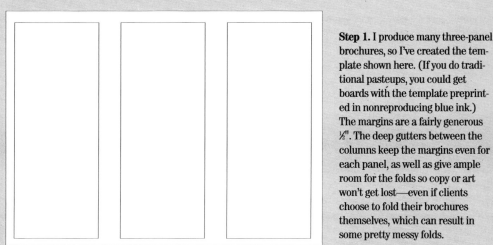

Step 1. I produce many three-panel brochures, so I've created the template shown here. (If you do traditional pasteups, you could get boards with the template preprinted in nonreproducing blue ink.) The margins are a fairly generous ½". The deep gutters between the columns keep the margins even for each panel, as well as give ample room for the folds so copy or art won't get lost—even if clients choose to fold their brochures themselves, which can result in some pretty messy folds.

Marianna began to practice Yoga eighteen years ago and has been teaching Yoga since 1986 (3 years at the Belfast Dance Studio).

Through her experience, Marianna has found the Iyengar method of Hatha Yoga to provide the most profound relaxation, healing and growth. This method has become the focus of her practice. She continues to study with senior Iyengar teachers such as Arthur Kilmurray, Ramanand Patel, Francois Raoult, Patricia Walden, Gabriel Halpern. Twice a year she travels to Washington, DC, to participate in a Yoga Teacher Training program led by John Schumacher.

Marianna brings to her teaching a background of studying and working in the field of Education and Psychology. The healing through Homeopathy has been a focus of her interest and study for several years. A practitioner of Vipassana Meditation, Marianna integrates the practice of mindfulness with Iyengar Yoga.

In a warm and caring way, students are motivated to work intensively on special aspects of Yoga practice in a joyful and supportive atmosphere.

New Century Schoolbook — 11/13

Marianna began to practice Yoga eighteen years ago and has been teaching Yoga since 1986 (3 years at the Belfast Dance Studio).

Through her experience, Marianna has found the Iyengar method of Hatha Yoga to provide the most profound relaxation, healing and growth. This method has become the focus of her practice. She continues to study with senior Iyengar teachers such as Arthur Kilmurray, Ramanand Patel, Francois Raoult, Patricia Walden, Gabriel Halpern. Twice a year she travels to Washington, DC, to participate in a Yoga Teacher Training program led by John Schumacher.

Marianna brings to her teaching a background of studying and working in the field of Education and Psychology. The healing through Homeopathy has been a focus of her interest and study for several years. A practitioner of Vipassana Meditation, Marianna integrates the practice of mindfulness with Iyengar Yoga.

In a warm and caring way, students are motivated to work intensively on special aspects of Yoga practice in a joyful and supportive atmosphere.

Avant Garde — 11/13

Park Avenue — 11/13

Step 2. The client supplied her own copy, but I had to organize it and the panels and set each major section clearly apart from the others. The largest block of copy was the explanation of the Iyengar Yoga, so I based my type design on what worked for that copy. Since this piece is primarily text, I chose New Century Schoolbook for its clarity and readability. There is too much text for a sans serif font, even for an easily read sans serif such as Avant Garde. A decorative face would be appropriate for the client but, as you can see here, would be completely unreadable for this much text.

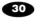

The Assignment: Develop a low-budget, three-panel brochure with simple graphics that can be reproduced by photocopying on white or colored paper.

Days & Times

Monday	4:30 - 6:00 PM	Level I & I cont.
Tuesday	9:15 - 10:45 AM	Level I women
	5:30 - 7:00 PM	Level I
	7:15 - 8:45 PM	Level II
Thursday	4:00 - 5:30 PM	Level I
	5:45 - 7:15 PM	Level I, cont.
Friday	9:00 - 10:30 AM	Level I, cont.
Saturday	9:00 - 10:30 AM	Level I, cont.

Classes are held at the
Belfast Yoga Studio
Belfast Center • 426A
175 High Street

Registration & Fees

13 Week Session (No classes: 2/4 – 2/16)	$91.00
Drop-in Fee	$8.00
Private Instruction —hourly rate	$30.00

Missed classes may be made up anytime during same session.

Yoga for "growing-up" kids, ages 12 and over Dates TBA

Restorative Yoga, Feb. 17—Mar 31, Wednesdays 4:30 - 6:30 pm 6 weeks $66 Registration only. No drop in.

Registration for the Winter Session begins December 21.
For more information regarding classes, call Marianna at:
338-6577

Levels

Level I	An introduction to Iyengar Yoga as well as a review and grounding in the fundamentals for students of all levels
Level I (cont.)	For students who have some experience with the Iyengar method.
Level II	Students should have a working understanding of the different groups of Yoga poses (standing, inversion, backward bending, forward bending, lateral twist, balancing and restorative).

If you look after the root of the tree, the fragrance and flowering will come by itself. If you look after the body, the fragrance of the mind and spirit will come of itself.

—B.K.S. Iyengar

Iyengar Yoga is spiritual practice in physical form. Inner action is expressed in physical form through the practice of asana—physical posture. Careful attention is paid to alignment of the body. Proper alignment creates stability and strength, balances the work of the muscles and protects the joints and the spine from injury. As the body is aligned the breath can flow freely. At a deeper level, alignment involves integration, bringing one part of the body into appropriate relationship with another. Yoga Asanas aim at re-creating the proper space between the spinal vertebrae so that the nerves can be released and health re-established.

Many common physical ailments and defects including chronic disorders can be improved by the practice of Yoga postures. They work on specific areas of the body such as the joints, the liver, kidneys and heart. The movements and extensions in the postures, including the positioning of the inner organs in inverted sequences, have a profound effect on how they function. The body is oxygenated and filled with healthy blood, decongested and rested. Stamina, lung capacity, heart performance, muscle tone, circulation and respiration all improve.

Through Iyengar Yoga, strength, flexibility, balance, endurance and lightness of limb are developed. These are actually side effects of the practice. Steadiness of both, mind and body are developed. One becomes consciously and totally absorbed as asana is practiced. This absorption is actually meditation in action.

Step 3. This piece has many levels of emphasis. Except for the title and cover blurb, I used the same face in different point sizes and styles for the different levels in order to reduce confusion. The use of Caslon 540 Roman for the title and cover blurb remains consistent with my client's business card and stationery. New Century Schoolbook Bold is quite heavy, so it doesn't need to be large to stand out on the page. That makes it easy to emphasize several different items without the piece appearing to scream at the reader.

Step 4. The client had chosen to use the graphic that she uses on her business card and stationery. Since it depicts an asana, a yoga posture, it is (fortunately) appropriate to the piece. And since it's line art, it will reproduce well when photocopied. I scanned in the art, touched it up in a drawing program and then saved it in EPS (encapsulated PostScript) format. If I didn't have the scanner, I would get stats made and then touch them up. On this piece, scanning meant that I could easily use the art at two different sizes without having to pay for two stats—a good money-saving tactic for a low-budget project. And since this piece will be recycled several times, there is no need to worry about stats getting lost or damaged.

Specifications:

One 8½" x 11" sheet

Three-panel brochure

Two parallel folds

Ink color: One, black

Paper: Blue bond, 20 pound

Art: Line art illustration

Margins:

 Top: ½" Bottom: ½"

 Left: ½" Right: ½"

Grid: One column per panel, column width of 2⅔"; gutter: 1"

Type:

 Title: Caslon 540 Roman, 60/60

 Subtitle: New Century Schoolbook, 9/10

 Cover blurb: Caslon 540 Roman, 18/36

 Headlines: New Century Schoolbook Bold, 14/16

 Body copy: New Century Schoolbook Roman, 11/13

 Quotation: New Century Schoolbook Italic, 10/12

Printing: Photocopying

Two-Sided, All-Type Brochure

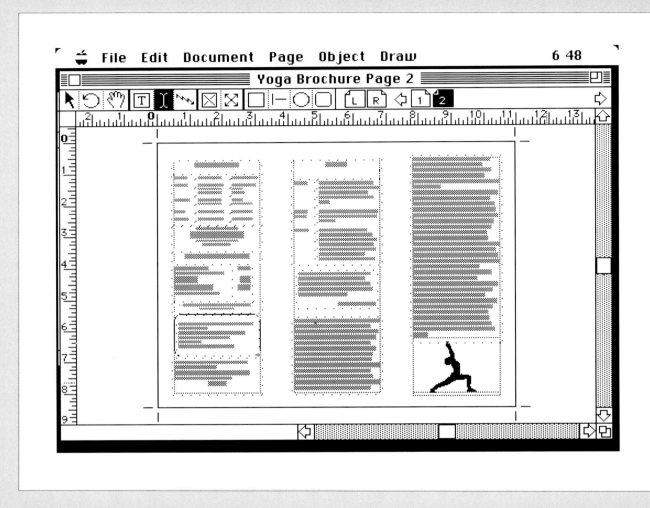

Step 5. I use a page layout program, so I prepared the mechanical on the computer—no physical pasteup was required at all, with the graphic saved as an EPS file. (My program allows me to size graphics on the page, so I need only one EPS file.) I broke the text in such a way as to fill the entire center panel, knowing that I could balance it by sizing the graphic in the third panel appropriately. On low-budget projects like this one, I usually try to do all the typesetting and layout on the computer to keep costs down.

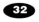

Marianna began to practice Yoga eighteen years ago and has been teaching Yoga since 1986 (3 years at the Belfast Dance Studio).

Through her experience, Marianna has found the Iyengar method of Hatha Yoga to provide the most profound relaxation, healing and growth. This method has become the focus of her practice. She continues to study with senior Iyengar teachers such as Arthur Kilmurray, Ramanand Patel, Francois Raoult, Patricia Walden, Gabriel Halpern. Twice a year she travels to Washington, DC, to participate in a Yoga Teacher Training program led by John Schumacher.

Marianna brings to her teaching a background of studying and working in the field of Education and Psychology. The healing through Homeopathy has been a focus of her interest and study for several years. A practitioner of Vipassana Meditation, Marianna integrates the practice of mindfulness with Iyengar Yoga.

In a warm and caring way, students are motivated to work intensively on special aspects of Yoga practice in a joyful and supportive atmosphere.

Marianna Moll-Anderson
RR 2 Box 388
Belfast, ME 04915

YOGA

at the Belfast Yoga Studio

a road

to better

health

and

greater

peace

of mind

Marianna was pleased with the results. As you can see, the brochure contains a lot of information, but there is still room for white space and adequate leading, two major keys to legibility. Since the client really liked this layout, I'll be able to recycle it for her at least twice by updating only the panel with the class information. That will save me design time and help hold down ongoing costs for my client.

Days & Times

Monday	4:30 - 6:00 PM	Level I & I cont.
Tuesday	9:15 - 10:45 AM	Level I women
	5:30 - 7:00 PM	Level I
	7:15 - 8:45 PM	Level II
Thursday	4:00 - 5:30 PM	Level I
	5:45 - 7:15 PM	Level I, cont.
Friday	9:00 - 10:30 AM	Level I, cont.
Saturday	9:00 - 10:30 AM	Level I, cont.

Classes are held at the

Belfast Yoga Studio
Belfast Center • 426A
175 High Street

Registration & Fees

13 Week Session (No classes: 2/4 – 2/16)	$104.00
Drop-in Fee	$9.00
Private Instruction —hourly rate	$30.00

Missed classes may be made up anytime during same session.

Yoga for "growing-up" kids, ages 12 and over Dates TBA

Restorative Yoga, Feb. 17—Mar 31, Wednesdays 4:30 - 6:30 pm
6 weeks $66
Registration only. No drop in.

Registration for the Winter Session begins December 21.
For more information regarding classes, call Marianna at:
338-6577

Levels

Level I	An introduction to Iyengar Yoga as well as a review and grounding in the fundamentals for students of all levels
Level I (cont.)	For students who have some experience with the Iyengar method.
Level II	Students should have a working understanding of the different groups of Yoga poses (standing, inversion, backward bending, forward bending, lateral twist, balancing and restorative).

If you look after the root of the tree, the fragrance and flowering will come by itself. If you look after the body, the fragrance of the mind and spirit will come of itself.

—B.K.S. Iyengar

Iyengar Yoga is spiritual practice in physical form. Inner action is expressed in physical form through the practice of asana—physical posture. Careful attention is paid to alignment of the body. Proper alignment creates stability and strength, balances the work of the muscles and protects the joints and the spine from injury. As the body is aligned the breath can flow freely. At a deeper level, alignment involves integration, bringing one part of the body into

appropriate relationship with another. Yoga Asanas aim at recreating the proper space between the spinal vertebrae so that the nerves can be released and health reestablished.

Many common physical ailments and defects including chronic disorders can be improved by the practice of Yoga postures. They work on specific areas of the body such as the joints, the liver, kidneys and heart. The movements and extensions in the postures, including the positioning of the inner organs in inverted sequences, have a profound effect on how they function. The body is oxygenated and filled with healthy blood, decongested and rested. Stamina, lung capacity, heart performance, muscle tone, circulation and respiration all improve.

Through Iyengar Yoga, strength, flexibility, balance, endurance and lightness of limb are developed. These are actually side effects of the practice. Steadiness of both, mind and body are developed. One becomes consciously and totally absorbed as asana is practiced. This absorption is actually meditation in action.

Project 3: Three-Panel Letterfold

The Client: A friend and former student who wanted a "cute" piece to send to friends and family.

Margit is an avid animal lover who can see distinctive traits in critters that those of us with less well-developed sensibilities often tend to miss. For instance, I never realized that my pooch (who is featured in this brochure, along with Margit's three canine companions) had any nursing skills.

Since this piece is intended to amuse rather than inform or generate revenue, it won't be produced in great quantity. A trip to the copy shop is all that's required.

The information contained in the brochure is twofold: What is Tippy Toes (or what would it be if it really existed) and what does it have to offer? Setting up the back panel as a self-mailer gives the piece a certain credibility, and the whimsical illustrations amplify its humor.

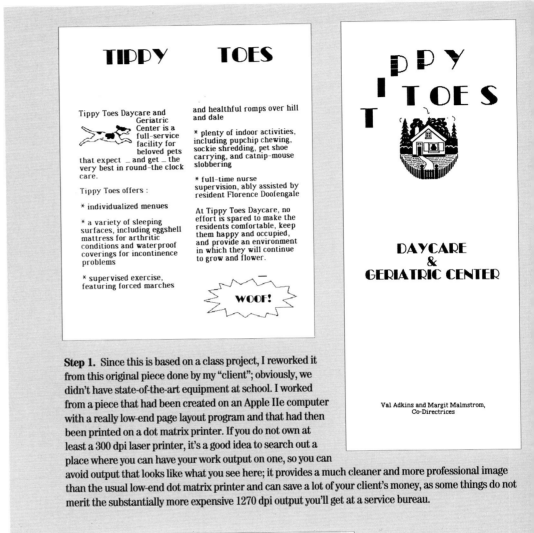

Step 1. Since this is based on a class project, I reworked it from this original piece done by my "client"; obviously, we didn't have state-of-the-art equipment at school. I worked from a piece that had been created on an Apple IIe computer with a really low-end page layout program and that had then been printed on a dot matrix printer. If you do not own at least a 300 dpi laser printer, it's a good idea to search out a place where you can have your work output on one, so you can avoid output that looks like what you see here; it provides a much cleaner and more professional image than the usual low-end dot matrix printer and can save a lot of your client's money, as some things do not merit the substantially more expensive 1270 dpi output you'll get at a service bureau.

Step 2. Once again, I chose to go with the garden-variety three-panel brochure format. I had the option of using 1½" margins but chose to go with ⅜" in order to avoid crowding the text or further reducing the artwork.

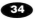

Brochure

The Assignment: Develop a three-panel letterfold brochure with type and line art to be reproduced by photocopy.

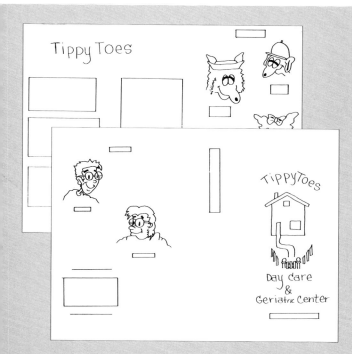

Step 3. A pencil and legal pad junkie, I sketched out the placement of each piece of information and each drawing in order to ensure balance and order. I rearranged the information from Margit's original piece, and added the introduction she had written for a newspaper column about Tippy Toes. (We have very long winters in Maine, and must entertain ourselves as best we can.) I added space to include the line art she requested from graphic artist Michael Hanrahan. My plan of attack was to place the descriptive copy first, and then the Tippy Toes offerings, and finally to incorporate the "portraits" of the residents.

Specifications:

One 8½" x 11" sheet

Three-panel brochure

Two parallel folds

Ink color: One, black

Paper: Blue bond, 20 pound

Art: Line art, commissioned from graphic artist

Margins:

 Top: ⅜" Bottom: ⅜"

 Left: ⅜" Right: ⅜"

Grid: One column per panel, column width of 2.92"; gutter: ¾"

Type:

 Title: Broadway 60/73.33

 Headlines: Palatino Bold 14/16.33, Broadway 12/16

 Body copy: Palatino Roman 12/16

 Quotation: Palatino Italic 16/20

 Illustration captions: Palatino 10/11.67

Printing: Photocopying

TippyToes

The Residents

TippyToes Day Care and Geriatric Center is a full-service facility for beloved pets that expect—and get—the very best in round-the-clock care.

TippyToes Day Care and Geriatric Center is located on the specious grounds of lovely Mosquito Manor, hard by the Lincolnville Bog. It is the entirely fictitious creation of a fevered imagination. The residents, however, are real…all too real…

At **TippyToes Daycare and Geriatric Center**, no effort is spared to make the residents comfortable, keep them happy and occupied, and provide an environment in which they will continue to grow and flower.

TippyToes offers:

- individualized menus
- a variety of sleeping surfaces, including an eggshell mattress for arthritic conditions and waterproof coverings for incontinence problems
- supervised exercise, featuring forced marches and healthful romps over hill and dale
- plenty of indoor activities, including pupchip chewing, sockie shredding, pet shoe carrying, and catnip-mouse slobbering
- full-time nurse supervision, ably assisted by residents Florence Doofingale, RN, and Candy Striper Nussy vonFluffentusche

Ms. Sue, Alpha Pooch

Florence Doofingale, RN from Hell

Miss Nussy vonFluffentusche

Mrs. Emma Grufflebutt Doofwell III

Step 4. Now it's time to place the interior copy. To keep the irreverent feel of the original, I used Broadway for the title and heads, and Palatino Roman, Palatino Bold and Palatino Italic for the body copy and captions, heads and advertising slogan respectively. Broadway is a fun typeface that yells "wheee" and Palatino is, of course, very readable and utilitarian. Both faces exemplify the concept of Tippy Toes. I've used a list bulleted with Zapf Dingbats to draw attention to the important information contained in the center. I've left spaces on the interior left panel for the illustrations of the "residents," to come later.

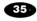

Three-Panel Letterfold Brochure

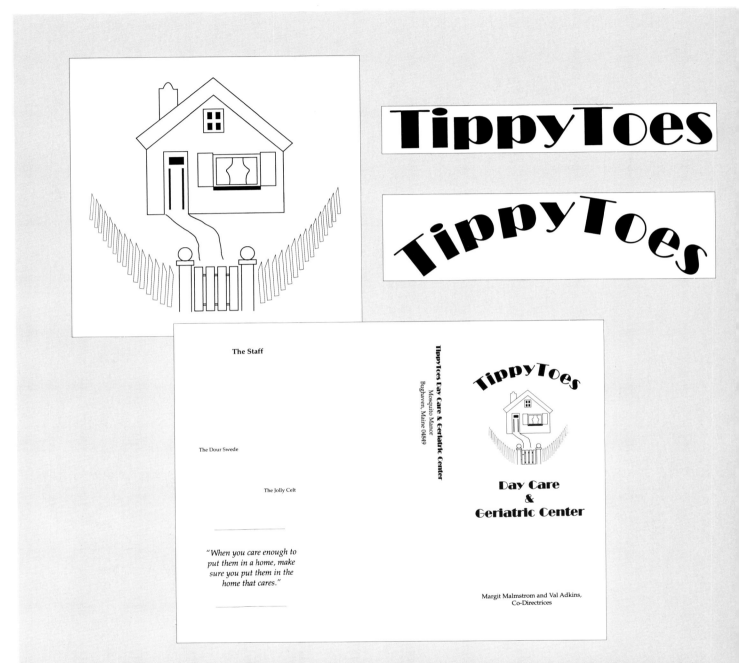

Step 5. Using Adobe Illustrator, I created an EPS drawing similar to the client's original cover graphic, and arced the title with Smart Art, a desk accessory that does some fancy manipulation of PostScript typefaces. If you want to do this and don't have an accessory like this, you have a few other options: You could type in the word and set the baseline shift function differently for each letter (if you're working on a Mac) until you get the effect you want; you could draw a separate text box for each letter, placing the text boxes so you get the desired effect; or, if you don't have a page layout program, you could print out the letters and arc them by placing them that way on the mechanical manually (a tedious and painstaking task I wouldn't recommend). The tongue-in-cheek co-directrices information is set in the same Palatino typeface as the body copy of the brochure.

Step 6. The other illustrations were commissioned from Mr. Hanrahan, who, I must say, captured the true essence of both the residents and the staff.

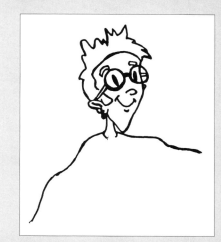

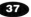

Step 7. To create balance, I decided to place the staff pictures facing each other. Since the drawing of the Dour Swede was facing the wrong way for this, I had to flop it. I did this by copying it onto clear film, turning it over and then copying it onto laser paper. Voila! She's heading in the right direction now. Then I added the official Tippy Toes slogan under the drawings, and set it off by centering it within two $1/8$-point lines drawn with the line-drawing tool of my page layout program. (If I'd wanted to get really fancy, I could have used a line of very small dingbats instead; however, I thought my client called for a more simple, dignified approach.)

Three-Panel Letterfold Brochure

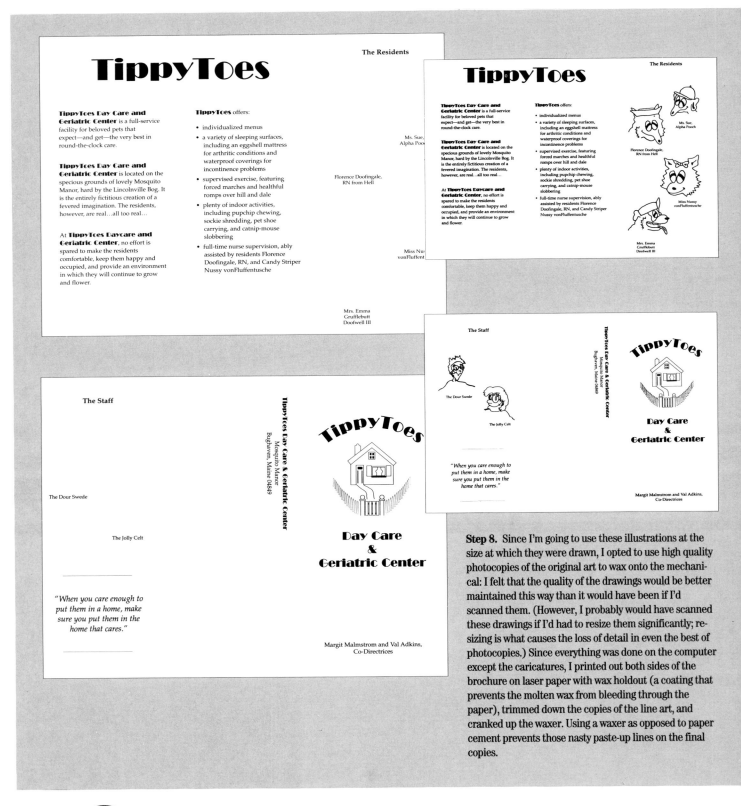

Step 8. Since I'm going to use these illustrations at the size at which they were drawn, I opted to use high quality photocopies of the original art to wax onto the mechanical: I felt that the quality of the drawings would be better maintained this way than it would have been if I'd scanned them. (However, I probably would have scanned these drawings if I'd had to resize them significantly; resizing is what causes the loss of detail in even the best of photocopies.) Since everything was done on the computer except the caricatures, I printed out both sides of the brochure on laser paper with wax holdout (a coating that prevents the molten wax from bleeding through the paper), trimmed down the copies of the line art, and cranked up the waxer. Using a waxer as opposed to paper cement prevents those nasty paste-up lines on the final copies.

TippyToes

TippyToes Day Care and Geriatric Center is a full-service facility for beloved pets that expect—and get—the very best in round-the-clock care.

TippyToes Day Care and Geriatric Center is located on the specious grounds of lovely Mosquito Manor, hard by the Lincolnville Bog. It is the entirely fictitious creation of a fevered imagination. The residents, however, are real…all too real…

At **TippyToes Daycare and Geriatric Center**, no effort is spared to make the residents comfortable, keep them happy and occupied, and provide an environment in which they will continue to grow and flower.

TippyToes offers:

- individualized menus
- a variety of sleeping surfaces, including an eggshell mattress for arthritic conditions and waterproof coverings for incontinence problems
- supervised exercise, featuring forced marches and healthful romps over hill and dale
- plenty of indoor activities, including pupchip chewing, sockie shredding, pet shoe carrying, and catnip-mouse slobbering
- full-time nurse supervision, ably assisted by residents Florence Doofingale, RN, and Candy Striper Nussy vonFluffentusche

Florence Doofingale, RN from Hell

Ms. Sue, Alpha Pooch

Miss Nussy vonFluffentusche

Mrs. Emma Grufflebutt Doofwell III

The Staff

The Dour Swede

The Jolly Celt

"When you care enough to put them in a home, make sure you put them in the home that cares."

TippyToes Day Care & Geriatric Center
Mosquito Manor
Bughaven, Maine 04849

TippyToes

Day Care & Geriatric Center

Margit Malmstrom and Val Adkins, Co-Directrices

The final product is a success. The piece is very readable with good-sized type, lots of white space, and plenty of humor. Since everything except the artwork was done with a page layout program, text changes will be easy, and Mr. Hanrahan is young enough to draw many generations of dogs, thereby keeping the artistic style consistent.

Project 4: Adding Color With Ink

The sight of black ink can get old. After all, nearly everyone uses it. And you want your piece to be noticed. Perhaps using something a little different is in order. Many printers have stock colors that are available at no extra cost. Ask! If your budget allows it, a special PMS (Pantone Matching System) color might be the way to go. But keep in mind that using PMS colors can be quite expensive, perhaps even $40 or $50 over stock colors (or more, depending upon how many copies you need).

Another possibility is the use of two colors. A simple example of this is an all-text piece with heads in one color and body text in another. Keep in mind, too, that black counts as one color if, for instance, you are having a piece printed in black and blue. This will be more expensive than a one-color job, due to several possible scenarios. First, if the printing press can print only one color at a time, the operator will have to completely wash the ink off the rollers before adding the second color. He or she will also have to make another negative and plate, and time, of course, is money. Second, if the press is capable of printing two colors at once, you can bet the rent that it's a much more expensive piece of equipment. In either case, the cost will be passed on to you.

Four-color process is an even better way to get your message across pictorially. It is also, alas, the most expensive, and most time-consuming, method of offset printing. If that old devil budget permits, however, definitely look into this one. You can reproduce your photography in living color, and, as we all know, a picture is worth a thousand words.

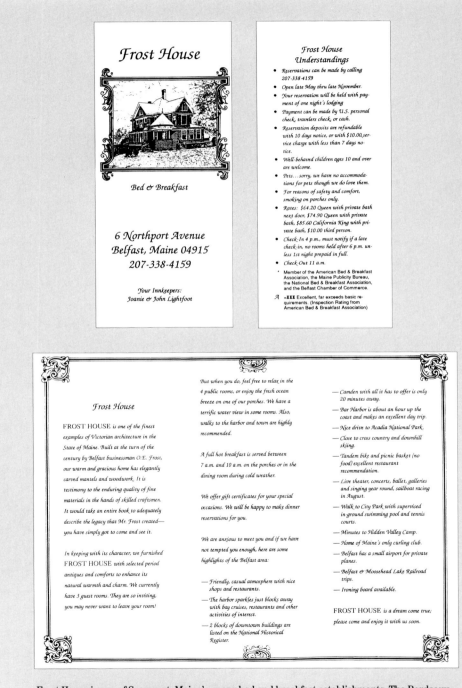

Frost House is one of Searsport, Maine's, many bed and breakfast establishments. The Bordeaux red ink against a background of natural light gray parchment echoes the gracious style of this century-old home. The script typeface is decorative but readable, and helps to give the list of understandings on the accompanying flyer a polite feel.

Creating Brochures & Booklets

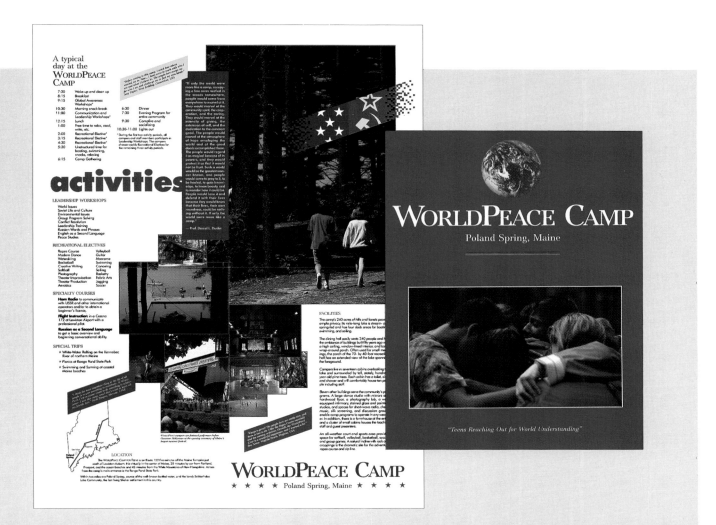

This brochure is printed on the plainest of white coated stock, but it's anything but dull. The design, which uses red, white and blue ink as well as gold accents, manages to convey the Russian/American nature of this organization without undue visual discord, because of its use of reliable old black ink to present the majority of the text. Using any of these accent colors as the color of the paper would have overwhelmed the serious information presented in this brochure, and using them for the body of the text would have made reading the brochure difficult at best. This is an excellent example of ink color chosen strategically to convey the message of the client.

Adding Color With Ink

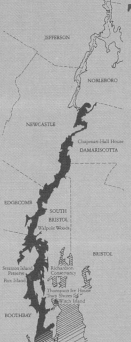

Dear Friends and Members,

Now that the days have grown longer, we are all making plans for the warmer month of 1988. We hope that your plans will include active support of and membership the Damariscotta River Association. 1987 brought an increased awareness that Lincoln County is growing at an unprecedented rate. Newspapers have reported population growth estimates as high as 20% over the next ten years and are increasingly focusing attention on how towns are attempting to deal with the impacts of this growth. A showing of aerial slides at last year's annual meeting opened eyes to changes that cannot be seen from local roads. The Damariscotta River Association has viewed this growth with great concern and underlined its commitment to the preservation and protection of the beautiful river and watershed by forming a land conservation trust last June. The Trust has already advised numerous land owners, town officials and developers about the many benefits that may be derived from conservation easements. Apart from personal satisfaction gained from helping to preserve the character and beauty of our river and its neighborhood, easements can be of considerable value to families concerned about inheritance taxes as well as to towns considering protection for areas of vital natural resource. We are pleased to announce that the Trust has recently completed an agreement to receive and protect for public access an exceptional island in the river, presented by a generous donor as a gift to the community. We are also completing steps to accept easements on several important properties along the river's edge and are working with a developer to ensure that potential residential development will have minimal impact on the environment. Besides promoting continuing awareness of watershed history and natural resource, we believe that the Association with its land trust provides another option for those who wish to preserve important wildlife habitat, scenic beauty, and water quality in this region. Public awareness is essential to ensure that growth does not come at the expense of the environment, public access, traditional employment and the security of families who have lived here for generations. We welcome your thoughts, assistance and your new or renewed membership. Please return the lower portion of this brochure with your membership donation. If you know of someone else who might be interested, please send us their name and address. Future generations of your family living in this region will be the ultimate beneficiaries of your support.

Land Conservation Trust

The purpose of the Damariscotta (Maine) River Association is twofold: to promote public awareness of the area's natural resources and wildlife and to protect them. The use of deep blue in various screens with burnished orange serves to create a beautiful and gentle depiction of the area. These colors are echoed in the printing of the text, providing continuity.

The Damariscotta River and watershed was formed over ten thousand years ago when the ice cover receded. Ocean water has been ebbing and flowing twice a day since with approximately twenty-three billion gallons rushing through the Fort Island Narrows on every change of tide. Wildlife abounds in the water, along its shore and overhead. Majestic pine and oak border high bluffs and marshes change color with the tide and season. Although the landscape has been altered over the years there still exist many areas where one can experience quiet, natural beauty and the wildness of a varied plant and animal life as it may have existed in the time of the Wawenocks and earlier native Americans.

Initially, both France and England claimed this region, but after Louisburg was captured in 1758 English people settled in relative security. Massachusetts provided jurisdiction here as a British colony and later one of the United States until Maine became a state in 1820. By then, the division into towns was well established with eight bordering the river and its reaches: Boothbay, Edgecomb, Newcastle, Jefferson, Nobleboro, Damariscotta, Bristol and South Bristol.

The town is a basic political unit with a form of government unchanged since colonial times. While the boundaries are precise, villages are less defined with Newcastle, Sheepscot and North Newcastle all in the town of Newcastle and Damariscotta Mills in both Newcastle and Nobleboro. As citizens we cherish our form of government and are proud that we can directly influence what our towns accomplish. Now, more than ever, cooperation between towns is imperative as problems associated with growth become regional and transcend these boundaries.

Each town has some ordinances and regulations governing certain activities and construction near the river, but experience in southern Maine has shown that these guidelines are often inadequate to preserve the character and traditional resources of communities. The Damariscotta River is officially designated as one of Maine's scenic rivers, but it is also a vital part of the historical, recreational and economic base of all eight towns and deserves our special care and attention.

The Damariscotta River Association and Land Conservation Trust needs your membership.

Annual Membership Fees:
- [] Individual Membership $5.00
- [] Family Membership $7.50
- [] Sponsoring Membership $25.00
- [] Patron Membership $50.00 or more

Name _____
Date _____
Address _____

Your fee and donation is approved for deduction by the I.R.S. and your cancelled check is your receipt.
Please return to: Damariscotta River Association Membership Chairman, P.O. Box 333, Damariscotta, Maine 04543.

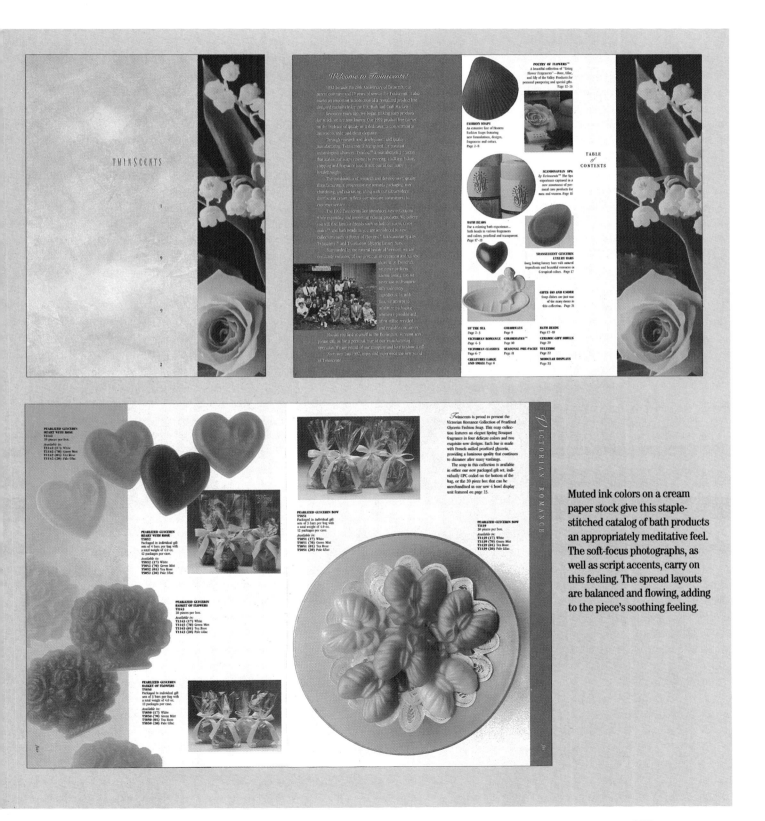

Muted ink colors on a cream paper stock give this staple-stitched catalog of bath products an appropriately meditative feel. The soft-focus photographs, as well as script accents, carry on this feeling. The spread layouts are balanced and flowing, adding to the piece's soothing feeling.

Adding Color With Ink

Gorgeous, surprisingly coordinated ink colors lend a feeling of excitement to this booklet, which promotes a special event put on by AT&T. The orange lightning bolt border on the cover, when combined with the green and pink borders, creates an optical illusion that almost makes these bolts appear three-dimensional, and all these elements point to the cover information. The back cover is longer than the rest of the booklet trim, a clever device that emphasizes the president's quote on the border. The lightning bolt border is also used as a graphic device throughout the booklet, lending continuity to its design.

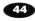

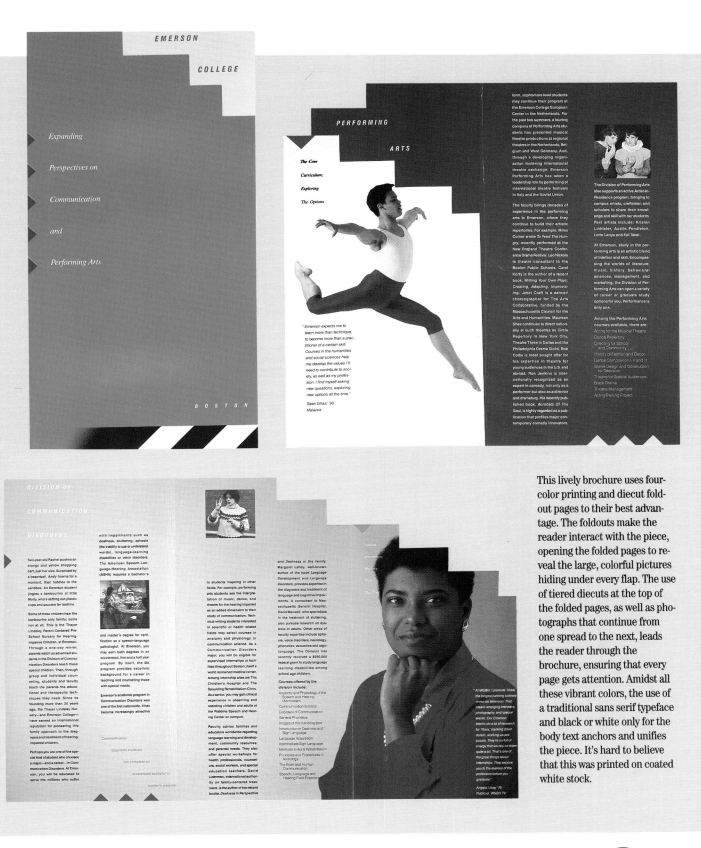

This lively brochure uses four-color printing and diecut fold-out pages to their best advantage. The foldouts make the reader interact with the piece, opening the folded pages to reveal the large, colorful pictures hiding under every flap. The use of tiered diecuts at the top of the folded pages, as well as photographs that continue from one spread to the next, leads the reader through the brochure, ensuring that every page gets attention. Amidst all these vibrant colors, the use of a traditional sans serif typeface and black or white only for the body text anchors and unifies the piece. It's hard to believe that this was printed on coated white stock.

Project 5: Four-Color Brochure

The Client: Robert Bolton, Jr., owner of The Glass Workbench.

Robert is a rather laid-back gentleman who, after many years in the stained glass business, decided that a color piece would be a good way to promote his business. Obviously, he doesn't make decisions lightly. He wanted the brochure to convey the message of the beauty, desirability and practicality of stained glass. The piece was to contain illustrations, both in black and white and in color, as well as the answers to commonly asked questions, background information on Robert and, of course, sell copy.

This project was done jointly by me and my friend and colleague Carol Gillette of Communication Graphics. We began by meeting with Robert to discuss his intended use for the brochure. His target audience included both designers and homeowners, so he wanted the information presented in a nontechnical and nonthreatening manner. Obviously, it had to catch the eye as well.

The piece contains four important kinds of information. The most noticeable, of course, are the illustrations. The flow continues with the section headed "Imagine the Beauty," which touts the aesthetic value of stained glass art. Next, we have the practical section, which addresses some common concerns: Will the glass break easily? Is it energy efficient?

Finally, we're given some information on Robert's professional history, along with a photo of the "Genius at Work." People do like to know who they're dealing with, after all.

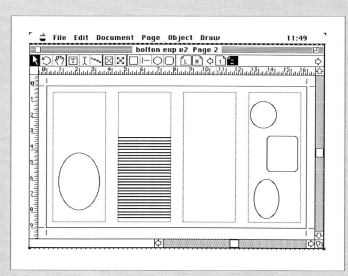

Step 1. After we met with Robert to decide on the specs for the job, we created a preliminary comp. First we planned the layout: an eight-panel gatefold design printed on a 9" x 16" sheet. The grid would be one column per panel. Then, we produced a mock-up brochure based on this design with lines to represent type and keylines to show the area for photographs and art. The client was charged for our time only, and it gave him an idea of what we were conceptualizing. Using the gatefold meant readers would first see plenty of full-color photographs of Robert's work to pique their interest; unfolding the brochure completely would reveal background information about the stained glass depicted in full color on the front of the brochure. Printing four-color on one side and only one color on the other side would save our client a substantial amount of money.

Step 2. Now that we had a reasonable idea of what we were working with (we're all very visual people), I discussed with Robert the points he wanted to cover, and wrote, and then revised, the copy accordingly. (Calls for "Renaissance Desktop Publishers" are fairly infrequent. It isn't unusual for clients to ask me to write the copy for their printed pieces, but it is not an everyday occurrence. Although I don't think it's necessary to read the dictionary in preparation for such a request, if you feel uncomfortable doing it, admit it to your client or call upon a colleague for help.)

The Assignment: Create a four-color process brochure with illustrations.

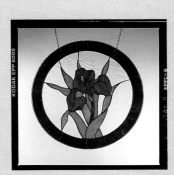

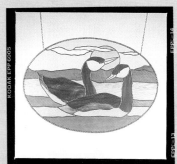

Specifications:

One 9" x 16" sheet

Eight panels, four each side

Ink colors: 4c/1c (four colors on one side, one color on the other), process

Paper: White coated, 70 pound

Art: Photographs, line art

Margins:

 Top: ½" Bottom: ½"

 Left: ½" Right: ½"

Grid: One column per panel, column width of 3¼"; gutter: ¾"

Type:

 Cover head: Trump Medieval Bold 48/52 and 44/45

 Text: Trump Medieval Roman 12/14

 Q/A: Trump Medieval Bold and Roman 11/13

 Address: Stripped in by the printer because client moved after the brochure was designed

 Logo: Trump Medieval 18/19.5

Printing: Offset lithography

Step 3. The client hired a professional photographer to take the photos to be used in the piece to ensure the quality. We then chose the photographs we would use from those supplied by the client. We wanted to display a variety of his smaller pieces, both windows of unusual shapes and cupboard doors. The photographer had taken at least three shots of each piece, so we had to decide which transparency of each was the best. Our choice was heavily influenced by colors and contrast—something that's easiest to see when you compare each photograph to all the others, rather than to the original artwork itself. For instance, compare the top and bottom photos in the set of three at left: Note how washed out and flat the top photo appears in comparison to the more vivid one at the bottom.

Four-Color Brochure

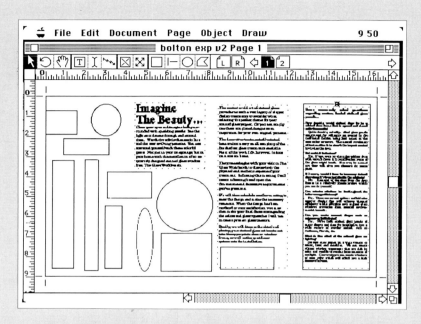

Step 4. We fit the photos and the copy into the layout and did a more realistic comp for Robert's approval. This comp included the copy and keylines showing the dimensions of the visuals. For the inside panels I drew keylines to show the approximate sizes and shapes for line art that would illustrate more of Robert's designs. I created a small graphic in Adobe Illustrator that suggested a piece of faceted glass to go above a question-and-answer section in the far right panel.

Step 5. Robert requested some minor changes in the copy, which we executed quickly. Remember, the later in this process that you make changes the costlier they will be, so it's a good idea to work very closely with a client, getting approvals nearly every step of the way. If Robert had come up with copy changes after the output had been received from the service bureau, the cost of the project would have been higher. If you can hold down costs by getting your client to make changes early in the process, your client will appreciate the savings and will probably call you the next time a printed piece is needed.

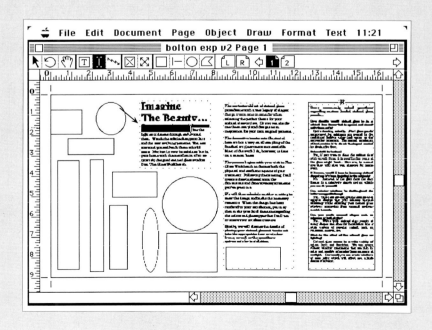

Step 6. Carol created the black-and-white drawings with pen and ink, as well as the background art for the cover. We scaled (resized) this art and the photos to fit the layout after Robert approved it. I used a proportion wheel (available at art supply stores) to determine the percentages of enlargement or reduction. I measured both the art and the space for it in the layout. I aligned the size of one side of each photo (inner wheel) with the size I wanted (outer wheel) and looked up the percentage on the scale in the window. For example, a 4" x 4" photo would be reduced to 75 percent of the original to fit it into a 3" x 3" space. To fit the same photo into a 6" x 6" space, it would be enlarged 150 percent.

Step 7. We decided to knock the type out of a blue background on the two outside panels of the color section, so I set the type color to white and rectangles at 100 percent black in my page layout program. (Remember, what goes to the printer is black. The printer then prints in whatever color you request.) We chose PMS 541 for the blue and asked the printer to match that color with a mix of the four process colors. Using a color matching system let us show the service bureau making the separations and the printer exactly what color we wanted. You can specify colors and create your own separations in page layout programs, but I prefer to leave that to my service bureau. I then placed the biographical text and keylines for the two photos on that panel.

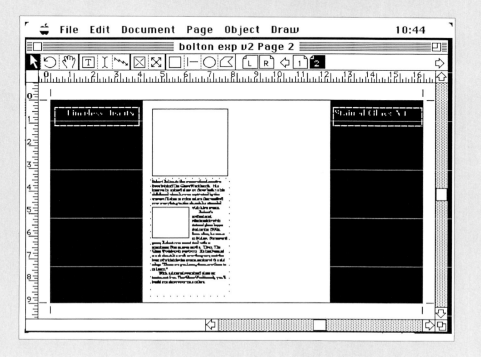

Four-Color Brochure

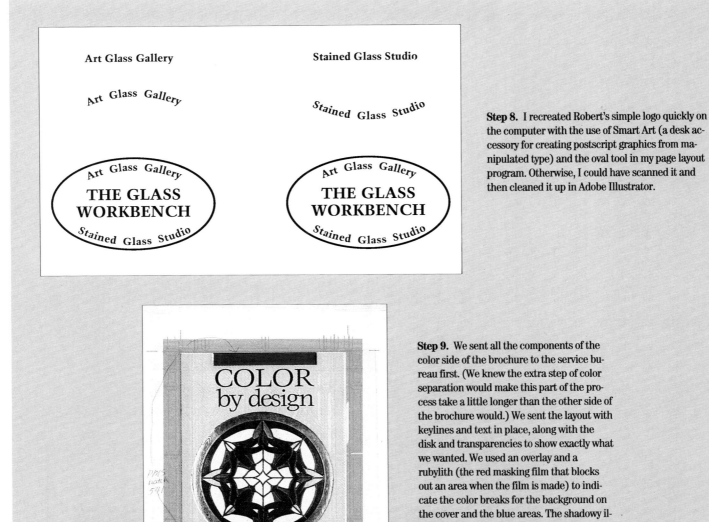

Step 8. I recreated Robert's simple logo quickly on the computer with the use of Smart Art (a desk accessory for creating postscript graphics from manipulated type) and the oval tool in my page layout program. Otherwise, I could have scanned it and then cleaned it up in Adobe Illustrator.

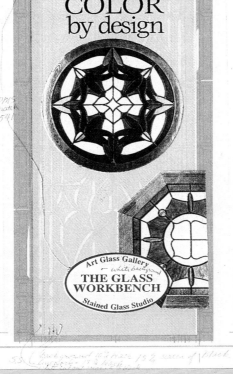

Step 9. We sent all the components of the color side of the brochure to the service bureau first. (We knew the extra step of color separation would make this part of the process take a little longer than the other side of the brochure would.) We sent the layout with keylines and text in place, along with the disk and transparencies to show exactly what we wanted. We used an overlay and a rubylith (the red masking film that blocks out an area when the film is made) to indicate the color breaks for the background on the cover and the blue areas. The shadowy illustration would be created by printing its background at 10 percent, the linework at 15 percent, and the areas cut out of the rubylith at 5 percent black. The color photos were scanned in and placed by the service bureau. We included full position prints of our color transparencies on the overlay, so the service bureau and the printer would know where the transparencies should go. This was especially important since we wanted them to follow the outlines of the frames and because one piece split across two panels.

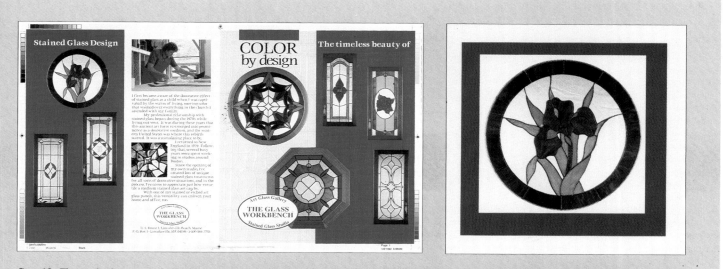

Step 10. The service bureau used all this material we sent them to output the file to film and make a color proof, which they sent to us for evaluation. It's important to make sure that the colors of the scans are at least true to, if not better than, the original photography. As you can see from comparing this color proof to our final brochure, this color proof was too dark (look at the blue on this proof compared to the final brochure) and did not have enough contrast (look at the stained glass; it appears flat). We sent the proofs back with the corrections marked so the service bureau could make the needed adjustments.

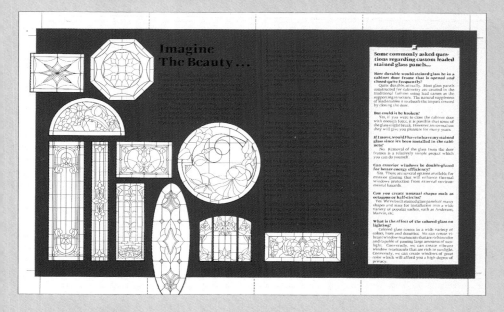

Step 11. We created the pasteup of the inside of the brochure using the service bureau's high resolution type and PMTs (photomechanical transfers) of Carol's artwork pasted onto the board. The gray background effect on the interior was created with a rubylith overlay, with cutouts around the artwork and the question-and-answer sections that would print on a white background instead. We instructed the printer to print the areas indicated by the overlay at 15 percent black. I could have scanned in and retouched the art and then created the gray background by specifying a 15 percent black, but that would have been much more time-consuming. The fold lines (the dotted lines) and the crop marks (solid lines) were output as part of our layout by the service bureau. We pasted on the registration marks and used them to align the overlay. The printer would also use them to check the alignment.

Four-Color Brochure

Step 12. Our service bureau, ImageSet, now provided us with our corrected color separations, so the complete package could be sent to the printer. The service bureau output one piece of film for each of the four process colors—cyan, magenta, yellow and black. At the printer, this film was assembled into film flats, the composites that would be used to make the printing plates.

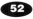

The timeless beauty of Stained Glass Design

Imagine The Beauty . . .

Close your eyes and imagine being surrounded with sparkling jewels. See the light as it dances through and around them. Watch the subtle changes in hue and the ever evolving patterns. You can surround yourself with the colorful gems. Not just in your imaginings, but in your home with the installation of an exquisitely designed stained glass window by Robert Bolton, Jr., of The Glass Workbench.

The centuries-old art of stained glass provides us with a vast legacy of elegant design treatments to consider when selecting the perfect theme for your stained glass project. Or you can simply use these completed designs as an inspiration for your own original patterns.

The decorative treatments illustrated here are but a very small sampling of the finished art glass treatments available. Most of the work I do, however, is done on a custom basis.

The process begins with an initial meeting, during which we will discuss both the structural and aesthetic aspects of your treatment. Following this meeting, I will create a drawing based upon the dimensions and decorative requirements you've given me.

We will then schedule another meeting to view the design and make the necessary revisions. When the design has been rendered to your satisfaction, you may then make your final decisions regarding the colors and glass types that I will use to create your art glass treasure.

Finally, we will discuss the details of placing your stained glass art treatment into the appropriate door or window frame, as well as the specific requirements for installation.

COLOR by design

Art Glass Gallery **THE GLASS WORKBENCH** *Stained Glass Studio*

But could it be broken?
Yes, if you were to close the cabinet door with enough force, it is possible that some of the glass might break. However, in normal use they will give you pleasure for many years.

If I move, would I have to leave my stained glass since it's been installed in the cabinets?
No. Removal of the glass from the door frames is a relatively simple project which you can do yourself.

Can exterior windows be double-glazed for better energy efficiency?
Yes. There are several options available for exterior glazing that will enhance thermal windows protection from external environmental hazards.

Can you create unusual shapes such as octagons or half-circles?
Yes. We've built stained glass panels of many shapes and sizes for installation into a wide variety of popular sashes, such as Anderson, Marvin, etc.

What is the effect of the colored glass on lighting?
Colored glass comes in a wide variety of colors, hues and densities. We can create vibrant window treatments that are rich in color and capable of passing large amounts of sunlight. Conversely, we can create windows of great color which will afford you a high degree of privacy.

The client was delighted with the finished product. However, he was not equally delighted with the delivery service who damaged the packages—not once, but twice—so that the piece had to be reprinted both times. The job was finally delivered in usable condition and will be distributed by hand and by mail to designers and homeowners throughout the land.

Project 6: Adding Color With Paper

You'll find that most clients must work within a budget. For some, the budget will easily cover all your expenses. There will be those, however, whose dollars are held in very tightly clenched fists, yet who want high quality, slick results. Using colored paper—of whatever description—is a good way to create an eye-catching, expensive-looking brochure without spending a bundle.

If you've decided to go with a colored paper, deciding what color to use is no longer the simple task it used to be. Rather than just your garden-variety range of, oh, let's say several hundred colors, you now have the option of preprinted "four-color" papers, as well. These will give you the look of a four-color brochure without the expense. Such a deal! And some are even prefolded or have cutouts. Although you'll pay extra for all these goodies, the amount of time and work saved by having a supply of these available—not to mention the flexibility of this format—could make them well worth the investment. Before you even go to your printer, get a bunch of good paper catalogs and make a point of educating yourself about what's out there.

That said, don't let the array of choices you discover blind you to what's appropriate for the specific project in question. You wouldn't use acid green or hot pink for a brokerage firm's brochure, any more than you'd use a pastel rose piece to promote the raucous sounds of a heavy metal rock band. And keep white, or off-white, high on the list when you are using photographs. If you were to choose yellow, the president of the board could appear jaundiced.

And consider the choice of col-

This lovely perfect-bound almanac uses a tan recycled paper to serve as an appropriate backdrop for its message of environmentally sensitive living. This choice of paper color befits the old-time design of the booklet, and interacts beautifully with the subtly colored illustrations, which almost appear watercolored. Note how printing the colored photograph of the cover on the tan background causes the photograph to appear to be a work of art—a fitting undercutting of technology for this kind of booklet. A white paper, even a recycled one, couldn't have created such a subtle effect.

Creating Brochures & Booklets

This perfect-bound annual report uses the unusual color scheme of tan paper with light teal accents to add visual interest to the dry subject matter it presents. The body of the front uses an elegant serif typeface, accented by quirky watercolor-like illustrations and dark red, whimsically lettered initial caps and pull quotes. Charts in the back are made visually interesting with graph lines that maintain the report's friendly tone. The financial statements portion of the brochure is printed on a pale teal recycled stock that livens up, yet does not undercut the seriousness of, the financial information presented. If this booklet had been printed on traditional annual report white, the designer would not have achieved such a warm, reader-friendly look.

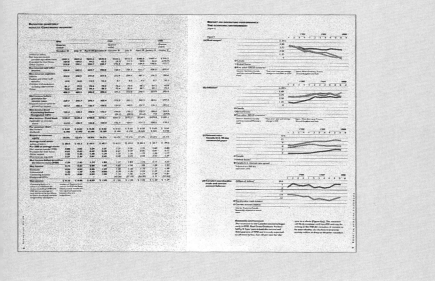

ored paper you're making in tandem with your choice of ink color. By and large, ink is not opaque, and if you decide to use blue ink on yellow paper, guess what? Your text and/or illustrations will appear green. This is not the effect you wanted, now, is it? Coordinate your choices of ink and paper carefully—testing them before a big print run, if possible.

Suppose you've chosen to use black ink and types of illustration other than photographs—line art, for instance. In this situation, you can feel more comfortable choosing colored paper. But be sensible. If you have anything more than a paragraph or so, don't use extremely bright or dark colors. People don't read things that overtax their eyes, and believe me, chartreuse neon can overtax even the strongest eyes.

Adding Color With Paper

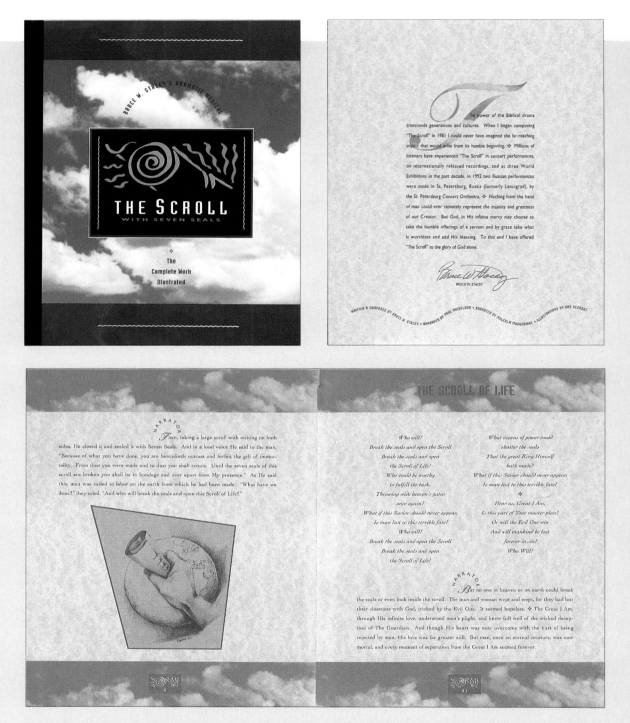

The use of a parchment paper is an appropriate choice for this program for the Biblical musical *The Scroll*. The paper is complemented with a royal purple ink with gold accents; the sky border adds to the spiritual feel of the brochure. A dark or bright paper would have clashed with the rest of the design, but a white paper would have been too clinical; parchment adds the appropriate note of warmth and historicity to the program.

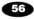

The ninety-mile views from Clausen Farms over the Mohawk Valley into the Adirondack and the Green Mountains of Vermont are just as beautiful today as they were in 1890 when Henry Clausen Jr. purchased the property. Drawn to the area for its hops production, the Clausens, who had a brewery in New York City, saw Sharon Springs as an ideal location for their country estate.

We (Tim and Kathy Spofford and our children), representing fifth and sixth Clausen generations, are your hosts at this beautiful and unusual property that we have restored and converted to a Bed and Breakfast Inn and llama farm.

Clausen Farms encompasses 80 acres, offering hiking, cross-country skiing, a swimming pool, a restored bowling lane, access to fishing and small boating at a nearby lake, or just quiet relaxation. Two houses are available for guests. The Casino, a Victorian gentleman's guesthouse completed in 1892, is open from April through October. Its dramatic tower and large porch enhance the panoramic views. Seven separate bedrooms with adjoining baths for shared or private use are available individually or as family suites. As the Casino is separated from the main house by a large lawn, small conferences or family reunions can make use of the property in its entirety. Three bedrooms with private baths also are available in the main house year round.

Guests are served a delicious country breakfast (all you can eat), along with home-baked goods and refreshments in the afternoon and evening. Full catering services can provide gourmet meals for small groups. Additional private parties or special events can be accommodated. While we welcome families, we ask that you not bring your pets (we have plenty for your enjoyment). We request that smoking be limited to the outside porches and grounds.

As guests have breakfast in the Casino dining room, they will be treated not only by the ever-changing views of the Mohawk valley, but also of our llamas walking and grazing in the fields below. Raising llamas has become very popular in the U.S., and our guests will have a first-hand opportunity to learn why their gentle manner and quiet intelligence make them a delight to have around.

Clausen Farms
Central New York's best kept secret.

The Sharon Springs area offers numerous leisure activities and seasonal events, including antiquing, auctions and an Amish community that sells handmade furniture, quilts, and homemade baked goods.

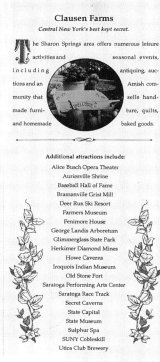

Additional attractions include:
Alice Busch Opera Theater
Auriesville Shrine
Baseball Hall of Fame
Bramanville Grist Mill
Deer Run Ski Resort
Farmers Museum
Fenimore House
George Landis Arboretum
Glimmerglass State Park
Herkimer Diamond Mines
Howe Caverns
Iroquois Indian Museum
Old Stone Fort
Saratoga Performing Arts Center
Saratoga Race Track
Secret Caverns
State Capital
State Museum
Sulphur Spa
SUNY Cobleskill
Utica Club Brewery

Circa 1890

Bed & Breakfast Inn
Sharon Springs
New York

*The charm of yesterday...
the comfort and convenience
of today.*

Circa 1890

Bed & Breakfast Inn
Room Rates

Double Room, Private Bath	$70.00
Double Room, Shared Bath	$65.00
Single Room, Private Bath	$60.00
Single Room, Shared Bath	$55.00
Children's Room, Double	$45.00
Children's Room, Single	$40.00
Family Suite	$110.00

Winter Rates, $5.00 Less
(October 15th—April 15th)

Rollaways—$15.00 Each

7% Sales Tax Additional

A deposit of one night's rate
secures your reservation.

MasterCard and VISA accepted.

Clausen Farms
*The charm of yesterday...
the comfort and convenience of today.*

Rt. 20, P.O. Box 395
Sharon Springs, NY 13459
518/284-2527

This brochure for a bed and breakfast is printed on a heavier than average rose-colored paper, which adds to the brochure's formality and elegance. Using decorative devices such as embellished drop caps and borders gives this brochure a delightful old-fashioned elegance that befits the client. The graceful floral border also serves as an idée fixe that lends continuity to the entire brochure. The use of the matching insert keeps printing costs down, because only the insert will need to be reprinted each time the prices change. The use of only two colors of ink (gray and black) on the colored paper gives the brochure an expensive look at a limited cost to the client.

Project 7: Three-Panel Gatefold

The Client: Mary-Lib Whitney, a professional storyteller who is new to the area.

After a performance, a performer will often be considered for other sessions. In a profession such as storytelling, where it's preferable to hold the playful mood of the performance, it could easily be a bane rather than a boon to hand over a résumé. Mary-Lib required a brochure that provided information regarding past accomplishments as well as a brief description of her career overall. Since many of the organizations that do the hiring ask for a photograph, she opted to include one in this piece.

Included here are lists of past accomplishments in storytelling, as well as a list of some past performances. If the organization's interest is piqued, Mary plans to follow up this brochure with a more formal résumé.

An often-asked question is "How did you get started as a storyteller?" The large panel on the back answers this question, as well as answering "Why I love what I do." It also contains a comment from a listener.

Since this piece is used as a handout, or as something to be included with other items, it is not necessary to use it as a self-mailer. This leaves an entire 3½" panel free for Mary's biographical information. However, since we have this brochure on disk, we always have the option of knocking out that panel and putting the self-mailing information in it if we decide to mail this brochure out in the future.

Step 1. The grid for this piece is a bit different from that used in other projects, since the panels are not equal in size. The center panel has ½" margins, leaving a usable space of 2½" x 6"; the side panels have ¼" margins. I could have gone to 3/16", but Laurie at Olsen's Motherwit has a machine that requires a ¼" margin. Remember—always check with your favorite copy shop before you design a piece that is going to be photocopied. Machines differ, so don't take the chance of designing something your favorite copy shop can't work with.

Step 2. First, I've placed the type for the lists on the inside of the piece. I chose Futura Book for its clarity.

Founding member of
Salt City Storytellers
Syracuse, NY

Member of
Theatre a la Carte

Member of
Mimosa Imagination
Theater

Member of
National Association
for the Preservation
and Promotion of
Storytelling

She's led storytelling
programs at

Ferry Beach Camp,
Saco, ME

Unirondack,
Lowville, NY

Camp Adelphi,
Syracuse, NY

Women Harvest,
Syracuse, NY

A Few Performances
include;

Clever Gretchen
Storytelling
Conference

Syracuse University

Erie Canal Museum

Onondaga Indian
School

as well as numerous

Schools
Parks
Nature Centers
Senior Centers
Nursing Homes
Churches
Conferences

throughout the
Northeast and
Canada

The Assignment: Prepare a three-panel gatefold brochure with type, line art and halftones to be reproduced by photocopy.

Founding member of
Salt City Storytellers
Syracuse, NY

Member of
Theatre a la Carte

Member of
Mimosa Imagination
Theater

Member of
National Association
for the Preservation
and Promotion of
Storytelling

She's led storytelling
programs at

Ferry Beach Camp,
Saco, ME

Unirondack,
Lowville, NY

Camp Adelphi,
Syracuse, NY

Women Harvest,
Syracuse, NY

A Few Performances
include:

Clever Gretchen
Storytelling
Conference

Syracuse University

Erie Canal Museum

Onondaga Indian
School

as well as numerous

Schools
Parks
Nature Centers
Senior Centers
Nursing Homes
Churches
Conferences

throughout the
Northeast and
Canada

Mary-Lib Whitney

Step 3. Next I outlined the area that the halftone would occupy and added the caption. Since the original photo is almost a perfect fit (with a little cropping), I could have the halftone shot at 100 percent. Often, a photo can be used without reduction if it can be cropped; you keep the detail that way.

Specifications:

One 8½" x 7" sheet

Three-panel brochure

Six panels, one 3½" and two 1¾" each side

Two parallel folds, gatefold

Ink color: One, black

Paper: Gray bond, 20 pound

Art: Line art, halftone

Margins:

Large panels: ½" all around

Small panels: ¼" all around

Grid: 1 column per panel, one 3½" panel and two 1¾" panels; gutter: ¾"

Type:

Cover: Domestic Uncial 16/18

Caption: Domestic Uncial 14/16

Text:

Lists: Futura Book 9/10

Body: Futura Book 12/15

Quote: Futura Book Oblique 12/15

Printing: Photocopying

Three-Panel Gatefold

Mary-Lib got her imagination and her love of storytelling from her father who told her wild sea stories when she was a child. She has been telling stories professionally for over ten years and it is to him that she dedicates her programs.

To Mary-Lib, storytelling is a way of connecting with the interdependent web of all life. Its roots reach deep into the past, its branches far into the future. In a world that often lives too much in the mind, a story reaches into the heart and brings truth to life in a gentle way. Her own past springs to life in her stories, as well as her love of nature, romance and the folklore of many countries.

A day without a story shared is a day in which a dream has been lost.

Mary-Lib is a cross between Mother Goose and Mother Earth.
—Pat Hoertdoerfer

Step 4. The biographical information and testimonial quote are next. I've used Futura Book Oblique for the quote.

Step 5. I chose the Domestic Uncial font for display purposes to reflect the Celtic descent of Mary-Lib and her stories.

Mary-Lib
Whitney

Mary-Lib got her imagination and her love of storytelling from her father who told her wild sea stories when she was a child. She has been telling stories professionally for over ten years and it is to him that she dedicates her programs.

To Mary-Lib, storytelling is a way of connecting with the interdependent web of all life. Its roots reach deep into the past, its branches far into the future. In a world that often lives too much in the mind, a story reaches into the heart and brings truth to life in a gentle way. Her own past springs to life in her stories, as well as her love of nature, romance and the folklore of many countries.

A day without a story shared is a day in which a dream has been lost.

as
Jenny
the
Yarnspinner

introducing

Mary-Lib is a cross between Mother Goose and Mother Earth.
—Pat Hoertdoerfer

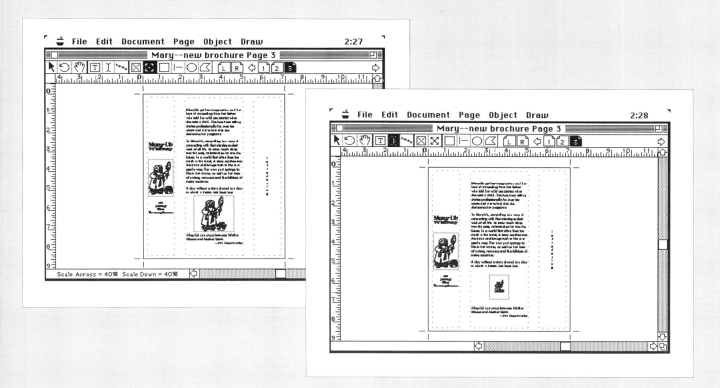

Mary-Lib got her imagination and her love of storytelling from her father who told her wild sea stories when she was a child. She has been telling stories professionally for over ten years and it is to him that she dedicates her programs.

To Mary-Lib, storytelling is a way of connecting with the interdependent web of all life. Its roots reach deep into the past, its branches far into the future. In a world that often lives too much in the mind, a story reaches into the heart and brings truth to life in a gentle way. Her own past springs to life in her stories, as well as her love of nature, romance and the folklore of many countries.

A day without a story shared is a day in which a dream has been lost.

introducing

Mary-Lib is a cross between Mother Goose and Mother Earth.
—Pat Hoertdoerfer

Step 6. Now I've added the line drawing the client provided; I scanned the drawing, because it's easier to size images with the computer than it is with a photocopier. I've placed the scanned image where I want it; it's easy to experiment with sizes this way. Here are a few of the things I tried before I got to my final choice of sizing for this image.

 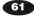

Three-Panel Gatefold

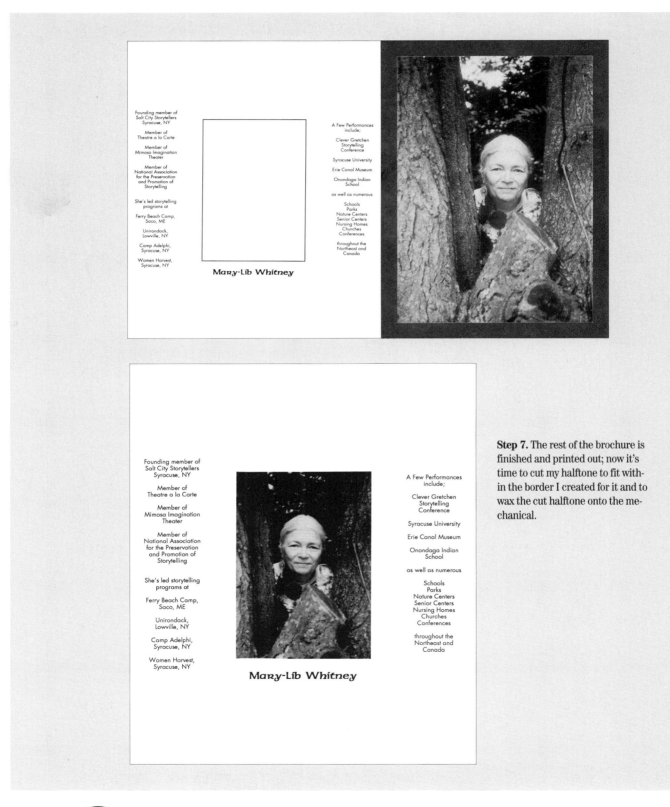

Step 7. The rest of the brochure is finished and printed out; now it's time to cut my halftone to fit within the border I created for it and to wax the cut halftone onto the mechanical.

Panel 1 (left brochure outer panel)

Mary-Lib Whitney

i
n
t
r
o
d
u
c
i
n
g

as
Jenny
the
Yarnspinner

Panel 2 (center brochure spread)

Founding member of
Salt City Storytellers
Syracuse, NY

Member of
Theatre a la Carte

Member of
Mimosa Imagination
Theater

Member of
National Association
for the Preservation
and Promotion of
Storytelling

She's led storytelling
programs at

Ferry Beach Camp,
Saco, ME

Unirondack,
Lowville, NY

Camp Adelphi,
Syracuse, NY

Women Harvest,
Syracuse, NY

Mary-Lib Whitney

A Few Performances
include;

Clever Gretchen
Storytelling
Conference

Syracuse University

Erie Canal Museum

Onondaga Indian
School

as well as numerous

Schools
Parks
Nature Centers
Senior Centers
Nursing Homes
Churches
Conferences

throughout the
Northeast and
Canada



The finished mechanical has had a visit with Laurie at the copy shop. It has returned as the proud mother of a hundred brochures on gray bond, each of which is going to tell a story of its own.

Panel 3 (bottom brochure spread)

**Mary-Lib
Whitney**

as
Jenny
the
Yarnspinner

Mary-Lib got her imagination and her love of storytelling from her father who told her wild sea stories when she was a child. She has been telling stories professionally for over ten years and it is to him that she dedicates her programs.

To Mary-Lib, storytelling is a way of connecting with the interdependent web of all life. Its roots reach deep into the past, its branches far into the future. In a world that often lives too much in the mind, a story reaches into the heart and brings truth to life in a gentle way. Her own past springs to life in her stories, as well as her love of nature, romance and the folklore of many countries.

A day without a story shared is a day in which a dream has been lost.

Mary-Lib is a cross between Mother Goose and Mother Earth.
—Pat Hoertdoerfer

i
n
t
r
o
d
u
c
i
n
g

Project 8: Double Parallel Fold

The Client: Black Widow Mysteries.

This brochure promotes mystery dinners. (A mystery dinner, if you don't know, is a dinner party where a guest "dies" and the other chowers-down have to figure out whodunit.)

The client wanted to project an air of—what else?—mystery. This was effectively done with spooky typeface and drawings.

The piece lists the various types of events that "Miss Mapletree" will host, as well as the audience she will address. It also contains descriptions of the various "cases" that can be presented, as well as promotional information for an ongoing presentation at a local restaurant.

Folded, this brochure is odd-sized. The client felt that a uniquely sized piece would be more apt to be noticed than a common three-panel piece. I checked with the local postmaster, who assured me that if this were to be modified later to be used as a self-mailer, it would be within the postal service's guidelines regarding size.

Step 1. Yet again, I've begun with a grid. This one is a bit different from others demonstrated in this book in that I'm placing four columns on 8½" x 11" sheets of paper. If the client hadn't wanted "something different," this piece could have been done on 8½" x 14" paper.

Productions in the Web

- The Game's Afoot, or Whose Move Is It, Anyway? What does Miss Appropriate know about the goings on at Thoreau Games. Rivalries abound, and perhaps a bit of sabotage.

- Death Drinks a Toast, or The Tainted Menu Who made the fatal drink and what did the dead stranger, Ivan Inkling, have to do with the group? Does Rosemary Sage, the cook, know?

- Mystery in Chorus, or The Entertainment Is Flat Was this madrigal dinner just another fund raiser or did Lord Sterling Silva know more about Baron Waste than he is telling?

- Deadly Reunion or The Unsaintly Sisters Was Helen Highwater's death senior year really an accident? Sorority sisters discover the truth at an reunion of ΣΑΦ.

Mysteries on the Way

- Words in the Woods, or The Concerned Campers When Sonia Papermoon found the strange object on the trail, it was only the beginning of a series of eerie events involving a group of camping friends.

- The Bleeding Blackbird, or The Bewildered Birders Brock O'Lee found the bleeding bird on a rocky shore with a note tied to its leg, partially watersoaked and illegible, but one of the Sapsucker Birdwatchers knew more than she should.

- The Story Is Told, or The Gregarious Ghost A program of ghost stories becomes all too real when Cliff Hanger sees a strange skull-shaped light hovering in the trees.

Step 2. By and large, I like to work on one side at a time, as opposed to a panel here and there, because that way I can get a much better overview of the whole piece. In this case, I began with the inside. The panels on either side contain bulleted lists of available and soon-to-be-available productions. The heads are done in the rather Karloff-esque Jasper typeface, and the lists are done in Futura, a very legible sans serif face. I've stuck to the principle of using display faces for heads only and using a more conservative typeface for the text, to keep the piece readable.

The Assignment: Create an eight-panel, double parallel fold brochure.

Black Widow Mysteries
presents

Murder by Thunder
or
Not Enough Sense To Come In Out of the Rain

starring

Holly Jeffrey as Gloria N. Excelsis
Emlyn Davids as Warren Pease
and
Mary-Lib Whitney
as
Miss Mapletree

October 6 to 25

CIDERPRESS RESTAURANT
Brookside, NY
Admission including dinner: $25.00

Productions in the Web

- The Game's Afoot, or
 Whose Move Is It, Anyway?
 What does Miss Appropriate
 know about the goings on at
 Thoreau Games. Rivalries
 abound, and perhaps a bit of
 sabotage.

- Death Drinks a Toast, or
 The Tainted Menu
 Who made the fatal drink and
 what did the dead stranger,
 Ivan Inkling, have to do with
 the group? Does Rosemary
 Sage, the cook, know?

- Mystery in Chorus, or
 The Entertainment Is Flat
 Was this madrigal dinner just
 another fund raiser or did Lord
 Sterling Silva know more
 about Baron Waste than he is
 telling?

- Deadly Reunion or
 The Unsaintly Sisters
 Was Helen Highwater's death
 senior year really an accident?
 Sorority sisters discover the
 truth at an reunion of ΣΑΦ.

Mysteries on the Way

- Words in the Woods, or
 The Concerned Campers
 When Sonia Papermoon
 found the strange object on
 the trail, it was only the
 beginning of a series of eerie
 events involving a group of
 camping friends.

- The Bleeding Blackbird, or
 The Bewildered Birders
 Brock O'Lee found the
 bleeding bird on a rocky
 shore with a note tied to its
 leg, partially watersoaked and
 illegible, but one of the
 Sapsucker Birdwatchers knew
 more than she should.

- The Story Is Told, or
 The Gregarious Ghost
 A program of ghost stories
 becomes all too real when
 Cliff Hanger sees a strange
 skull-shaped light hovering in
 the trees.

Step 3. The two center panels are used to herald an event-in-progress. They could also be used as a program for a single event.

Specifications:

One 8½" x 11" sheet

Eight panels, four each side

Two folds, double parallel-style

Ink color: One, black

Paper: Mauve laurentine text, 60 pound

Art: Line art

Margins:

Top: ⅜" Bottom: ⅜"

Left: ⅜" Right: ⅜"

Grid: One column per panel, column width of 2"; gutter: ¼"

Type:

Inside center heads: Jasper 18/18 and 24/26

Text: Futura Book, 10/13

Heads:

Columns: Jasper 18/18

Inside center: Jasper 18/18 and 24/26

Back: Jasper 36/42

Cover: Jasper 29/29

Printing: Photocopying

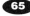

Double Parallel Fold

Step 4. The two columns on the left side of the unfolded outside contain information/suggestions for various types of events and groups. The typefaces, as always, remain consistent with the interior of the brochure.

Step 5. The two panels on the right side let the reader know what to do and whom to contact to get the job done right. Yet again, Jasper and Futura: two typefaces are quite enough for a brochure the size of this one.

Entertainment with a Difference for

- Small dinners or parties in the home
- Fund raising dinners
- Special events for your organization

Programs available for your needs:

- Group sizes 6 to 120
- Ages 10 to 100+
- Adaptable to your favorite period of history—encourage your friends to dress appropriately
- Adjustable to size and type of space where the event will take place
- All female, all male or mixed genders
- A variety of lifestyles taken into consideration

Small Events (6 - 12 people)

Each guest becomes a character and receives a packet with a name tag, character description, background information, clues and sealed envelopes that reveal more information as the event goes on.

Also included: Invitations, clues (such as photos, printed materials, objects, etc.) solutions, prizes and refreshments

Large Events (12 - 120 people)

"Miss Mapletree" will meet with the committee and prepare them to enact characters. The audience will solve the mystery as it unfolds.

Also included: Invitations, newspaper releases or newsletter articles, clues, solution forms and pens for each audience member and prizes.

Treat yourself to

a

Dinner to Die For

Black Widow Mysteries

Black Widow Productions
Main Street
Jamesville, NY 13206
(315) 555-0000

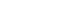

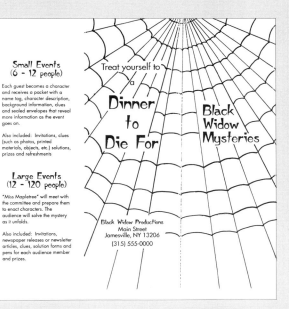

Step 6. The client knew exactly what she wanted in the way of line art, and drew it herself directly on the mechanical. If her pen had slipped, or some other inky calamity had occurred, I still had a whole computer full of mechanicals for her to draw on. If this had been a high quality mechanical, though—that is, one printed by a service bureau that would cost me time and money to replace—I would have had her draw this on a transparent overlay, so as not to ruin the more expensive mechanical should things go wrong.

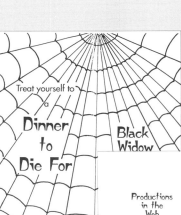

The final piece, which will be hand-folded by my client, is ready for distribution at local establishments, mystery dinners and by mail. The layout makes it easy to reuse the design of this brochure, changing the center interior panel when new productions require it.

Black Widow Mysteries
presents

Murder by Thunder
or
Not Enough Sense To Come In Out of the Rain

starring

Holly Jeffrey as Gloria N. Excelsis

Emlyn Davids as Warren Pease

and

Mary-Lib Whitney

as

Miss Mapletree

October 6 to 25

CIDERPRESS RESTAURANT
Brookside, NY
Admission including dinner: $25.00

Productions in the Web

- The Game's Afoot, or
 Whose Move Is It, Anyway?
 What does Miss Appropriate
 know about the goings on at
 Thoreau Games. Rivalries
 abound, and perhaps a bit of
 sabotage.

- Death Drinks a Toast, or
 The Tainted Menu
 Who made the fatal drink and
 what did the dead stranger,
 Ivan Inkling, have to do with
 the group? Does Rosemary
 Sage, the cook, know?

- Mystery in Chorus, or
 The Entertainment Is Flat
 Was this madrigal dinner just
 another fund raiser or did Lord
 Sterling Silva know more
 about Baron Waste than he is
 telling?

- Deadly Reunion or
 The Unsaintly Sisters
 Was Helen Highwater's death
 senior year really an accident?
 Sorority sisters discover the
 truth at a reunion of ΣΑΦ.

Mysteries on the Way

- Words in the Woods, or
 The Concerned Campers
 When Sonia Papermoon
 found the strange object on
 the trail, it was only the
 beginning of a series of eerie
 events involving a group of
 camping friends.

- The Bleeding Blackbird, or
 The Bewildered Birders
 Brock O'Lee found the
 bleeding bird on a rocky
 shore with a note tied to its
 leg, partially watersoaked and
 illegible, but one of the
 Sapsucker Birdwatchers knew
 more than she should.

- The Story Is Told, or
 The Gregarious Ghost
 A program of ghost stories
 becomes all too real when
 Cliff Hanger sees a strange
 skull-shaped light hovering in
 the trees.

Project 9: Roll-Fold, Multi-Panel

The Client: Laura Petovello, Director of the Holocaust Human Rights Center of Maine Education Institute.

Laura needed a folded piece to send to educators throughout the state informing them of the Holocaust Human Rights Center's Summer Seminar. This organization is dedicated to Holocaust education, and the Summer Seminar is an annual event to educate teachers, who then carry the message of human rights back to their classrooms.

Although this brochure contains quite a bit of information, it was much easier than many other projects since Laura has had experience in layout and printing. She knew exactly what she wanted and she speaks the language of the desktop publisher.

This piece contains six distinct blocks of information: what the seminar is; comments from those who have attended previously; what you'll do during the week; the Institute's mission statement; information about dates, housing, cost, credits, etc.; and the registration form. We chose the four-panel, barrel-fold brochure format to ensure that each piece of information would occupy its own panel and that this information would unfold in the correct order.

In order to keep costs down (this is a nonprofit organization, after all), the piece is a self-mailer—no envelopes are required.

Step 1. As always, I began with a grid. This one has ⅜" margins with ¼" gutters. This allows for sufficient white space to frame the text.

The Summer Seminar

This intensive five and one half day seminar presents sessions designed to provide a historical perspective and comprehensive understanding of the Holocaust and modern day massice human rights violations.

Programs include lectures by distinguished scholars-in-residences, presentations by Holocaust survivors and authors, and workshops led by teachers experienced in Holocaust education. Documentaries and feature films will be available for viewing.

Discussions will focus on ideas, strategies, and resources for use in the classroom. For K–3 teachers, special emphasis will be placed on using children's literature to introduce children to the concept of diversity.

The subject matter will be identical for both seminars. Robert Bernheim, a teacher at Champlain Valley Union High School, will be the Resident Scholar at U-M Presque Isle. Paul Bookbinder, Professor of History at the University of Massachusetts, will be the Resident Scholar at Bates.

Participants will receive information packets and other materials for use in their classrooms.

12/14

The Summer Seminar

This intensive five and one half day seminar presents sessions designed to provide a historical perspective and comprehensive understanding of the Holocaust and modern day massice human rights violations.

Programs include lectures by distinguished scholars-in-residences, presentations by Holocaust survivors and authors, and workshops led by teachers experienced in Holocaust education. Documentaries and feature films will be available for viewing.

Discussions will focus on ideas, strategies, and resources for use in the classroom. For K–3 teachers, special emphasis will be placed on using children's literature to introduce children to the concept of diversity.

The subject matter will be identical for both seminars. Robert Bernheim, a teacher at Champlain Valley Union High School, will be the Resident Scholar at U-M Presque Isle. Paul Bookbinder, Professor of History at the University of Massachusetts, will be the Resident Scholar at Bates.

Participants will receive information packets and other materials for use in their classrooms.

10/15

The Summer Seminar

This intensive five and one half day seminar presents sessions designed to provide a historical perspective and comprehensive understanding of the Holocaust and modern day massice human rights violations.

Programs include lectures by distinguished scholars-in-residences, presentations by Holocaust survivors and authors, and workshops led by teachers experienced in Holocaust education. Documentaries and feature films will be available for viewing.

Discussions will focus on ideas, strategies, and resources for use in the classroom. For K–3 teachers, special emphasis will be placed on using children's literature to introduce children to the concept of diversity.

The subject matter will be identical for both seminars. Robert Bernheim, a teacher at Champlain Valley Union High School, will be the Resident Scholar at U-M Presque Isle. Paul Bookbinder, Professor of History at the University of Massachusetts, will be the Resident Scholar at Bates.

Participants will receive information packets and other materials for use in their classrooms.

11/14

Step 2. Next, I typed the information and placed it in the appropriate panels. Since Laura had already made the decisions regarding placement, it made my job much easier. I received the information from her in the form of 8½" x 11" sheets, typed double-spaced, with notes regarding the panel each section should appear on. She needed to include a lot of information in this brochure, so I had to play with type size and leading in order to fit it all in. Since all the text I had been given was tightly edited, and all of it had to fit in the brochure, I wasn't able to cut to fit, so I opted for New Century Schoolbook 11/14, which seemed able to include all of the information more comfortably than other type size and leading combinations.

Brochure

The Assignment: Prepare a four-panel, roll-fold brochure that will be used as a self-mailer.

Registration Form

To register, please complete this form, detach, and mail with check payable to the Holocaust Human Rights Center to:
Summer Seminar
The Education Institute
Maine State Library, Station #64
Augusta, ME 04330-0064

Name

Address

City State Zip

Tel. (W) (H)

School

Address

Please check the appropriate boxes:

Elementary English
Junior High Social Studies
High School Other

Briefly describe your experience with Holocaust education if any.

Special needs/requests:

Credit option (please check)

Certificate CEUs Graduate credit

Registration Form

To register, please complete this form, detach, and mail with check payable to the Holocaust Human Rights Center to:
Summer Seminar
The Education Institute
Maine State Library, Station #64
Augusta, ME 04330-0064

Name _____

Address _____

City _____ State _____ Zip _____

Tel. (W) _____ (H) _____

School _____

Address _____

Please check the appropriate boxes:

❏ Elementary ❏ English
❏ Junior High ❏ Social Studies
❏ High School ❏ Other

Briefly describe your experience with Holocaust education if any.

Special needs/requests:

Credit option (please check)

❏ Certificate ❏ CEUs ❏ Graduate credit

Step 3. The registration form needed some lines to write on and some boxes to check. Since this is essentially an all-text piece, I decided to live a little and use drop-shadow check boxes from Zapf Dingbats. The lines were drawn, as always, with the line tool in my page layout program.

Specifications:

One 8½" x 14" sheet

Four-panel brochure

Three folds, barrel-style

Printed on two sides

Ink color: One, black

Paper: Blue bond, 20 pound

Art: Line art

Margins:

Top: ⅜" Bottom: ⅜"

Left: ⅜" Right: ⅜"

Grid: One column per panel; gutter: ¾"

Type:

Heads: New Century Schoolbook Bold 12/14

Text: New Century Schoolbook 11/14

Cover blurb: New Century Schoolbook Plain and Italic 12/13

Text on registration form: New Century Schoolbook 9/12

Printing: Offset lithography

Step 4. Now I've moved on to the other side of the brochure. The cover and the rest of the text are tight fits, but because I've picked the right type size and leading, they'll be OK. Here, I'm putting my self-mailer panel into place vertically.

Roll-Fold, Multi-Panel Brochure

Step 5. With the text and the form all in place, all that's left is the Center's logo, which depicts the journey from brokenness to wholeness. This had been created previously. The Center has several sheets of stats and had already provided me with one, since I do quite a lot of work for them. This works much more easily than scanning the image, and looks much better than it would at 300 dpi. Since this was a one-shot deal, I photocopied the size that I wanted onto good quality paper with wax holdout. All I had to do was slash and wax.

The Education Institute of the Holocaust Human Rights Center of Maine

The mission of the Education Institute is to:

With the active cooperation of the University system, Department of Education, and State Library, encourage the teaching of critical and reflective thinking, through Holocaust and human rights studies at all levels of the education process, so that students confront prejudice, analyze and respond to social problems, and become reflective and compassionate citizens capable of engaging in public policy debate and improving the quality of life for all people.

The Education Institute is dedicated to supporting teachers who want to teach the Holocaust and human rights. To this end, the HHRC subsidizes most of the seminar costs. In return, teachers are asked to do some preliminary work and to come prepared for active participation in the seminar.

Teachers Speak About the Summer Seminar

"This was without a doubt the most intense, revealing, disturbing, heart-wrenching, educational experience I have ever had."

"Paul Bookbinder is a brilliant man and a wonderful instructor. This course is the best I've ever taken, because of him and the variety of speakers and activities offered."

"Robert Bernheim was *excellent*. I learned so much from him. He made all of the pieces of WWII fit together."

"Discussion of the Holocaust makes me realize the great responsibility I have to myself and my students to open their hearts and minds to the injustices of the world."

"I am leaving here a different person. This program has deeply moved me to look at history beyond the facts."

"I am so glad that I took this class... I feel certain that I can go back and teach *The Spirit That Moves Us* much more effectively to my 1st and 2nd graders."

"I can't say enough about how much I have benefited from this week. It has made me a better teacher, and perhaps a better person."

HHRC Education Institute
Maine State Library, Station #64
Augusta, ME 04330-0064

Non-Profit Org.
U.S. Postage Paid
Permit # 631
Augusta, Maine

Holocaust Human Rights Center of Maine
Education Institute

offers

Third Annual Summer Seminar
(A Residential Program)
at
University of Maine at Presque Isle
July 18–23, 1993

Bates College
August 8–13, 1993

A Holocaust Study Program
for beginning and experienced teachers grades K–12 integrating human rights and Maine concerns

It is all too easy for what yesterday was burned into public consciousness to fade tomorrow into the margins of history.

Robert L. Woodbury, Chancellor
University of Maine

The Summer Seminar

This intensive five and one half day seminar presents sessions designed to provide an historical perspective and comprehensive understanding of the Holocaust and modern day massive human rights violations.

Programs include lectures by distinguished scholars-in-residence, presentations by Holocaust survivors and authors, and workshops led by teachers experienced in Holocaust education. Documentaries and feature films will be available for viewing.

Discussions will focus on ideas, strategies, and resources for use in the classroom. For K–3 teachers, special emphasis will be placed on using children's literature to introduce children to the concept of diversity.

The subject matter will be identical for both seminars. Robert Bernheim, a teacher at Champlain Valley Union High School, will be the Resident Scholar at U-M Presque Isle. Paul Bookbinder, Professor of History at the University of Massachusetts, will be the Resident Scholar at Bates.

Participants will receive information packets and other materials for use in their classrooms.

Abbreviated Schedule

Sunday:	Registration (12-2) Welcome & Overview Unique and Universal Aspects of the Holocaust Theory and Practice of Prejudice and Oppression
Monday:	Development of Jew Hatred Rise of the Nazis Power of Propaganda Resources for the Classroom
Tuesday:	European Jewry Between the Wars Nazis in Power Holocaust and the Arts Women in the Holocaust
Wednesday:	Final Solution Confronting Prejudice Teaching Diversity Teaching the Holocaust
Thursday:	Life and Death in the Ghetto Armed Jewish Resistance World Reaction Human Rights as a Guide to Moral Action
Friday:	Genocide Throughout History The Revisionists Farewell Lunch (12:30 - 1:30)

General Information

Institute participants are housed in single rooms in a comfortable dormitory. All meals, including a banquet Thursday evening, are provided. Participants are welcome to explore the campuses and to use all recreational facilities, such as swimming pools and tennis courts.

Dates:

July 18–23	August 8–13
University of Maine Presque Isle	Bates College Lewiston

Cost: $130 for registration and materials. (HHRC subsidizes room and board costs.) Receipt of $130 is required with the registration form.

Eligibility: All Maine teachers, K–12, and school librarians. Enrollment is limited to 25 per seminar. Rolling admission.

Credit Options:
• Certificate of Attendance
• 4.5 CEUs
• 3 Inservice Graduate Credits (at additional cost), University of Southern Maine

Contact: Laura Petovello, Director
HHRC Education Institute
Maine State Library, #64
Augusta, ME 04330-0064
287-5620

Registration Form

To register, please complete this form, detach, and mail with check payable to the Holocaust Human Rights Center to:
Summer Seminar
The Education Institute
Maine State Library, Station #64
Augusta, ME 04330-0064

Name _____

Address _____

City _____ State ____ Zip _____

Tel. (W) _____ (H) _____

School _____

Address _____

Please check the appropriate boxes:

❑ Elementary ❑ English
❑ Junior High ❑ Social Studies
❑ High School ❑ Other_____

Briefly describe your experience with Holocaust education, if any.

Special needs/requests:

Credit option (please check)
❑ Certificate ❑ CEUs ❑ Graduate credit

Here's the finished piece, properly printed and folded at the printshop. Since the Summer Seminar is an annual event, I'll save the file on disk and trot it out again next year. It serves its purpose well, disseminating all the pertinent information in an easy-to-read fashion.

 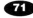

Project 10: Four-Page Booklet

The Client: Maine Mensa, the state branch of a national, primarily social society.

The *Mains'l* is used to disseminate information and opinions to the membership, which covers an age range from ten-year-olds to retirees. The day a copy of the *Mains'l* arrived in my mailbox, I decided that I should answer their plea for a volunteer editor. The issue in my hands had been hastily thrown together with the aid of a daisywheel printer and reproduced on a photocopier left over from the Dark Ages. I smiled and dialed the number in the ad. I learned that they wanted someone with the equipment to produce a nice-looking piece each month, edit it and get it photocopied on 24-pound ivory bond. "Okay," I said, "I can do that."

I first needed to choose a structure and format for the newsletter. Newsletters can have a variety of forms and structures, resembling a multi-page press release, a newspaper, a brochure or even a magazine. Although I could not have a separate cover on the group's budget for the newsletter, I decided to slant the design to more of a brochure look. Articles would occupy the major portion of each page, and all other items (such as a listing of new members) would be kept in one column and would be treated as if they were sidebars to the articles.

Step 1. My first order of business was to redraw the sailboat and silhouette map of Maine. I decided to create a new original piece of art, since the one I received was several generations removed from the original and had lost a lot of detail. Creating a new original was actually quicker and cleaner than scanning in and touching up the old one. I use a photocopy of my original on the mechanical each month; if I keep my original intact and use only a photocopy each month, I'll be able to pass the original artwork on to the next editor, who may not have the same kind of computer that I do.

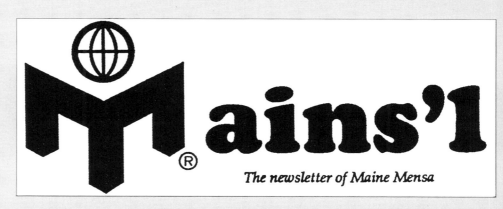

The newsletter of Maine Mensa

Step 2. The American Mensa logo is a fairly simple one, made up of straight lines and curves. It was easy to scan it in, touch it up in Adobe Illustrator, add the type for "ains'l" and save it in EPS format. This saves me a step in creating the mechanical each month, and assures that the title will be straight on the page. I can always output this and have a stat made of it if the next editor needs it in that form.

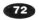

With Halftones

The Assignment: Produce a monthly four-page newsletter that can be photocopied, folded and mailed second-class.

Vol. 18 No. 1 ISSN 0164-9280 January, 1992

Step 3. I then created the grid—two columns on each page for news and articles, and one for general information that shows up each month such as the calendar, officers' directory, birthday list, etc. The general information is separated from the articles by 1/2-point rules, a treatment similar to the handling of sidebars in brochures and magazines. Panels (pages) are numbered and the newsletter's title and the date appear at the top of each page as well.

Specifications:

11" x 17" sheet, printed on both sides

Four-panel brochure with a single parallel fold

Folded in half horizontally after printing to reduce size for mailing

Ink color: One, black

Paper: Ivory bond, 24 pound

Art: Halftones, line art

Rules: .5 point

Margins:

 Top: 1" Bottom: ¾"

 Left: ⅝" Right: ⅝"

Grid: Three-column, two columns 2¼" wide and one column 2" wide; gutter: ¼" between columns

Type:

 Nameplate: Cooper Black 64/64; the letter "M" is the American Mensa logo

 Headlines: articles, calendar, directory of officers: Helvetica Bold, 18/20

 Headlines: birthday/anniversary/ new members list, poetry,etc.: New Century Schoolbook Bold, 18/20

 Body copy: New Century Schoolbook Roman, 10/10.83

Printing: Photocopying

Four-Page Booklet With Halftones

Step 4. Next comes the information that remains virtually unchanged each month. I set up the format for each of the narrower columns. The calendar has the most changes, but by listing the regular activities first, and then any special events (if there are any—keep in mind that this is the January edition from Maine), changes are easy to make. The only differences from month to month for the regular happenings are the dates. On the back page is the mailing information: indicia (preprinted postal permit), disclaimer, return address and request for address correction.

Mains'l 1/92 Page 2 & 3

Step 5. Now it's time for the body copy. Since I write an article each month, I can write to fit the available space. I sometimes need to cut other articles or columns to fit (usually I must keyboard typewritten copy anyway) or find an appropriate graphic to keep the page from appearing too naked. For this issue, as it happened, there was room for everything and no need for extra graphics. Note the standard typeface I've chosen: New Century Schoolbook in various weights (roman, bold and italic) and sizes for clarity and readability. Using one type family builds in unity for a piece whose contents have a lot of variety. For the regular columns, the calendar, and the directory of officers I use Helvetica Bold for heads. For the birthday/anniversary/new members listings, informal notices and columns, and occasional poetry that would appear, I chose New Century Schoolbook Bold for the heads.

Four-Page Booklet With Halftones

Step 6. Now that I know exactly how much space is available, I can go get my halftone shot. The process camera operator must create the final halftone at the exact size it will be printed. (You can't go back and enlarge or reduce the halftone on the photocopier if you've made a mistake—that would defeat the purpose of having the halftone shot.) Because the printing of this brochure will be done on a photocopier, I need a halftone positive—a halftone printed on paper, rather than on film.

The newsletter of Maine Mensa

| Vol. 18 No. 1 | ISSN 0164-9280 | January, 1992 |

The World Around Me
by Val Adkins

As editor of *Mains'l*, I've decided to take the liberty (and time) to actually write something besides desperate pleas for more articles, etc., for these pages. I see many things in life, and have opinions about most of them. In fact, I have precious few unexpressed opinions. This month, I'd like to ramble on about a super pooch who came into my life two years ago when I began sharing a home with her "Mom." In my humble opinion, she should be a member of Mensa.

Suki, a/k/a Ms. Sue, is a thirteen-year-old mostly Staffordshire terrier who hails from New York City. She's bi-lingual due to the fact that her first human was Puerto Rican. Alas, her linguistic abilities are no longer an issue since she is deaf. But no matter, she still has a nose that can gather enough information to fill an encyclopedia!

Looking into Suki's eyes is like staring into the depths of ancient wisdom. She knows instinctively when we're cutting carrots (her favorite food) in the kitchen, and knows enough to get our attention in order to cash in on the "carrot coins."

While Suki has been the scourge of varmints from New York to Maine, she is not one-dimensional. She has also attended countless openings at countless galleries in New York,

and has a social life independent of her humans. She's a very personable pup. For instance, she does not annoy us by scratching at the door to come in after she's been clearing the meadow of vermin. She knocks. She does not bark or jump if we are late with her dinner. She simply gives us such a reproachful look that we fall all over ourselves to prepare her Alpo, and beg her forgiveness while we're about it. Clearly, Ms. Sue knows how to get what she wants.

I'm a card-carrying Mensan and this canine can outdo me intellectually any day of the week. Let's waive the usual membership requirements. I ask for a poll of the membership. Could we have a show of paws, please?

Calendar of Events

General Information

Monthly Dinner Meetings
(2nd Thursday each month)
Meet at 6:30 pm at
The Village Cafe
112 Newbury Street, Portland
Contact: Carol Hayden
774-6571

Weekly Luncheon
(every Tuesday at noon)
Friendly's at Mallside
South Portland
Contact: Mike Kennedy
839-5954

Please Note

Mensans are being sought to serve on the nominating committee. You may volunteer or nominate another member. Send name, address and phone number of your Nominations Committee Nominee to:

Joe Zanca
PO Box 363
Tilton, NH 03276

Step 7. I've created a frame for the image by using the oval tool in my page layout program to create an oval the right size to fit the space. I also used a little banner from a Dover book of clip art onto which I superimposed the subject's name.

Step 8. Trimming the halftone was easy enough. I printed out the page and cut out the center of the oval with my trusty X-Acto knife. Then I positioned the cutout over the halftone and trimmed the halftone to fit.

Step 9. Now I can complete the job by waxing the trimmed halftone and pasting it into the frame on the sheet that I'll use for printing.

 ains'l
The newsletter of Maine Mensa

Vol. 18 No. 1 ISSN 0164-9280 January, 1992

The World Around Me
by Val Adkins

As editor of *Mains'l*, I've decided to take the liberty (and time) to actually write something besides desperate pleas for more articles, etc., for these pages. I see many things in life, and have opinions about most of them. In fact, I have precious few unexpressed opinions. This month, I'd like to ramble on about a super pooch who came into my life two years ago when I began sharing a home with her "Mom." In my humble opinion, she should be a member of Mensa.

Suki, a/k/a Ms. Sue, is a thirteen-year-old mostly Staffordshire terrier who hails from New York City. She's bi-lingual due to the fact that her first human was Puerto Rican. Alas, her linguistic abilities are no longer an issue since she is deaf. But no matter, she still has a nose that can gather enough information to fill an encyclopedia!

Looking into Suki's eyes is like staring into the depths of ancient wisdom. She knows instinctively when we're cutting carrots (her favorite food) in the kitchen, and knows enough to get our attention in order to cash in on the "carrot coins."

While Suki has been the scourge of varmints from New York to Maine, she is not one-dimensional. She has also attended countless openings at countless galleries in New York,

and has a social life independent of her humans. She's a very personable pup. For instance, she does not annoy us by scratching at the door to come in after she's been clearing the meadow of vermin. She knocks. She does not bark or jump if we are late with her dinner. She simply gives us such a reproachful look that we fall all over ourselves to prepare her Alpo, and beg her forgiveness while we're about it. Clearly, Ms. Sue knows how to get what she wants.

I'm a card-carrying Mensan and this canine can outdo me intellectually any day of the week. Let's waive the usual membership requirements. I ask for a poll of the membership. Could we have a show of paws, please?

Ms. Sue

Calendar of Events

General Information

Monthly Dinner Meetings
(2nd Thursday each month)
Meet at 6:30 pm at
The Village Cafe
112 Newbury Street, Portland
Contact: Carol Hayden
774-6571

Weekly Luncheon
(every Tuesday at noon)
Friendly's at Mallside
South Portland
Contact: Mike Kennedy
839-5954

Please Note

Mensans are being sought to serve on the nominating committee. You may volunteer or nominate another member. Send name, address and phone number of your Nominations Committee Nominee to:

Joe Zanca
PO Box 363
Tilton, NH 03276

Four-Page Booklet With Halftones

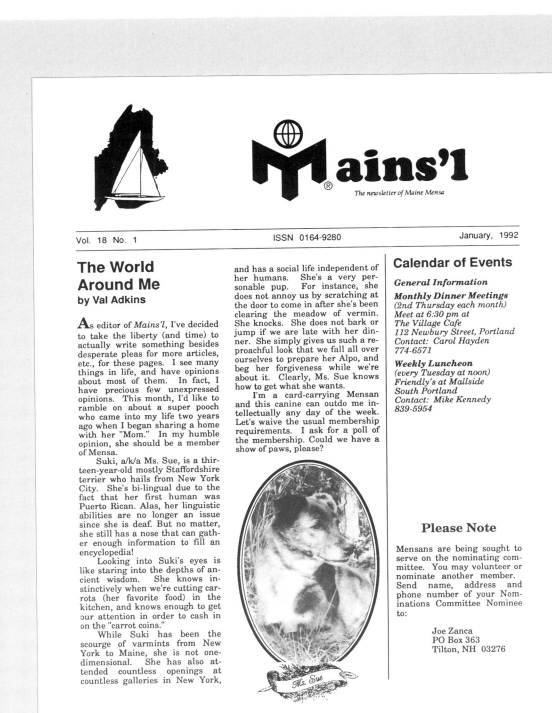

Mains'l

The newsletter of Maine Mensa

Vol. 18 No. 1 ISSN 0164-9280 January, 1992

The World Around Me
by Val Adkins

As editor of *Mains'l*, I've decided to take the liberty (and time) to actually write something besides desperate pleas for more articles, etc., for these pages. I see many things in life, and have opinions about most of them. In fact, I have precious few unexpressed opinions. This month, I'd like to ramble on about a super pooch who came into my life two years ago when I began sharing a home with her "Mom." In my humble opinion, she should be a member of Mensa.

Suki, a/k/a Ms. Sue, is a thirteen-year-old mostly Staffordshire terrier who hails from New York City. She's bi-lingual due to the fact that her first human was Puerto Rican. Alas, her linguistic abilities are no longer an issue since she is deaf. But no matter, she still has a nose that can gather enough information to fill an encyclopedia!

Looking into Suki's eyes is like staring into the depths of ancient wisdom. She knows instinctively when we're cutting carrots (her favorite food) in the kitchen, and knows enough to get our attention in order to cash in on the "carrot coins."

While Suki has been the scourge of varmints from New York to Maine, she is not one-dimensional. She has also attended countless openings at countless galleries in New York,

and has a social life independent of her humans. She's a very personable pup. For instance, she does not annoy us by scratching at the door to come in after she's been clearing the meadow of vermin. She knocks. She does not bark or jump if we are late with her dinner. She simply gives us such a reproachful look that we fall all over ourselves to prepare her Alpo, and beg her forgiveness while we're about it. Clearly, Ms. Sue knows how to get what she wants.

I'm a card-carrying Mensan and this canine can outdo me intellectually any day of the week. Let's waive the usual membership requirements. I ask for a poll of the membership. Could we have a show of paws, please?

Ms. Sue

Calendar of Events

General Information

Monthly Dinner Meetings
(2nd Thursday each month)
Meet at 6:30 pm at
The Village Cafe
112 Newbury Street, Portland
Contact: Carol Hayden
774-6571

Weekly Luncheon
(every Tuesday at noon)
Friendly's at Mallside
South Portland
Contact: Mike Kennedy
839-5954

Please Note

Mensans are being sought to serve on the nominating committee. You may volunteer or nominate another member. Send name, address and phone number of your Nominations Committee Nominee to:

Joe Zanca
PO Box 363
Tilton, NH 03276

Whims
by Gail Everett

In this installment of Whims you get a special deal—three television reviews for the price of one. Originally I was going to write about *Doctor, Doctor*, a TV show which was on last year (talk about procrastination!). If you were dedicated enough to read every listing of every day in *TV Guide*, you could find where they'd moved the show to that week, if it hadn't been preempted or temporarily taken off the air. The star of that show was Matt Frewer, the original Max Headroom, who recently turned up on *Star Trek: The Next Generation*. I think Matt Frewer is the next Robin Williams, and *Doctor, Doctor* used to make me roll on the floor, laughing. I miss it.

But *Doctor, Doctor* has disappeared without ever being reviewed by anyone, so let's talk about a show you may have at least heard of. It's *Northern Exposure*, about a young, obnoxious New York City doctor who has to practice in a small town in Alaska to pay off his student loans. For a long time I didn't watch this series, because I couldn't relate to the star's baby face. Also, at first it was compared to *Twin Peaks*, which by that time I loathed. But I caught one or two shows, and like them, and now I look forward to it.

Most of the episodes I've seen have ended with a scene encompassing the whole community, either at a funeral, a picnic, a Christmas pageant, or just an aerial view of the town, that has an unsentimentalized sweetness rare in network TV. The writers don't cater to the lowest possible educational level. Last week's program discussed physics and the nature of reality in some detail, and this week one of the characters casually mentioned Proust without feeling a need to explain.

For me, the heart of each episode is a monologue by the local disk jockey, Chris, which usually takes place about three quarters of the way through the hour as he's shown talking into his mike. The content of this speech is unusually thoughtful, even philosophical, in a way that I don't remember seeing in a network entertainment program before. Yet it's handled with a lightness that makes it accessible to the general audience. If you think this is easy or trivial, think again.

Many of the characters on the show are a little weird, yet they are rounded personalities in whom we can see ourselves or our acquaintances. Holling is the owner of a bar/restaurant who lives with a girl about 40 years his junior. Their relationship has been covered from every angle, from the laughable (the girl, Shelley, hints that Holling's private parts are, well, different, and he's tempted to get circumcised but is scared out of it by the doctor) to the serious (they feel that their age difference may be too much to overcome) to the touching (Shelley longs for the beauty of the Christmas Masses she remembers from her Catholic childhood, and Holling sings *Ave Maria* for her in the church). This last scene was a beautiful, understated expression of love that compares well with anything I've seen on TV.

A lot of these scenes might not come off quite so well if the actors weren't so good. Considering the strange people in town (Chris, the disk jockey, apparently is an ordinary by choice, and there was one reference to his "choosing to be a person of color" although he is quite obviously white; he is a mail-order priest, and perfectly willing to "perform a divorce" for a couple if they feel they need such a ceremony), the fact that you can identify with them proves that the actors are a cut above average.

The Christmas episode had several subplots: the Shelley/Holling plot about the Mass; an un-

expected visit to Maurice the exastronaut by a Korean son and grandson he didn't know about, along with their mother whom he had completely forgotten; Joel's (the Jewish doctor's) first Christmas tree; Maggie the bush pilot's ambivalence about her annual trip home for Christmas, which she refuses to admit is connected to her sudden rash of minor accidents; and tying all these together, the "raven pageant" of the Eskimos. (I guess they're supposed to be Eskimos, although some of the ethnic actors look a lot more like Indians). The raven story's last line—"and from then on we didn't have to live in the darkness any more"—concludes the episode. The comparison with the Christmas story is never stated explicitly, as it would be on 99% of the other shows on TV.

I get the feeling of being allowed into the lives of these people, and even though I don't ever quite believe that they could be real, they do seem much more whole than, for instance, the characters on *L.A. Law*, who all seem like jigsaw puzzles of different stereotypes put together in unusually interesting ways.

I don't want you to think that *Northern Exposure* always makes me feel squishy inside. There's plenty of humor, too. In the Christmas show, Chris the disk jockey, during his philosophical exposition, was wearing a cap with a huge raven's beak and head jutting out over his eyes. He looked like a seven-year-old boy. I wouldn't have laughed so hard if there had been the slightest attempt by the actor or writers to underline the ridiculousness of it. You are allowed—not forced—to realize that Chris is the sort of person who can be either a complete airhead or very wise, sometimes both at the same time, and that wearing that cap is his mystical identification with the native legends.

There are a couple of things I'd quibble about if I had to. Joel, the doctor, is a little more obnoxious and Woody Allen-ish than I think is necessary. Sometimes I wish he'd just shut up and relax. Marilyn, the receptionist, is apparently supposed to be an Eskimo and seems rather stereotyped in her massive calm; but the thing that drives me crazy about her is her incredibly flat monotone. I can't believe any actor would talk that way except on purpose, but what the purpose is is beyond me. She sounds depressed. The only other thing that consistently bothers me is that a lot of people seem to have Texas accents. I can accept it from the astronaut, but Holling seems to talk that way too, and I can't figure out why. I've never been to Alaska, so maybe everyone up there does have a drawl, but it would surprise me.

At the end of the Christmas show, Maurice has gone from a rather strong racist reaction to his son to being will-

died. For most of the hour his body was parked outside on a picnic table or something, and everybody who came by went over to talk to him (yes, they knew he was dead) and try to identify him. This could have been tasteless, but it wasn't—they know just how far to stretch the humor to make you laugh but not gag. The show about Holling's personal hygiene decision was also pretty funny. It may sound like a dirty joke in print, but in fact it was hysterical, with just the right amount of raunchiness. Holling may have some kind of obsession with sex, because his restaurant has a huge, phallic sign with "The BRICK" in neon letters cascading vertically down it.

Directory of Officers and Committee Chairs

President/LocSec.
Gifted Child Coordinator
Dale W. Doughty · 627-4507
P.O. Box 58
Casco, ME 04015

Vice President
Michael Kennedy · 839-5954
17 Daniel Street
Gorham, ME 04038

Treasurer
Membership Chair
Gail Everett · 878-3794
12 Dakota Street
Portland, ME 04103

Clerk
Lee Halle Shenton · 781-4080
12 Dale Street
Falmouth, ME 04105

Proctor Coordinator
Keith Williams · 892-8391
15 Ridge Road
Windham, ME 04062

Director at large
Carol Hayden · 774-6571
147 Pinecrest Road
Portland, ME 04102

Director at large
Open

Editor
Val Adkins · 338-2365
P.O. Box 413
27 Main Street
Belfast, ME 04915

Sight Coordinator
Vern McFarlin · 743-5959
1 Frederick Ave.
So. Paris, ME 04281

Publications Officer
Tom Handcock · 772-4730
17 Penman Street
Portland, ME 04103

Anniversaries
January

Andrea J. Keirstead *Farmington*	12
Thomas P. Reardon III *E. Parsonsfield*	12
James M. Perry *Camden*	11
Jennifer Jane *West Peru*	7

Birthdays
January

Anne M. Moreau	2
Ken McConvey	10
Dr. Thomas B. Clapp	16
Sandra B. Vega	24
Alexander Sheive	25
Harold E. Goldrup	28

New Members—1991

*George W. Bentley, Portland
MacDonald C. Booze, York
Andrea Cook, Bowdoin Col., Brunswick
*Brendan G. Crotty, Kennebunkport
*Liam P. B. Crotty, Kennebunkport
*Mary J. B. Crotty, Kennebunkport
Elaina Deabay, Bucksport
Norman Dickinson, Windham
Joseph Leo Fitzpatrick, Alfred
Richard J. Hartman, U/NE, Biddeford
Michael Kennedy, Gorham
*Gareth Kucinkas, Portland
*Robert Eric Lindner, Loring AFB
Bruce Charles Roberts, Bangor
*Michael Sczeken, Lisbon Falls
Alexander Sheive, Waterville
Ralph Sprague, South Paris
Wayne Colin Stilphen, Augusta
George Stowers, Farmingdale

*Rejoined after a lapse of more than 1 year. We note with special interest that 2 are listed as being 10 and 13 Al-

> There it is—a newsletter. All I need to do is take it to Jean at the copy shop where I'll get the prescribed number of copies, fold them and ship them off to the publications officer for labeling and mailing.

Whims
continued from page 3

ing to communicate with him as a person, and has even managed to remember his relationship with the woman affectionately. Joel has decided that he's just not cut out for a Christmas tree, and takes it to Maggie's house (managing to set it up, light and decorate it outside her front door without her knowledge—this is still TV, after all) and surprises her with it in the true Christmas spirit. Although everyone is aware of Maggie's dread of visiting her family, and openly suggests that her accident-proneness is related to it, there is no heavy-handed battering on the subject. And when she learns that her parents have gone elsewhere on vacation this year, her surprisedly rejected feeling is identified only in her body language and defensive chatter. No more is ever said about it, even when Joel surprises her with the tree. This makes me feel like the writers respect my intelligence and trust their actors. I wish all shows had as much nerve.

Trust

Forgive me, please, if I withdraw
Into myself and do not let you in.
Yes, that is where I hide,
Within myself, a solitude of the lonely,
Wherein, as Nietzsche said, the greatest
Danger lurks.
The inner isolation, where only
Those who are invited in
May enter.
Most lives allow on only one,
And while the danger of self-destruction
Does exist within those inner depths,
It is only that invited guest
Sprung from within those depths to show the world,
Triumphant and with pride, or
Scornful and with ridicule.
Little wonder is it then
That those whose inner thoughts
Brought forth to scorn and ridicule
Do not invite again.
Forgive me, please, but even as I withdraw,
I wonder, would you like to come within?

—*Robert L. Martin*

Mains'l *is the official publication of Maine Mensa. It is published monthly by Maine Mensa at RFD #1 Box 1612 River Road, Brunswick, ME 04011 and distributed to members of Maine Mensa with the subscription cost of $3 per year included in the national dues. Non-members may subscribe at $5 per year.*
Second class postage paid in Brunswick, ME 04011 Copyright 1991, Maine Mensa. No portion of this publication may be reproduced without permission of the publisher in writing. Official Mensa newsletters are hereby granted permission to reproduce from this newsletter material that is not individually copyrighted provided the publicaiton, the editor, and the author are credited.
POSTMASTER: send address changes to MAINS'L, *American Mensa, Ltd. 2626 E. 14th Street Brooklyn, NY 11235*

Mains'l solicits contributions, both literary and financial, from its readers. We seek stories, puzzles, comments, reviews, etc. Deadline for submission of materials is fht 15th of the preceding month for each issue. Materials arriving after the deadline will be saved for a later issue. The editor reserves the right to include, reject or edit submitted materials.

Mensa is an international organization of persons scoring in the top two percent on standard IQ tests. It is non-profit and exists for the purposes of communication and assembly. Mensa takes no official position and espouses no causes.

Postmaster: Send changes of address to American Mensa, Ltd. 2626 E. 14th St., Brooklyn, NY 11235

Mains'l
c/o Motherwit
P.O. Box 413
Belfast, ME 04915

Mains'l is the official publication of Maine Mensa

Project 11: Bound Booklet With

Client: Father David Sivret.

David thought that a booklet containing his entire ordination service, including the hymns that were to be sung, might help the non-Episcopals in attendance. So I had to create a practical, readable and attractive booklet with all the necessary parts of the service.

Since the service is in the Book of Common Prayer, and the chants and hymns are in the hymnal, neither of which match the booklet's size, I couldn't do a lot of quick and dirty photocopy and pasteup. I entered all of the text from the Book of Common Prayer and then reduced the hymns (cut from a hymnal)on the copier.

Note that, although it is alright to photocopy some pieces of music for one-time use, you should check on who owns the copyright, and then get written permission, before doing this. Remember that, while some hymns are old enough to be in the public domain, others are not, and virtually any piece of popular music can really get you into trouble. Even if you think you can get away with using the work you picked without permission, you could get a nasty surprise when you try to get your booklet printed, and your photocopy shop refuses to copy the work without written proof of permission from the music's copyright holder. So when in doubt—leave it out!

I had a copy of the Litany for Ordinations, including the music, on disk. I used sections of the litany in the booklet where the congregation was to respond to the chanted litany.

Step 1. When I began setting up this booklet, I couldn't predict how many pages it would contain (since hymns were chosen later in the process) so I started with a single page grid that could be translated into double pages later. Had I known what I had to work with, I could have made a small dummy booklet with just page numbers and set up my page layout program accordingly. There are all sorts of options for setting up booklets like these; what you choose to do will depend partially on the layout program you have and partially on your own personal preference. Check your program manual for the way most comprehensible to you to set up this kind of document; many page layout programs will let you see the entire document at once and pick up and move the pages of the document with your mouse; there are also ways to set this up automatically. Plan carefully before you go any further.

Step 2. I input and formatted the text to match the Book of Common Prayer as closely as possible, since the BCP is set up in a very readable fashion. I used New Century Schoolbook for ease of reading, as there's a lot of text here.

Simple Graphics

The Assignment: Create a staple-stitched booklet with type and simple graphics to be reproduced by photocopy.

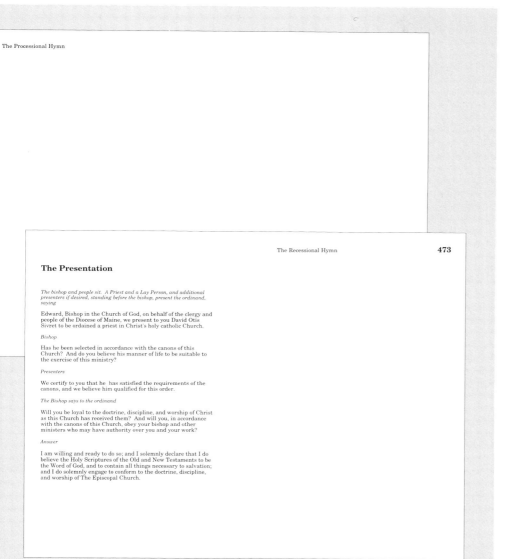

Specifications:

Seven 8½" x 11" sheets

Single fold to 5½" x 8½" pages

Ink color: One, black

Paper:

 Cover: Parchment text, 60 pound

 Interior: Ivory laid, 24 pound

Art: Simple graphics

Margins:

 Top: ½" Bottom: ½"

 Left: ½" Right: ½"

Grid: Two columns per 8½" x 11" sheet; 1½" between columns

Type:

 Cover and title page: New Century Schoolbook Bold 14/24; 24/24; 12/13

 Heads: New Century Schoolbook Bold 14/16

 Text: Rubrics-New Century Schoolbook Italic 9/9.75

 Body: New Century Schoolbook Roman 10/10.83

Printing: Photocopying

Step 3. Since the hymns were to be added later, I left pages for them with the hymnal numbers, etc., on them. Planning to include only music on these pages gives me more latitude in sizing the pages from the hymnal when I put them in, since I won't have to work around any text.

Bound Booklet With Simple Graphics

The Litany for Ordinations

For use at Ordinations as directed. On Ember Days or other occasions, if desired, this Litany may be used for the Prayers of the People at the Eucharist or the Daily Office, or it may be used separately.

God the Father,
Have mercy on us.

God the Son,
Have mercy on us.

God the Holy Spirit,
Have mercy on us.

Holy Trinity, one God,
Have mercy on us.

We pray to you, Lord Christ.
Lord, hear our prayer.

For the holy Church of God, that it may be filled with truth and love, and be found without fault at the Day of your Coming, we pray to you, O Lord.
Lord, hear our prayer.

For all members of your Church in their vocation and ministry, that they may serve you in a true and godly life, we pray to you, O Lord.
Lord, hear our prayer.

For Edmond, our Presiding Bishop, and for all bishops, priests, and deacons, that they may be filled with your love, may hunger for truth, and may thirst after righteousness, we pray to you, O Lord.
Lord, hear our prayer.

4

The Bis...
Receiv...
the Wo...
forget the trust committed to you as a priest of the Church of God.

The Bishop greets the newly ordained.

The Peace

The new Priest then says to the congregation
 The peace of the Lord be always with you.
People And also with you.

The Presbyters present greet the newly ordained; who then greets family members and others, as may be convenient. The Clergy and People greet one another.

At the Celebration of the Eucharist *[P. 333, BCP]*

The liturgy continues with the Offertory. Deacons prepare the table.

Offertory Anthem **Brother James' Air** Senior Choir

Standing at the Lord's Table, with the Bishop and other presbyters, the newly ordained Priest joins in the celebration of the Holy Eucharist and in the Breaking of the Bread.

After Communion

In place of the usual postcommunion prayer, the following is said

Almighty Father, we thank you for feeding us with the holy food of the Body and Blood of your Son, and for uniting us through him in the fellowship of your Holy Spirit. We thank you for raising up among us faithful servants for the ministry of your Word and Sacraments. We pray that David may be to us an effective example in word and action, in love and patience, and in holiness of life. Grant that we, with him, may serve you now, and always rejoice in your glory; through Jesus Christ your Son our Lord, who lives and reigns with you and the Holy Spirit, one God, now and for ever. *Amen*

The Bishop then asks the new priest to bless the people.

13

Step 4. Because I myself served as litanist, I didn't want to take any chances with my memory for the tone, so I created a sheet in Adobe Illustrator with the music for the chant. I then created another file by cutting out the sections needed for the congregational response and positioned them on the page.

The booklet pages (dummy layout):

The Presentation

The bishop and people sit. A Priest and a Lay Person, and additional presenters if desired, standing before the bishop, present the ordinand, saying

Edward, Bishop in the Church of God, on behalf of the clergy and people of the Diocese of Maine, we present to you David Otis Sivret to be ordained a priest in Christ's holy catholic Church.

Bishop

Has he been selected in accordance with the canons of this Church? And do you believe his manner of life to be suitable to the exercise of this ministry?

Presenters

We certify to you that he has satisfied the requirements of the canons, and we believe him qualified for this order.

The Bishop says to the ordinand

Will you be loyal to the doctrine, discipline, and worship of Christ as this Church has received them? And will you, in accordance with the canons of this Church, obey your bishop and other ministers who may have authority over you and your work?

Answer

I am willing and ready to do so; and I solemnly declare that I do believe the Holy Scriptures of the Old and New Testaments to be the Word of God, and to contain all things necessary to salvation; and I do solemnly engage to conform to the doctrine, discipline, and worship of The Episcopal Church.

2

Postlude

15

Let us go forth into the world, rejoicing in the power of the Spirit.

People Thanks be to God.

From Easter Day through the Day of Pentecost "Alleluia, alleluia," may be added to the dismissal and to the response.

14

3

example in word and action, in love and patience, and in holiness of life. Grant that we, with him, may serve you now, and always rejoice in your glory; through Jesus Christ your Son our Lord, who lives and reigns with you and the Holy Spirit, one God, now and for ever. *Amen*

The Bishop then asks the new priest to bless the people.

4

God, for ever and ever.

The People in a loud voice respond Amen.

The new priest is now vested according to the order of priests.

12

Lord, hear our prayer.

5

Step 5. The final choices (and last-minute changes) of hymns have been made. I had allotted one page per hymn, but David ended up deciding upon a processional hymn that required three pages. Armed with this information, I was now ready to create side-by-side page layouts. This is where I manually create a dummy booklet, complete with text and music, to discern which pages of the booklet will be opposite each other before moving them around in my document. Here's a sample of some of the pages after I've rearranged them into proper order, i.e., the page with the section entitled "The Presentation" is now facing the page with the recessional hymn, etc.

The offering this evening will be donated, in thanksgiving, to Hospice of Kennebec Valley, The AIDS Project in Portland, the Alzheimer's Unit, Gardiner, for ministry supplies and to the Hallowell Adult Day Care for scholarships.

The Parish Family of St. Matthew's cordially invites the congregation to a reception in the Parish Hall following the service.

Special thanks to all who assisted with both the liturgy and the reception.

370 The Holy Trinity

Step 6. All I had to do was wax in the hymns, and the interior of the booklet was complete.

Bound Booklet With Simple Graphics

Step 7. The cover is next. This was the easiest part of the project. Since I had a scanned image of the Diocesan seal on disk, I had only to enter the text, position the image and use the round rectangle tool to draw the border. I chose the thin/thick line border because it served to "corral" the text and art, yet was not so heavy that it fought with it or so thin that it appeared ineffective. I plan to include this cover twice on each brochure—once as a title page, and once, on heavier stock, as a cover page. Not only does this give the booklet a formal, professional feel, it also ensures that, should the cover be ripped or rained on, it can be removed so that the recipient can still have an intact memento of this occasion.

THE ORDINATION OF

David Otis Sivret

to the Sacred Priesthood

December 17, 1988

The Litany for Ordinations

For use at Ordinations as directed. On Ember Days or other occasions, if desired, this Litany may be used for the Prayers of the People at the Eucharist or the Daily Office, or it may be used separately.

God the Father,
Have mercy on us.

God the Son,
Have mercy on us.

God the Holy Spirit,
Have mercy on us.

Holy Trinity, one God,
Have mercy on us.

We pray to you, Lord Christ.
Lord, hear our prayer.

For the holy Church of God, that it may be filled with truth and love, and be found without fault at the Day of your Coming, we pray to you, O Lord.
Lord, hear our prayer.

For all members of your Church in their vocation and ministry, that they may serve you in a true and godly life, we pray to you, O Lord.
Lord, hear our prayer.

For Edmond, our Presiding Bishop, and for all bishops, priests, and deacons, that they may be filled with your love, may hunger for truth, and may thirst after righteousness, we pray to you, O Lord.
Lord, hear our prayer.

For David, chosen priest in your Church, we pray to you, O Lord.
Lord, hear our prayer.

That he may faithfully fulfill the duties of this ministry, build up your Church, and glorify your Name, we pray to you, O Lord.
Lord, hear our prayer.

That by the indwelling of the Holy Spirit he may be sustained and encouraged to persevere to the end, we pray to you, O Lord.
Lord, hear our prayer.

For his family [the members of his household or community], that they may be adorned with all Christian virtues, we pray to you, O Lord.
Lord, hear our prayer.

For all who fear God and believe in you, Lord Christ, that our divisions may cease and that all may be one as you and the Father are one, we pray to you, O Lord.
Lord, hear our prayer.

For the mission of the Church, that in faithful witness it may preach the Gospel to the ends of the earth, we pray to you, O Lord.
Lord, hear our prayer.

For those who do not yet believe, and for those who have lost their faith, that they may receive the light of the Gospel, we pray to you, O Lord.
Lord, hear our prayer.

For the peace of the world, that a spirit of respect and forbearance may grow among nations and peoples, we pray to you, O Lord.
Lord, hear our prayer.

4

5

The final project was a success. It provided continuity in the service and cut down on the roar of rustling pages. I'm even told that the bishop heartily approved of it.

Bishop Will you be diligent in the reading and study of the Holy Scriptures, and in seeking the knowledge of such things as may make you a stronger and more able minister of Christ?

Answer I will.

Bishop Will you endeavor so to minister the Word of God and the sacraments of the New Covenant, that the reconciling love of Christ may be known and received?

Answer I will.

Bishop Will you undertake to be a faithful pastor to all whom you are called to serve, laboring together with them and with your fellow ministers to build up the family of God?

Answer I will.

Bishop Will you do your best to pattern your life [and that of your family, *or* household, *or* community] in accordance with the teachings of Christ, so that you may be a wholesome example to your people?

Answer I will.

Bishop Will you persevere in prayer, both in public and in private, asking God's grace, both for yourself and for others, offering all your labors to God, through the mediation of Jesus Christ, and in the sanctification of the Holy Spirit?

Answer I will.

Bishop May the Lord who has given you the will to do these things give you the grace and power to perform them.

Answer Amen.

10

11

Project 12: Bound Booklet With

The Client: A statewide AIDS organization.

The Maine AIDS Alliance (MAA) had been working with two small fold-up brochures. They were exactly alike except that one was aimed at IV drug users and the other at folks who were at risk for transmitting the disease sexually. Peaches, the executive director, called and asked if I would combine the two brochures into one booklet. These two brochures were up-to-date, and it wasn't difficult to transfer the information from the small brochures to the booklet since the pages were the same size.

A major constraint was the client's unalterable choice of page size. The information in the two originals was the same except for the artwork directed at each at-risk group, so I had to use a small point size to fit all the information into the allotted space and therefore had to utilize a two-column format. Had the size and number of the pages been left open, I would have used a larger typeface and more white space. Unfortunately, this client had a very limited budget, which precluded any suggestions regarding the number of pages, and they were equally adamant regarding size. (If you know that a piece will be redone from time to time, and if the client's budget permits, it's a good idea to plan ahead by creating a design that can include all the copy comfortably.)

This booklet contains all the resource information that a person with HIV, or in one of the HIV risk groups, would need to find services anywhere in the state. It will be distributed directly from the MAA office, as well as at AIDS workshops and health fairs throughout the state.

Step 1. Here you see the notations I made on the original two pamphlets to help me collate the contents of the two original brochures. Since the client had mandated the number of pages, there was no question of information spilling over onto the next page; I had to make it fit. I then set up a template for facing pages at the appropriate size.

Line Art

The Assignment: Create a staple-stitched informational booklet designed to fit in the back pocket of a pair of jeans.

Specifications:

Three 5½" x 4¼" sheets

Two panels, one fold

Ink color: One, blue

Paper:

Cover: Card stock rippletone

Interior: Bond, 20 pound

Art: Line art

Margins:

Top: ³⁄₁₆" Bottom: ³⁄₁₆"

Left: ³⁄₁₆" Right: ³⁄₁₆"

Grid: Two panels 2⅜" x 3⅞"; gutter: ⅜"

Type:

Cover: Helvetica Bold 12/14; Helvetica Roman 10/11.67

Body: Helvetica Narrow Bold 9/10.5; Helvetica Narrow Roman 9/9.75; Times Bold 10/10

Printing: Offset

**MAINE
AIDS
ALLIANCE**

283 Water Street
Augusta, Maine 04330

(207) 621-2924

Step 2. The first order of business is the cover. The organization's name, address and phone number is all that is necessary since it's the starting place for the whole brochure. With this serious subject matter, clip art or any other decorative element would be too frivolous. Don't feel obligated to add graphics just to fill up white space; sometimes, as in this case, a starker approach is more appropriate to your subject matter.

Maine AIDS Alliance
Member Organizations

The Maine AIDS Alliance is composed of organizations across Maine. These organizations are dedicated to helping communities affected by AIDS and HIV through support and education programs.

AIDS Coalition for Lincoln County 563-8953
PO Box 421, Damariscotta, ME 04543

AIDS Lodging House 874-1000
233 Oxford St., Portland, ME 04101

Androscoggin Valley AIDS Coalition 786-4697
PO Box 7977, Lewiston, ME 04243-7977

Community AIDS Awareness Program 369-0259
PO Box 457, Rumford, ME 04276

Community Task Force on AIDS Ed. 583-6608
PO Box 941, Naples, ME 04055

Dayspring 626-3432
20 Middle St., Augusta, ME 04330

Down East AIDS Network 667-3506
114 State St., Ellsworth, ME 04605

Eastern Maine AIDS Network 990-3626
PO Box 2038, Bangor, ME 04401

Merrymeeting AIDS Support Services 725-4955
PO Box 57, Brunswick, ME 04011-0057

Names Project/Maine 774-2198
PO Box 4319, Portland, ME 04101

Open Up and Talk 774-1413
PO Box 793, Portland, ME 04104

Oxford Hills Community AIDS Network 743-7451
PO Box 113
Paris, ME 04271-0013

People With AIDS Coalition of Maine 773-8500
377 Cumberland, Ave., Portland, ME 04101

St. John Valley AIDS Task Force 834-6002
c/o NMMC, 143 E. Main St.
Fort Kent, ME 04743

The AIDS Project 774-6877
22 Monument Sq., 5th flr, Portland, ME 04101

Waldo-Knox AIDS Coalition 338-1427
PO Box 956, Belfast, ME 04915

AIDS-LINE (TDD accessible) 1-800-851-2437
The call is free and anonymous.

For other **emergency services**, rape crisis services, family violence services, youth programs, mental health centers, housing assistance, soup kitchens, hotlines, and other assistance, refer to the customer service numbers on pages 2 and 3 of the NYNEX telephone white pages.

Step 3. The Maine AIDS Alliance is the group that coordinates services to people with HIV statewide. It is composed of many regional groups. The mailing and telephone information for each group is the first piece of information listed. To utilize all the space, I had to make use of the inside covers. Since I had to incorporate a lot of text in such a small space, I used a sans serif condensed font, Helvetica Narrow. For contrast, I used a serif font, Times Bold, for some of the heads. To emphasize the name and phone number of each group, I used Helvetica Narrow Bold. For the original brochures, the copy for the booklet was given to me in the form of handwritten text on legal paper, so I had to input it myself. When the piece was finished, it went back to Peaches for proofing; it's altogether too easy to transpose the digits in phone numbers.

Bound Booklet With Line Art

Sexually Transmitted Disease (STD/VD) Clinics	
Family Planning, **Augusta**	626-3426
Bangor STD Clinic, **Bangor**	947-0700
York County STD Clinic, **Biddeford**	282-1516
Downeast Family Planning, **Ellsworth**	667-5304
The Clinic, **Lewiston**	795-4019
Midcoast Family Planning, **Rockland**	594-2551
Portland STD Clinic, **Portland**	874-8952
Venus Clinic, **Presque Isle**	764-3721

Family Planning Clinics (main offices only)	
Aroostook County F.P., **Presque Isle**	764-3721
Down East F.P., **Ellsworth**	667-5304
Kennebec Valley F.P., **Waterville**	873-2122
Mid-Coast F.P., **Rockland**	594-2551
Penquis F.P., **Bangor**	941-2836
Planned Parenthood, **Portland**	874-1095
Southern Kennebec F.P., **Augusta**	626-3426
Tri-County F.P., **Lewiston**	795-4007

Gay & Lesbian Organizations
Outright (Youth Support)
PO Box 5028, Sta. A, Portland, ME 04102-5028
Outright Too
PO Box 2264, Bangor, ME 04402
Outright Central Maine
PO Box 802, Auburn, ME 04212
Maine Lesbian Gay Political Alliance (Advocacy)
PO Box 232, Hallowell, ME 04347

Drug & Alcohol Counseling Services	
Toll free for referrals & information	**1-800-322-5004**

Hemophilia Services	
Maine Hemophilia Treatment Center	8
M.M.C., 22 Bramhall St., Portland, ME 0410	

Services for Persons with AIDS/HIV	
Case Management Programs	
The AIDS Project	774-6877
(Cumberland, York, Androscoggin, Oxford)	
Dayspring	873-1127
(Franklin, Kennebec, Somerset, Waldo,	
Lincoln, Knox, Sagadahoc)	
Down East AIDS Network	667-3506
(Hancock, Washington)	
Eastern Maine AIDS Network	990-3626
(Penobscot, Piscataquis, Aroostook)	
Drug & Treatment Reimbursement Program	
AIDS Case Management Coordinator	289-5060
Bureau of Child & Family Services	
Housing	
AIDS Lodging House, Portland	874-1000
Social/Support	
PWA Coalition of Maine	773-8500
377 Cumberland, Portland, ME 04101	
Hospice	
Maine Hospice Council	626-0651
Provides referrals to local programs	

Legal/Discrimination	
Maine Civil Liberties Union	774-5444
Maine Human Rights Commission	289-2326
Volunteer Lawyers Project	774-4348
National Hot Lines (toll free)	
National AIDS Information	1-800-458-5231
Clearinghouse	
AIDS Hotline	1-800-342-AIDS
AIDS Clinical Trials	1-800-TRIALS-A
TDD:	1-800-243-7012
Teen TAP	1-800-234-TEEN

Anonymous HIV Antibody Counseling & Testing	
Bangor STD Clinic, **Bangor**	947-0700
York County STD Clinic, **Biddeford**	282-1516
Down East Health Service, **Ellsworth**	667-5304
Family Planning, **Gardiner**	626-3426
The Clinic, **Lewiston**	795-4019
The AIDS Project, **Portland**	775-1267
Portland STD Clinic, **Portland**	874-8452
ACAP Family Planning, **Presque Isle**	764-3721
Mid-Coast Family Planning, **Rockland**	594-2551

You must call first and make an appointment

Step 4. The next four pages contain listings by type of service. Heads are done with Helvetica Narrow Roman in shaded boxes: I created boxes using the rectangle tool in my page layout program, and then shaded them with a 15 percent screen. (If you don't have a program that can do this, you can create a screen with a rubylith overlay.) One of the sections has subheads, so I used Times Bold for those. I also experimented with the technique of not underlining letters with descenders, to avoid striking through the type. Some listings are by area, others by organization. This information, as well as phone numbers, is all in bold. Keep in mind that loss of visual acuity is one of the many symptoms of the disease, so I went with as big and as legible a typeface and as bold a treatment as the size of the brochure would allow.

Step 5. The original illustration for "Don't Share Works," on the left, wasn't realistic looking, so I had Mr. Hanrahan draw the new and improved version you see on the right. Then I scanned the new illustration and traced it with Adobe Illustrator to create an EPS file. This made it easy to insert the same drawing twice at a size that worked, and saved us the extra step of pasteup at the end of the process.

**MAINE
AIDS
ALLIANCE**

283 Water Street
Augusta, Maine 04330

(207) 621-2924

**Maine AIDS Alliance
Member Organizations**

The Maine AIDS Alliance is composed of organizations across Maine. These organizations are dedicated to helping communities affected by AIDS and HIV through support and education programs.

AIDS Coalition for Lincoln County	563-8953
PO Box 421, Damariscotta, ME 04543	
AIDS Lodging House	874-1000
233 Oxford St., Portland, ME 04101	
Androscoggin Valley AIDS Coalition	786-4697
PO Box 7977, Lewiston, ME 04243-7977	
Community AIDS Awareness Program	369-0259
PO Box 457, Rumford, ME 04276	
Community Task Force on AIDS Ed.	583-6608
PO Box 941, Naples, ME 04055	
Dayspring	626-3432
20 Middle St., Augusta, ME 04330	
Down East AIDS Network	667-3506
114 State St., Ellsworth, ME 04605	
Eastern Maine AIDS Network	990-3626
PO Box 2038, Bangor, ME 04401	

Notes/Other Numbers

Services for Persons with AIDS/HIV

Case Management Programs

The AIDS Project	774-6877
(Cumberland, York, Androscoggin, Oxford)	
Dayspring	873-1127
(Franklin, Kennebec, Somerset, Waldo, Lincoln, Knox, Sagadahoc)	
Down East AIDS Network	667-3506
(Hancock, Washington)	
Eastern Maine AIDS Network	990-3626
(Penobscot, Piscataquis, Aroostook)	

Drug & Treatment Reimbursement Program

AIDS Case Management Coordinator	289-5060
Bureau of Child & Family Services	

Housing

AIDS Lodging House, Portland	874-1000

Social/Support

PWA Coalition of Maine	773-8500
377 Cumberland, Portland, ME 04101	

Hospice

Maine Hospice Council	626-0651
Provides referrals to local programs	

If you shoot up (intravenous drugs)
**Don't Share Works
But if you have to share, clean them
between EVERY use!**

Rinse twice with bleach

then

Rinse twice with water

Do not squirt bleach back into bottles
For more info, call 1-800-851-2437

You Can Stop HIV!

- Get enough rest and exercise
- Eat well
- Don't abuse alcohol, drugs, tobacco
- Make sure you have a support system
- Enjoy safe sex (massage, fantasies, masturbation, etc.)
- Use condoms correctly:
 - Press air out of the condom tip
 - Unroll the condom to cover the entire erect penis
 - Use a water based lubricant or spermicide
 - After sex, hold the condom around the base and pull out gently

Legal/Discrimination

Maine Civil Liberties Union	774-5444
Maine Human Rights Commission	289-2326
Volunteer Lawyers Project	774-4348

National Hot Lines (toll free)

National AIDS Information	1-800-458-5231
Clearinghouse	
AIDS Hotline	1-800-342-AIDS
AIDS Clinical Trials	1-800-TRIALS-A
TDD:	1-800-243-7012
Teen TAP	1-800-234-TEEN

Anonymous HIV Antibody Counseling & Testing

Bangor STD Clinic, **Bangor**	947-0700
York County STD Clinic, **Biddeford**	282-1516
Down East Health Service, **Ellsworth**	667-5304
Family Planning, **Gardiner**	626-3426
The Clinic, **Lewiston**	795-4019
The AIDS Project, **Portland**	775-1267
Portland STD Clinic, **Portland**	874-8452
ACAP Family Planning, **Presque Isle**	764-3721
Mid-Coast Family Planning, **Rockland**	594-2551

You must call first and make an appointment

Sexually Transmitted Disease (STD/VD) Clinics

Family Planning, **Augusta**	626-3426
Bangor STD Clinic, **Bangor**	947-0700
York County STD Clinic, **Biddeford**	282-1516
Downeast Family Planning, **Ellsworth**	667-5304
The Clinic, **Lewiston**	795-4019
Midcoast Family Planning, **Rockland**	594-2551
Portland STD Clinic, **Portland**	874-8952
Venus Clinic, **Presque Isle**	764-3721

Gay & Lesbian Organizations

Outright (Youth Support)
PO Box 5028, Sta. A, Portland, ME 04102-5028
Outright Too
PO Box 2264, Bangor, ME 04402
Outright Central Maine
PO Box 802, Auburn, ME 04212
Maine Lesbian Gay Political Alliance (Advocacy)
PO Box 232, Hallowell, ME 04347

Family Planning Clinics (main offices only)

Aroostook County F.P., **Presque Isle**	764-3721
Down East F.P., **Ellsworth**	667-5304
Kennebec Valley F.P., **Waterville**	873-2122
Mid-Coast F.P., **Rockland**	594-2551
Penquis F.P., **Bangor**	941-2836
Planned Parenthood, **Portland**	874-1095
Southern Kennebec F.P., **Augusta**	626-3426
Tri-County F.P., **Lewiston**	795-4007

Drug & Alcohol Counseling Services

Toll free for referrals & information	1-800-322-5004

Hemophilia Services

Maine Hemophilia Treatment Center	871-6160
M.M.C., 22 Bramhall St., Portland, ME 04102	

Step 6. Now it's time for me to arrange the pages of the booklet so that each page faces the page it will be opposite from (i.e., page 1 will face page 16, page 15 will face page 2, etc.). Here you see some of the pages of the booklet after this process, but before they've been collated by the printer.

Bound Booklet With Line Art

Maine AIDS Alliance Member Organizations

The Maine AIDS Alliance is composed of organizations across Maine. These organizations are dedicated to helping communities affected by AIDS and HIV through support and education programs.

AIDS Coalition for Lincoln County 563-8953
PO Box 421, Damariscotta, ME 04543

AIDS Lodging House 874-1000
233 Oxford St., Portland, ME 04101

Androscoggin Valley AIDS Coalition 786-4697
PO Box 7977, Lewiston, ME 04243-7977

...ty AIDS Awareness Program 369-0259
7, Rumford, ME 04276

...ty Task Force on AIDS Ed. 583-6608
1, Naples, ME 04055

 626-3432
St., Augusta, ME 04330

...t AIDS Network 667-3506
St., Ellsworth, ME 04605

...aine AIDS Network 990-3626
38, Bangor, ME 04401

Merrymeeting AIDS Support Services 725-4955
PO Box 57, Brunswick, ME 04011-0057

Names Project/Maine 774-2198
PO Box 4319, Portland, ME 04101

Open Up and Talk 774-1413
PO Box 793, Portland, ME 04104

Oxford Hills Community AIDS Network 743-7451
PO Box 113
Paris, ME 04271-0013

People With AIDS Coalition of Maine 773-8500
377 Cumberland, Ave., Portland, ME 04101

St. John Valley AIDS Task Force 834-6002
c/o NMMC, 143 E. Main St.
Fort Kent, ME 04743

The AIDS Project 774-6877
22 Monument Sq., 5th flr, Portland, ME 04101

Waldo-Knox AIDS Coalition 338-1427
PO Box 956, Belfast, ME 04915

AIDS-LINE (TDD accessible) 1-800-851-2437
The call is free and anonymous.

For other **emergency services**, rape crisis services, family violence services, youth programs, mental health centers, housing assistance, soup kitchens, hotlines, and other assistance, refer to the customer service numbers on pages 2 and 3 of the NYNEX telephone white pages.

MAINE AIDS ALLIANCE

283 Water Street
Augusta, Maine 04330

(207) 621-2924

...s for Persons with AIDS/HIV

...agement Programs

...ject 774-6877
...ork, Androscoggin, Oxford)

 873-1127
...ebec, Somerset, Waldo,
...agadahoc)

...IDS Network 667-3506
...hington)

Eastern Maine AIDS Network 990-3626
(Penobscot, Piscataquis, Aroostook)

Drug & Treatment Reimbursement Program
AIDS Case Management Coordinator 289-5060
Bureau of Child & Family Services

Housing
AIDS Lodging House, Portland 874-1000

Social/Support
PWA Coalition of Maine 773-8500
377 Cumberland, Portland, ME 04101

Hospice
Maine Hospice Council 626-0651
Provides referrals to local programs

Legal/Discrimination
Maine Civil Liberties Union 774-5444
Maine Human Rights Commission 289-2326
Volunteer Lawyers Project 774-4348

National Hot Lines (toll free)
National AIDS Information 1-800-458-5231
 Clearinghouse
AIDS Hotline 1-800-342-AIDS
AIDS Clinical Trials 1-800-TRIALS-A
 TDD: 1-800-243-7012
Teen TAP 1-800-234-TEEN

Anonymous HIV Antibody Counseling & Testing

Bangor STD Clinic, **Bangor** 947-0700
York County STD Clinic, **Biddeford** 282-1516
Down East Health Service, **Ellsworth** 667-5304
Family Planning, **Gardiner** 626-3426
The Clinic, **Lewiston** 795-4019
The AIDS Project, **Portland** 775-1267
Portland STD Clinic, **Portland** 874-8452
ACAP Family Planning, **Presque Isle** 764-3721
Mid-Coast Family Planning, **Rockland** 594-2551

You must call first and make an appointment

Sexually Transmitted Disease (STD/VD) Clinics	
Family Planning, **Augusta**	626-3426
Bangor STD Clinic, **Bangor**	947-0700
York County STD Clinic, **Biddeford**	282-1516
Downeast Family Planning, **Ellsworth**	667-5304
The Clinic, **Lewiston**	795-4019
Midcoast Family Planning, **Rockland**	594-2551
Portland STD Clinic, **Portland**	874-8952
Venus Clinic, **Presque Isle**	764-3721

Family Planning Clinics (main offices only)	
Aroostook County F.P., **Presque Isle**	764-3721
Down East F.P., **Ellsworth**	667-5304
Kennebec Valley F.P., **Waterville**	873-2122
Mid-Coast F.P., **Rockland**	594-2551
Penquis F.P., **Bangor**	941-2836
Planned Parenthood, **Portland**	874-1095
Southern Kennebec F.P., **Augusta**	626-3426
Tri-County F.P., **Lewiston**	795-4007

Gay & Lesbian Organizations

Outright (Youth Support)
PO Box 5028, Sta. A, Portland, ME 04102-5028
Outright Too
PO Box 2264, Bangor, ME 04402
Outright Central Maine
PO Box 802, Auburn, ME 04212
Maine Lesbian Gay Political Alliance (Advocacy)
PO Box 232, Hallowell, ME 04347

Drug & Alcohol Counseling Services	
Toll free for referrals & information	1-800-322-5004

Hemophilia Services	
Maine Hemophilia Treatment Center	871-6160
M.M.C., 22 Bramhall St., Portland, ME 04102	

The final product will, indeed, fit in the back pocket of a pair of jeans. It also contains all the information anyone in Maine might need to know about preventing AIDS, being tested or volunteering time and money to help in the ongoing fight. It is unfortunate that funding is not greater, since updating this material depends on the Alliance's budget.

You Can Stop HIV!

- Get enough rest and exercise
- Eat well
- Don't abuse alcohol, drugs, tobacco
- Make sure you have a support system
- Enjoy safe sex (massage, fantasies, masturbation, etc.)
- Use condoms correctly:
 - –Press air out of the condom tip
 - –Unroll the condom to cover the entire erect penis
 - –Use a water based lubricant or spermicide
 - –After sex, hold the condom around the base and pull out gently

If you shoot up (intravenous drugs)
Don't Share Works
But if you have to share, clean them between EVERY use!

Rinse twice with bleach

then

Rinse twice with water

Do not squirt bleach back into bottles
For more info, call 1-800-851-2437

Project 13: Twelve-Page Newsletter

The Client: Sharon Nichols, Executive Director, Holocaust Human Rights Center of Maine.

I've been working with Sharon for more than 5 years on this quarterly piece, which disseminates information regarding the activities of this organization. It has gone through several format changes. The first issue I saw of this newsletter consisted of 12 pages of poorly photocopied material from altogether too many sources, including dot matrix printers as well as typewriters that needed to be cleaned. The first issue I did was a three-column format with fully justified type, at the behest of the editor at that time. When Sharon came on board as editor, I suggested a two-column format with a ragged right in order to project a less rigid image.

Sharon is a very organized individual, which makes my job infinitely easier. She inputs the articles on her office computer and brings them to me on disk.

The first order of business each time we do a new issue is to brew a pot of coffee. Then we settle into the issues of the day, such as placement of the various articles and their continuations, where necessary, as well as photographs.

Since I keep each issue on file, the format is ready and waiting. The piece, given its length, needs to be easily readable, and articles need to be easily identifiable. Hence, the simplicity of Helvetica and New Century Schoolbook. The Zapf Chancery heads on the Update page are a pretty way of saying "thanks" to those individuals who have contributed so generously to the Center.

Step 1. Since this is an ongoing piece, I simply pull up the previous issue and change the volume number and date under the space I left blank for the masthead. It is also possible to include the masthead in the actual document by either developing it directly on the computer or by scanning it into the document. I chose not to do this since I was provided with the camera-ready art.

The Revisionists
by John Mizner

George Steiner tells the story of Simon Dubnow, the famous Jewish historian, who, aged 81, faced execution during the evacuation of the Riga ghetto in December 1941. His last words, directed apparently to the world at large, were "Shreibt un Farshreibt": Write and Record.

He could not have known how many would heed his admonishment. During the last three decades or so—ever since, say, the Eichmann trial—the study of the Holocaust has become a veritable industry. But, though innumerable people—scholars and laymen, victims and perpetrators, Jews and Gentiles—have recorded and are recording, the record is far from straight, and its message far from clear.

On April 19th, just a few weeks ago, a Roper poll reported that 22% of adults and 20% of high school students said that it was possible that the Holocaust, described as the Nazi extermination of Jews, never happened. Twelve percent of the adults and seventeen percent of the high school students said that they did not know. "What have we done" asked a stunned Eli Wiesel, "we've been working for years and years... I am shocked that 22%—Oh, my God." Perhaps as much to the point: What have they done? What have they been reading, watching, and listening to? A revised version of WW II?

The Revisionists
by John Mizner

George Steiner tells the story of Simon Dubnow, the famous Jewish historian, who, aged 81, faced execution during the evacuation of the Riga ghetto in December 1941. His last words, directed apparently to the world at large, were "Shreibt un Farshreibt": Write and Record.

He could not have known how many would heed his admonishment. During the last three decades or so—ever since, say, the Eichmann trial—the study of the Holocaust has become a veritable industry. But, though innumerable people—scholars and laymen, victims and perpetrators, Jews and Gentiles—have recorded and are recording, the record is far from straight, and its message far from clear.

On April 19th, just a few weeks ago, a Roper poll reported that 22% of adults and 20% of high school students said that it was possible that the Holocaust, described as the Nazi extermination of Jews, never happened. Twelve percent of the adults and seventeen percent of the high school students said that they did not know. "What have we done" asked a stunned Eli Wiesel, "we've been working for years and years... I am shocked that 22%—Oh, my God." Perhaps as much to the point: What have they done? What have they been reading, watching, and listening to? A revised version of WW II?

So it seems. Revisionist history seems to have had a profound impact. The revisionists of the Holocaust fall broadly into three categories: (1) those who deny that the Holocaust ever happened; (2) the revisionists of ignorance or willful amnesia; and (3) those who seek to relativize or normalize the Holocaust, who see it as one of the many horrors of history or, more particularly of the twentieth century, which has had more than its share, who see the extermination of the Jews as attributable to "the fortunes of war" and Auschwitz ultimately not much different from, say, Stalin's Gulag or, in a real stretch, Hiroshima. Even if Holocaust revisionism is not exclusively anti-Semitic propaganda, as the recent ADL pamphlet Hitler's Apologists suggests, it is invariably pernicious.

Step 2. Since Sharon provides these—fully edited—on disk for me, I don't have to retype anything, just change the typeface and adjust the point size and leading, as you see here. I then place each piece of text in the appropriate location, continuing them where necessary, usually reserving a page or so for these continuations. I simply link text boxes where necessary and let the computer do the rest. Sometimes there aren't enough articles to fill all the space. In that case, we would either leave the white space, use available clip art (the HHRC has purchased a great disk of Hebrew graphics), or both. If there is too much information, and if all of it is indispensable, we could go to a 16-page format. Remember, when you're working with a folded booklet and need to increase or decrease the number of pages, the magic number is four.

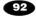 *Creating Brochures & Booklets*

The Assignment: Create a 12-page newsletter using halftones and line art.

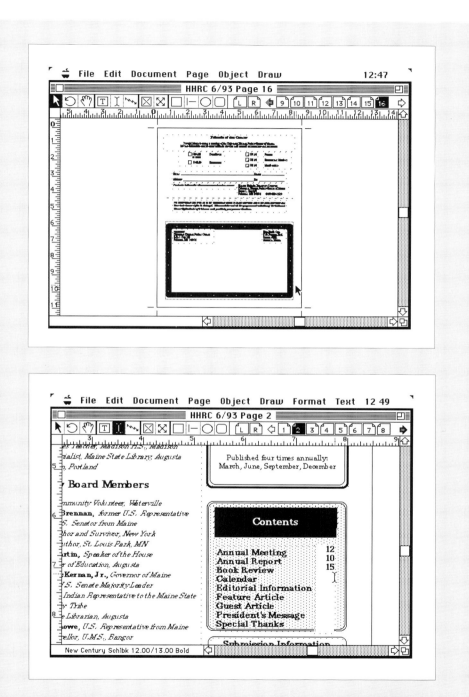

Specifications:

Three 11" x 17" sheets

Single fold to 8½" x 11" pages

Ink color: One, blue

Paper: White recycled Eastern opaque, 70 pound

Art: Halftones, line art

Margins:

Top: ½" Bottom: ½"

Left: ½" Right: ½"

Grid: Two columns per 8½" x 11" page; gutter: 1"

Type:

Heads: Helvetica Bold 18 pt.

Text: New Century Schoolbook Bold 10/12

Captions: Avant Garde 10/12

Membership Update Heads: Zapf Chancery 24/26

Bylines: Helvetica 12/14

Headers: New Century Schoolbook 12/13

Printing: Offset lithography

Step 3. The easiest pages of this layout are the second page, the membership update page and the back cover. Usually, the second page has only page number changes, on the membership update page only the names are changed, and the back cover remains the same. (I created the border from a piece of clip art that I had. It took several hours, and I've informed Sharon that a snowball will roll through hell before I use a different one!)

Twelve-Page Newsletter

Annual Meeting

The Eighth Annual Meeting of the Holocaust Human Rights Center of Maine took place on May 2 with Dr. Marion P. Pritchard as the keynote speaker. Pritchard vividly described her life under Nazi rule and her work in the underground to save Jews during World War II.

Michael Messerschmidt presented the Take a Stand Award to Peter E. O'Donnell, Portland City Councilor, for his courage in sponsoring and fighting for Portland's Municipal Human Rights Ordinance despite intense and sometimes violent opposition to equal rights for lesbians and gay men

Patty Gordon and Pat Stanton received the Volunteer of the Year Awards for their many hours working with the Multi-Cultural Group to Combat Bias and the Diversity Leadership Institute participants.

Sally Lerman reported on her participation in the Diversity Leadership Institute and recent programs.

Step 4. Next, by way of computer, I place black squares where the photographs will appear. The squares could also have been placed by cutting a piece of black construction paper to the size of the photograph and then waxing it onto the mechanical. This provides Laurie the printer with open spaces on the negatives in which to strip in the negative halftones. (Halftones and line shots must be done by different processes, so we can't just plop the photograph onto the mechanical and shoot it.) Since my printer has camera capabilities, she will be given the actual photos to shoot from, thereby saving me the delight of finding a parking space and having halftones shot.

Volume VIII No. 4 June 1993 Editor: Sharon Nichols

The Revisionists
by John Mizner

George Steiner tells the story of Simon Dubnow, the famous Jewish historian, who, aged 81, faced execution during the evacuation of the Riga ghetto in December 1941. His last words, directed apparently to the world at large, were "Shreibt un Farshreibt": Write and Record.

He could not have known how many would heed his admonishment. During the last three decades or so—ever since, say, the Eichmann trial—the study of the Holocaust has become a veritable industry. But, though innumerable people—scholars and laymen, victims and perpetrators, Jews and Gentiles—have recorded and are recording, the record is far from straight, and its message far from clear.

On April 19th, just a few weeks ago, a Roper poll reported that 22% of adults and 20% of high school students said that it was possible that the Holocaust, described as the Nazi extermination of Jews, never happened. Twelve percent of the adults and seventeen percent of the high school students said that they did not know. "What have we done" asked a stunned Eli Wiesel, "we've been working for years and years... I am shocked that 22%—Oh, my God." Perhaps as much to the point: What have they done? What have they been reading, watching, and listening to? A revised version of WW II?

So it seems. Revisionist history seems to have had a profound impact. The revisionists of the Holocaust fall broadly into three categories: (1) those who deny that the Holocaust ever happened; (2) the revisionists of ignorance or willful amnesia; and (3) those who seek to relativize or normalize the Holocaust, who see it as one of the many horrors of history or, more particularly of the twentieth century, which has had more than its share, who see the extermination of the Jews as attributable to "the fortunes of war" and Auschwitz ultimately not much different from, say, Stalin's Gulag or, in a real stretch, Hiroshima. Even if Holocaust revisionism is not exclusively anti-Semitic propaganda, as the recent ADL pamphlet Hitler's Apologists suggests, it is invariably pernicious.

The first and most famous—or, better, notorious—of those in the first category, is Arthur Butz, a NorthwesternUniversity professor of electrical engineering and computer science, whose 1976 book *The Hoax of the Twentieth Century* attacks "academic historians" and "established scholarship" for avoiding a truly dispassionate, critical examination of what he calls "the Holocaust hoax." According to Butz, the concentration camps held mostly people detained "for punitive or security reasons;" moreover, the professional historians who insist that the Holocaust happened were almost exclusively Jewish. Anything you read about the Holocaust, Butz implies, in then hopelessly biased and unreliable. Butz's scholarly apparatus is impressive; he documents his "case" with countless footnotes, appendices, plates, and diagrams, and a pseudoacademic style. Both the style and the method are exemplified by The Journal of Historical Review, which lists Butz as a member of its Editorial Advisory Board. Vol. I, No. 1 appeared miraculously in my mailbox shortly after I started teaching a course in the Holocaust at Colby in the early 80's. It is, to be kind, sorry stuff. Though both Butz and his disciples have been thoroughly discredited, even in courts of law, their influence has probably been significant.

Ronald Reagan is perhaps the most prominent among the revisionists of ignorance. In 1985, the fortieth anniversary of both the end of WW II and the liberation of the Nazi death camps, President Reagan planned to lay a wreath at the German military cemetery at Bitburg, which had recently been discovered to contain nearly 50 graves of soldiers in the Waffen SS. Reagan, in a question-and-answer session with the media on April 18, defends his Bitburg trip: "There is nothing wrong with visiting that cemetery where the young men [members of the SS] are victims of Nazism also... They were victims, just as surely as the victims in the concentration camps."

By the time Reagan gets to Bitburg on May 5, his speechmakers have tried to make amends. Speaking at the Bitburg Air Base after the ceremony in the cemetery, Reagan is conciliatory:

There are over 2,000 buried in Bitburg cemetery. Among them are 48 members of the SS. The crimes

see Revisionists page 8

NEWS

Holocaust Human Rights Center of Maine

Volume VIII No. 4 June 1993 Editor: Sharon Nichols

The Revisionists
by John Mizner

George Steiner tells the story of Simon Dubnow, the famous Jewish historian, who, aged 81, faced execution during the evacuation of the Riga ghetto in December 1941. His last words, directed apparently to the world at large, were "Shreibt un Farshreibt": Write and Record.

He could not have known how many would heed his admonishment. During the last three decades or so—ever since, say, the Eichmann trial—the study of the Holocaust has become a veritable industry. But, though innumerable people—scholars and laymen, victims and perpetrators, Jews and Gentiles—have recorded and are recording, the record is far from straight, and its message far from clear.

On April 19th, just a few weeks ago, a Roper poll reported that 22% of adults and 20% of high school students said that it was possible that the Holocaust, described as the Nazi extermination of Jews, never happened. Twelve percent of the adults and seventeen percent of the high school students said that they did not know. "What have we done" asked a stunned Eli Wiesel, "we've been working for years and years... I am shocked that 22%—Oh, my God." Perhaps as much to the point: What have they done? What have they been reading, watching, and listening to? A revised version of WW II?

So it seems. Revisionist history seems to have had a profound impact. The revisionists of the Holocaust fall broadly into three categories: (1) those who deny that the Holocaust ever happened; (2) the revisionists of ignorance or willful amnesia; and (3) those who seek to relativize or normalize the Holocaust, who see it as one of the many horrors of history or, more particularly of the twentieth century, which has had more than its share, who see the extermination of the Jews as attributable to "the fortunes of war" and Auschwitz ultimately not much different from, say, Stalin's Gulag or, in a real stretch, Hiroshima. Even if Holocaust revisionism is not exclusively anti-Semitic propaganda, as the recent ADL pamphlet Hitler's Apologists suggests, it is invariably pernicious.

The first and most famous—or, better, notorious—of those in the first category, is Arthur Butz, a NorthwesternUniversity professor of electrical engineering and computer science, whose 1976 book *The Hoax of the Twentieth Century* attacks "academic historians" and "established scholarship" for avoiding a truly dispassionate, critical examination of what he calls "the Holocaust hoax." According to Butz, the concentration camps held mostly people detained "for punitive or security reasons;" moreover, the professional historians who insist that the Holocaust happened were almost exclusively Jewish. Anything you read about the Holocaust, Butz implies, in then hopelessly biased and unreliable. Butz's scholarly apparatus is impressive; he documents his "case" with countless footnotes, appendices, plates, and diagrams, and a pseudoacademic style. Both the style and the method are exemplified by The Journal of Historical Review, which lists Butz as a member of its Editorial Advisory Board. Vol. I, No. 1 appeared miraculously in my mailbox shortly after I started teaching a course in the Holocaust at Colby in the early 80's. It is, to be kind, sorry stuff. Though both Butz and his disciples have been thoroughly discredited, even in courts of law, their influence has probably been significant.

Ronald Reagan is perhaps the most prominent among the revisionists of ignorance. In 1985, the fortieth anniversary of both the end of WW II and the liberation of the Nazi death camps, President Reagan planned to lay a wreath at the German military cemetery at Bitburg, which had recently been discovered to contain nearly 50 graves of soldiers in the Waffen SS. Reagan, in a question-and-answer session with the media on April 18, defends his Bitburg trip: "There is nothing wrong with visiting that cemetery where the young men [members of the SS] are victims of Nazism also... They were victims, just as surely as the victims in the concentration camps."

By the time Reagan gets to Bitburg on May 5, his speechmakers have tried to make amends. Speaking at the Bitburg Air Base after the ceremony in the cemetery, Reagan is conciliatory:

There are over 2,000 buried in Bitburg cemetery. Among them are 48 members of the SS. The crimes

see Revisionists page 8

Step 5. I now wax the masthead onto the mechanical. As I mentioned before, I had been provided with camera-ready art by the client. After I number the photos according to position, I'll be ready to send this to the printer.

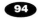

Step 6. The printer has created separate film output of all my text and halftones; here's a detail of the front of the combined film of the two. The pieces are joined with the help of a rubylith tape that will turn to black, like the rest of the film's background, when photographed.

Twelve-Page Newsletter

2

Board of Directors

Ragnhild Baade, *Teacher, Boothbay Regional H.S., Boothbay*
William D. Burney, Jr. *Mayor of Augusta*
Jed Davis, *Atty, Partner in Jim Mitchell and Jed Davis, P.A., Augusta*
Anna Gaméz Glass, *Student, Bowdoin College, Brunswick*
Roberta Kornfeld Gordon, *Bus. Writing Consultant, Cape Elizabeth*
Elisabeth Kalau, *Professor, University of Maine at Farmington*
Robert I. Katz, *Professor, University of Maine at Augusta*
Cecelia Levine, *Ex. Dir., Jewish Federation of So. Maine, Portland*
Burke Long, *Professor of Religion, Bowdoin College, Brunswick*
Michael Messerschmidt, *Attorney, Cape Elizabeth*
John S. Mizner, *Professor, Colby College, Waterville*
Merle Nelson, *Community Volunteer, Falmouth*
Nancy Schatz, *Physical Therapist, Augusta*
Harry Z. Sky, *Rabbi, Portland*
Jerry Slivka, *Survivor, Portland*
David Solmitz, *Social Studies Teacher, Madison H.S., Madison*
Walter Taranko, *Media Specialist, Maine State Library, Augusta*
Stephen Willis, *Businessman, Portland*

Honorary Board Members

Dorothy Levine Alfond, *Community Volunteer, Waterville*
The Honorable Joseph E. Brennan, *former U.S. Representative*
Senator William Cohen, *U.S. Senator from Maine*
Luba K. Gurdus, *Artist, Author and Survivor, New York*
Gerda Haas, *Survivor and Author, St. Louis Park, MN*
The Honorable John L. Martin, *Speaker of the House*
Leo G. Martin, *Commissioner of Education, Augusta*
The Honorable John R. McKernan, Jr., *Governor of Maine*
Senator George Mitchell, *U.S. Senate Majority Leader*
Joseph A. Nicholas, *former Indian Representative to the Maine State Legislature, Passamaquoddy Tribe*
J. Gary Nichols, *Maine State Librarian, Augusta*
The Honorable Olympia Snowe, *U.S. Representative from Maine*
Robert L. Woodbury, *Chancellor, U.M.S., Bangor*

✿ ✿ ✿ ✿ ✿

Sharon Nichols, *Executive Director*
Laura R. Petovello, *Program Director*

**HOLOCAUST
HUMAN RIGHTS CENTER
OF
MAINE
NEWS**

ISSN #0887-2945

R.R. 1 Box 825
Palermo, ME 04354

(207) 993-2620

Editor: Sharon Nichols
Logo: Conrad Ray

Printing & Layout:
Olsen's–Motherwit Press, Inc.
Searsport, ME
(207) 548-0160

Published four times annually:
March, June, September, December

Contents

Submission Information

Copy deadline: 10th of the month prior to publication. Submissions should be typewritten and double-spaced. They can also be sent on a 3 1/2 disk for the Macintosh® or Apple II or High Density for IBM®.

The views expressed herein are not necessarily the views of the editor or the HHRC.

3

President's Message

by Nancy Schatz, President of the Board

It's almost summer. I am recently returned from a heartwarming visit to Moscow to visit my son, returning in time for the Annual Meeting on May 2, 1993. In both instances, we were celebrating freedom, personal responsibility of today and remembering the lack of both from our quite recent past.

As Karl has invested his knowledge, integrity and hopefulness to his pursuit of understanding of another culture, its language and people, so have we, through the Holocaust Human Rights Center of Maine, pursued our goals of education and understanding. We address our friends, students, and the general public with information about the programs we present. The Holocaust combined with working to eliminate situations of prejudice and hate crim...

A student's letter to the editor, May ... es prejudice, hate crimes, bigotry. ... "just doesn't understand" how peopl... diced, because "it is so unfair", then ... the acknowledgment that there will ... world as long as parents teach their ... dice is acceptable. Our goal in the E... is to help dispel the inaccurate histo... tales, the tunnel vision of our parent... replace those with accurate knowledg... tools, and training seminars.

We are succeeding, slowly, to accomp... with the summer seminar teaching e... troduce and integrate teaching about... Human Rights to students of... generosity of our members has made...

The Multi-Cultural Group to Combat... strated the importance for the establi... logue about racial and religious issue... high and high schools. In August, 19... seminar will allow many students to... logue at the Diversity Leadership In...

at the University of Southern Maine. Those students who complete the weekend will have gained the insight and understanding needed to share and lead discussions about these delicate topics with their peers.

Also in August, the third Summer Seminar to educate teachers will be held at Bates College. Another week long seminar will be held at the University of Maine at Presque Isle. This demonstrates the coordination and cooperation of the Holocaust Center and the educational organizations of the State of Maine.

As we seem to make progress with our own objectives, I am reminded daily that the people of the world are still holding fast to xenophobic tendencies. While in Russia, I was reminded daily that bigotry and hatred were increasing when I saw swastikas on subway walls and hate graffiti on sidewalks. The Russians share similar ethnic problems in all its republics. Each insisting his own view is the most important.

While we invest our energies to understand and accept the cultures of Asians, African-Americans, Mexicans, and other immigrants to America, in Russia the borders are bulging with people from the neighboring Republics. There seems to be an ever present fear of the "new" members of any community, coupled with stories of "that" cultures hated idiosyncrasies.

Holocaust Human Rights Center of Maine

Volume VIII No. 4	June 1993	Editor: Sharon Nichols

The Revisionists
by John Mizner

George Steiner tells the story of Simon Dubnow, the famous Jewish historian, who, aged 81, faced execution during the evacuation of the Riga ghetto in December 1941. His last words, directed apparently to the world at large, were "Shreibt un Farshreibt": Write and Record.

He could not have known how many would heed his admonishment. During the last three decades or so—ever since, say, the Eichmann trial—the study of the Holocaust has become a veritable industry. But, though innumerable people—scholars and laymen, victims and perpetrators, Jews and Gentiles—have recorded and are recording, the record is far from straight, and its message far from clear.

On April 19th, just a few weeks ago, a Roper poll reported that 22% of adults and 20% of high school students said that it was possible that the Holocaust, described as the Nazi extermination of Jews, never happened. Twelve percent of the adults and seventeen percent of the high school students said that they did not know. "What have we done" asked a stunned Eli Wiesel, "we've been working for years and years... I am shocked that 22%—Oh, my God." Perhaps as much to the point: What have they done? What have they been reading, watching, and listening to? A revised version of WW II?

So it seems. Revisionist history seems to have had a profound impact. The revisionists of the Holocaust fall broadly into three categories: (1) those who deny that the Holocaust ever happened; (2) the revisionists of ignorance or willful amnesia; and (3) those who seek to relativize or normalize the Holocaust, who see it as one of the many horrors of history or, more particularly of the twentieth century, which has had more than its share, who see the extermination of the Jews as attributable to "the fortunes of war" and Auschwitz ultimately not much different from, say, Stalin's Gulag or, in a real stretch, Hiroshima. Even if Holocaust revisionism is not exclusively anti-Semitic propaganda, as the recent ADL pamphlet Hitler's Apologists suggests, it is invariably pernicious.

The first and most famous—or, better, notorious—of those in the first category, is Arthur Butz, a NorthwesternUniversity professor of electrical engineering and computer science, whose 1976 book *The Hoax of the Twentieth Century* attacks "academic historians" and "established scholarship" for avoiding a truly dispassionate, critical examination of what he calls "the Holocaust hoax." According to Butz, the concentration camps held mostly people detained "for punitive or security reasons;" moreover, the professional historians who insist that the Holocaust happened were almost exclusively Jewish. Anything you read about the Holocaust, Butz implies, in then hopelessly biased and unreliable. Butz's scholarly apparatus is impressive; he documents his "case" with countless footnotes, appendices, plates, and diagrams, and a pseudoacademic style. Both the style and the method are exemplified by The Journal of Historical Review, which lists Butz as a member of its Editorial Advisory Board. Vol. I, No. 1 appeared miraculously in my mailbox shortly after I started teaching a course in the Holocaust at Colby in the early 80's. It is, to be kind, sorry stuff. Though both Butz and his disciples have been thoroughly discredited, even in courts of law, their influence has probably been significant.

Ronald Reagan is perhaps the most prominent among the revisionists of ignorance. In 1985, the fortieth anniversary of both the end of WW II and the liberation of the Nazi death camps, President Reagan planned to lay a wreath at the German military cemetery at Bitburg, which had recently been discovered to contain nearly 50 graves of soldiers in the Waffen SS. Reagan, in a question-and-answer session with the media on April 18, defends his Bitburg trip: "There is nothing wrong with visiting that cemetery where the young men [members of the SS] are victims of Nazism also... They were victims, just as surely as the victims in the concentration camps."

By the time Reagan gets to Bitburg on May 5, his speechmakers have tried to make amends. Speaking at the Bitburg Air Base after the ceremony in the cemetery, Reagan is conciliatory:

There are over 2,000 buried in Bitburg cemetery. Among them are 48 members of the SS. The crimes

see Revisionists page 8

4

Professor Michael Marrus Speaks at the University of Maine
by David A. Zelz

The Minsky Lecture Fund, endowed by the Minsky family of Bangor, sponsored a very provocative lecture given at the University of Maine, Orono campus, on April 27, 1993. Michael Marrus, a professor of history at the University of Toronto and fellow of the Royal Society of Canada, presented his lecture, "Jewish and Polish Perceptions of Auschwitz." Marrus incorporated an historical perspective of the camp along with a discussion of some of the problems encountered with the preservation of the memory of Auschwitz and the Holocaust.

Auschwitz Birkenau has come to symbolize the atrocities of Nazi Germany. Man's inhumanity to Man is no better epitomized than in the crumbling ruins of this artifact of history. Built in 1940-41, the Auschwitz complex of Auschwitz, Auschwitz-Birkenau and Monowitz was intended for a variety of purposes. Auschwitz I, Marrus mentioned, was originally to house Polish political prisoners rounded up after the Nazi conquest of Poland. Later, Auschwitz-Birkenau was constructed with the intention of confining the infinite number of prisoners anticipated with the Nazi advance into the Soviet Union—Operation Barbarosa. Monowitz was a slave labor camp.

The complications, according to Marrus, arise with the historical interpretations and the resultant perspectives. Since the end of World War II, Marrus tells us, twenty million people have visited Auschwitz, 700,000 in 1991 alone. Marrus indicated that it is this camp that Poland and Jewish suffering converge. It is also at this camp that the perspectives fly asunder. Professor Marrus mentioned that the vast majority of visitors to the camp are Poles and that school children come on a regular basis. Poles visit because Auschwitz has come to symbolize their national suffering which, according to Marrus, has become a part of their national identity having been over run by the Nazis and then dominated by the Soviet Union. The Jews, on the other hand, view the camp in a somewhat different light. Their attitude is, no doubt, intensified by the fact that in on-site literature about the camp, in the Soviet records of the liberation, and in monuments at the camp, there is very little indication that, over all other camp victims, it was the Jews who were consciously singled out for destruction. During the fifty years since liberation, Marrus says, the Jewish presence has been continually down-played. Marrus indicated that Jews from all over Europe were imported to Auschwitz; whereas at Treblinka, for instance, mostly Polish Jews were persecuted. This being the case, Auschwitz-Birkenau has come to exemplify the suffering inflicted upon the Jews during the Nazi Holocaust. Ninety Percent of those who died in Auschwitz-Birkenau were Jews.

Combined with the differing perspectives of Auschwitz and the relative neglect of the fact that it was primarily Jews who were the victims of the atrocities, there are the present-day practical problems. Marrus mentioned that Poles lack many of the resources, specifically technology, to preserve the artifacts in Poland. The United States is seen to have limitless resources to dedicate to the memory of the Holocaust as exemplified by the recent opening of the Holocaust museum in Washington, D.C. This fact is troublesome to the Poles, according to Marrus. Furthermore, there is evidently concern over the possibility that with such state-of-the-art, multimedia museums like those in the United States, the memory of the Holocaust will be transferred from where the Holocaust actually occurred to a place of little relevance, like the United States, to the Nazi Holocaust.

Professor Marrus's lecture was well attended by many eager to hear about an event which will forever live in world history and which occurred, historically speaking, relatively recently. It is because of the work of scholars like Professor Marrus that we shall continually be reminded of the destructive capabilities of the human race and, thereby, learn to avoid that destruction.

The HHRC NEWS is underwritten in part by a generous gift from:

Mechanics Savings Bank

Local money serving local people since 1875

100 Minot Avenue, Auburn
Member FDIC Equal Housing Lender 🏠

Beyond the Walls
by Anita Charles

When I attended the HHRC summer ... ters last August, little did I kno... fects it would have on my life a... I went in seeking knowledge an... ideas. I came away feeling that ... nity of friends, a system of supp... ing of history and current event... yond the classroom walls.

As a teacher in the Alternative ... in Portland, a classroom for bri... who are "at risk" of dropping ou... I had not only a strong desire, b... velop a unit of study on the Hol... students. This conviction aros... had read and heard about that ... tory, but also from the relevanc... world and for young adults who ... their own quest for knowledge, ... ful events, and peace. It seeme... the Holocaust encompassed the ... can be and the best we can be a... of "never again" buzzed through my head as I frantically prepared materials and resources to use for the school year.

My first obstacle, after developing what looked like a workable and interesting year-long curriculum on Human Rights issues, was to find a way to obtain books. It seemed impossible, as I knew that the budget would not allow me to buy 20 copies of the four books on my "wish list"! (Two were to be used this year, two next year, as my curriculum cycles roughly through a two-year course of study.) I applied for a grant from HHRC, and, shortly thereafter, announced with joy to my class that we would, indeed, be studying the Holocaust, as the grant had come through for the purchase of all four books!

My next challenge was soon underway: to convey the material in a way that was responsible, complete and meaningful. We began with some history and numerous discussions about that period in history, the build up to the personal accounts we were soon to read. We read two short excerpts from books about the experiences of Jewish children, then "Night" by Elie Weisel, followed by "Seed of Sarah" by Judith Magyar Isaacson. The highlight of the unit was a visit to the classroom by Mrs. Isaacson. We also saw a movie and a short film. My students completed many worksheets, wrote many papers, and completed art projects, allowing them to

...Holocaust.

What about the far-reaching consequences for these young people? Their views of themselves and the world in which they live? Those lessons, too, are evidenced in their words:

Melanie M. wrote, in a letter to Mrs. Isaacson, "Knowing that you made it through everything gives me the hope and confidence that I can make it, too."

"I want to be able to sit down and let my son, when he gets old enough, know just how bad the Jewish people were treated." (Holly S.)

"I have learned that bigotry has no limits for either age, race, sex, ethnic background, sexual orientation... the list seems endless, and even as I wrote..., there are more and more hate crimes being committed against people the world over." (Raymond A.)

"I learned to look out in the world to see what's going on." (Rebecca W.)

"I've learned about how people will pawn their problems off on weaker people and punish them to make themselves feel strong." (Gerald D.)

see Walls page 13

Revisionists *continued from page 1*

of the SS must rank among the most heinous in human history. But other buried there were simply soldiers in the German army. How many were fanatical followers of a dictator and willfully carried out his cruel orders? And how many were on scripts, forced into service during the death throes of the Nazi war machine? We do not know. Many, however, we know from the dates on their tombstones, were only teenagers at the time.

True. Some of the teenagers, drafted in Hitler's last desperate attempt to stem the Allied advance, were doubtless "victims." Others buried there were, however, weren't. Or, if they were victims, they were willing victims: the executioners of Hitler's will. Unfortunately, Reagan's retraction did not garner headlines. And if Reagan really believed his earlier assertion, why shouldn't the American public be similarly deceived? Particularly those—the overwhelming majority—for whom the Second World War is as distant as Hastings or Waterloo?

The most prominent of these in my last category, the relativizers of revisionism, emerged in Germany in what is commonly known as the *Historikerstreit, liter-*

3. The majority of the German people were unaware of what was going on in Auschwitz. Scholars like Hilberg, who argue that perhaps two million people, from the administrators in Eichmann's office to the railroad timetable clerks, knew what was happening, don't understand modern societies. They don't realize the extent to which the extreme division of labor isolates people from the consequences of what they are doing.

4. German policies toward the Jews were to a certain extent justified. Since many partisans were Jews, the extermination of an entire people is a possible policy, justified in principle but carried out excessively. The Final Solution, then, could be considered an exaggerated form of the preventive suppression of partisans.

5. He makes some concessions to the view that the Final Solution never happened. Though this extreme view has heretofore been put forth only by scholars whose work had not been taken seriously, Nolte suggests that, since their motives are honorable, and since all opinions should be heard, we should listen to them. In this context, Nolte notes that most of those who have written about the Final Solution are Jewish. The implication is clear: most of the literature on Auschwitz is biased. We are, you see, back to Butz.

Evans reminds us what another German historian,

Quarterly Membership Update

Sustaining Members
Justice & Mrs. Louis Scolnik, Lewiston
I. Zaitlin & Sons, Inc., Biddeford
Benton Elementary School in honor of
Dr. Walter Ziffer
Gerda Haas, St. Louis Park, MN, Schild Memorial Fund
Bangor Theological Seminary in honor of
Dr. Walter Ziffer
Bruce & Nancy Schatz, Augusta
David & Beth Strassler, Kennebunkport
Cumberland County Child Abuse & Neglect Council
in honor of Judith Magyar Isaacson

Patrons
Joel & Sheri Otlstein, Lewiston
Cantor & Mrs. Kurt Messerschmidt, Portland
Alan Wainsberg, Cumberland Center
Dr. Julius Ciembroniewicz, Augusta
Lawrence High School in honor of Dr. Walter Ziffer
Winslow Junior High School in honor of Dr. Walter Ziffer
Sandi & Rick Lawrence, Albion

Supporting Members
Gemma F. Granger, Hallowell
Samuel & Ruth D. Small, Rockland
Dr. Barney Berube, Augusta
Mrs. Meredith R. Monte, Portland
Tanya & Greg Shapiro, Falmouth
Ms. Miriam Davis, Flushing, New York
JoAnn Oransky, Portland
eggy & Stephen Shapiro, Portland
Mrs. Martin Fleishman, Pittsburgh, PA
Rev. Landon Summers, Hampden
& Mrs. Benjamin L. Shapero, Bangor
artin & Elaine Hanish, Manchester
verly & Gerald Braustein, Portland
phanie & Alan Kumble, Rockport
& Mrs. Howard Miller, Waterville
Leo & Evelyn Elie, Lewiston
Harriet & Sid Katz, Augusta
olly Hock Dumaine, Mt. Vernon

Members
University of Maine, UMO Library
rtis Memorial Library, Brunswick
r. & Mrs. David Diamon, Portland
Bella Cowan, Saco
Jerry & Rochelle Slivka, Portland
Sally Regan, Rockport
Janice Doctor, South Portland
Dolly Hatfield, Stockton Springs
Ruth E. Ault, Wayne
Nancy Bogg, Casper, WY
ami Naierman, Chevy Chase, MD
Jeffrey S. Baron, Natick, MA
David A. Zelz, Bangor
Mrs. Lewis L. Levine, Waterville
Rhoda Boughton, Vinalhaven

Rita M. Kissen, Peaks Island
Bella Zimelman, Portland
Beatrice E. Schatz, Portland
Paula Hegyi, Portland

With best wishes in honor of
Sara Supnorte's 90th birthday
from Andy & Linda Brenner and baby Rachel,
Katonah, NY

Arno & Ethel Fleisher's 50th wedding anniversary
from Marion Goodman, W. Palm Beach, FL

Mrs. Dorothy Levine Alfond's birthday
from Mrs. Herbert C. Lee, Palm Beach, FL
Elaine Milstein & Ethel Schiff, Palm Beach, FL

Beatrice M. Flaschner's 71st birthday
from her daughter, Wendy, Readfield

Nancy Schatz' Bat Mitzvah
from Connie McDonald, Barbara Livingston, Nancy Kelly,
Nancy Frates & Dean Paterson
Sharon & Gary Nichols
Jerry & Rochelle Slivka

In Loving Memory of
Elizabeth Sax
from Jerry & Rochelle Slivka, Portland
Samuel E. Shatz, Portland
Richard & Judith Slivka, Palermo
Linda & Douglas Findlay, Winthrop
Stephen & Paige Russell, E. Winthrop
Mr. & Mrs. Oscar P. Gottschalk, South Portland
Schatz Fletcher & Associates, Augusta
C. Lila Segal, Winthrop
Irene D. Slosberg, Lowell, MA
David & Ethel Koscher, Portland
Charles & Laura Rothstein, Augusta
David & Barbara Turitz, Portland
Constance McDonald, Augusta
Dorothy Schepps, Austin, TX
Warren & Barbara Winslow, Augusta
Samuel and Harriet Hillson, Harvey, LA
Gail & Richard Schade, Augusta
Judge Franklin N. Slaccher
from his daughter, Wendy, Readfield
The Victims of the Holocaust from
Bangor Theological Seminary
Bonnie Moore
from Edward B. Goget, Prescott, AZ
Bertha Poisson
from Lyn & Sam Slosberg, Gardiner

Special Thanks To
The Jewish Federation of Bangor
for their generous gift.

Joint Program On Hate Crimes, Intolerance And Prejudice

The Maine Department of the Attorney General and the Holocaust Human Rights Center have developed a joint effort to offer Maine schools assistance in the planning and implementation of programs aimed at both increasing awareness and reducing the incidence of intolerance, prejudice and hate. Specifically, with a grant from the Maine Community Foundation, the Holocaust Human Rights Center and the Department of the Attorney General have retained the services of an educational consultant to train volunteers from the Holocaust Human Rights Center on the variety of approaches to teaching students at elementary, middle and high school levels about the issues of intolerance and prejudice. These trained volunteers are prepared to travel to schools throughout the State to meet with administrators, teachers, parents and students to help develop and (if requested) help implement programs on this important issue. These programs can vary from day-long school-wide presentations, to one-hour discussions addressing particular problems in particular class rooms. Additionally, the consultant has trained a group of Maine high school students who are available to work with our trained volunteers.

This program is provided at no cost to any Maine school. Any Maine school seeking information on this program should call the Civil Rights Unit at the Department of the Attorney General—626-8844. At the request of any school, the Civil Rights Unit will link you up with a trained volunteer facilitator who will work with your school in developing a program on intolerance, prejudice, and hate crimes.

> If you are interested in underwriting the cost of the HHRC News, please contact the editor at 993-2620.

Judith Magyar Isaacson

Isaacson Receives Award

The Deborah Morton Award was given to Judith Magyar Isaacson, author of *Seed of Sarah*, at Westbrook College's May 22 Commencement. The Deborah Morton Award honors the memory of Miss Deborah Morton of Round Pond, valedictorian of the 1879 class of Westbrook Seminary — forerunner of Westbrook College. The Award is presented by the Trustees of Westbrook College to outstanding women who, in the spirit of Miss Morton, have achieved high distinction in their careers or whose leadership in civic, cultural or social causes has been exceptional.

In presenting the award, President William Andrews stated: "In your career as teacher and then author — and in your continuing career as wife, mother, and grandmother — you have brought to bear the same persistence, optimism and faith that made you a survivor of the Holocaust. Your life and words inspire others, not just these facing catastrophe, but those facing the daily challenges that also call for the strength and positiveness that have characterized you."

An HHRC member and supporter, Isaacson is much in demand as a spenker on the Holocaust in Maine and elsewhere. This spring she also spent four days in Chicago lecturing at the Anne Frank Exhibit and numerous high schools. She was the keynote speaker at the Chicago Cultural Center on April 24, and at the DARE TO DREAM...AND MAKE IT REAL: A Conference for Teens in Foster Care, on June 5 in Portland.

Isaacson served on the boards of the Auburn Public Library, Kent's Hill School, Central Maine Medical Center, and Bowdoin College.

Rochelle Blechman Slivka

Yom HaShoah Statewide

Day of Remembrance observances were held this spring from Portland to Caribou. Yom HaShoah, the Day of Remembrance, sponsored by the Holocaust Human Rights Center was observed on April 18 at the University of Maine at Augusta with Rochelle Blechman Slivka as the keynote speaker. Mrs. Slivka, who lost most of her family in the Holocaust, has spoken to hundreds of school children about her experiences and the effects of prejudice.

Others on the program were guest speaker Professor Glenn Miller, Bangor Theological Seminary, who discussed what the Church has learned from the Holocaust. Representative Susan Dore, Auburn, read the legislative proclamation in memory of the victims of the Holocaust. The program included a beautiful musical tribute by Sarah and David Polisner, children of Dr. and Mrs. Bruce Polisner and grandchildren of Cantor and Mrs. Kurt Messerschmidt.

An evening observance co-sponsored by the HHRC and the Jewish Community Center was organized by Susan Harkins and Barry Freedman, executive director of the Jewish Community Center. The community observance was held at the Woodsford Church in Portland.

Later in the month, Mrs. Slivka spoke at Caribou High School's Day of Remembrance commemoration and Mr. Slivka also spoke briefly. Sponsored by the Social Studies Department and the Student Council of Caribou High School, Mrs. Slivka spoke to over 900 students, teachers and the public from throughout Aroostook County. The Social Studies Department staff and members of the Student Council joined the Slivka's for a dinner in their honor. A reception followed at the home of Lou and Ron Wiley.

Training Programs for Superintendents and Principals

The Department of the Attorney General and the Holocaust Human Rights Center conducted civil rights and tolerance training for Maine's elementary and secondary school administrators, teachers and students. The importance of addressing intolerance, prejudice and hate by training both educators and students has been clear for some time. What has not been clear is the severity of the problem of hate crimes and the extent to which it involves students as perpetrators.

Funded by a grant from the Maine Community Foundation, nine regional training programs were held with Betsy Sweet, Educational Consultant, as facilitator. The training programs presented a summary of some of the hate crime and civil rights complaints, which involved grades 2 through 12, filed with the Civil Rights Unit of the Attorney General; guidelines for superintendents and principals; and dialogue with students from the Diversity Leadership Institute.

Summer Seminars

There is still time to register for the Annual Summer Seminars at the University of Maine at Presque Isle, July 18-23, and Bates College, August 8-13. This is an intensive five and one-half day residential seminar. The following evening events (7:00 p.m. to 9:00 p.m.) are open to the public at no charge:

University of Maine Presque Isle July 18-23 7–9 pm
Mon. Dr. Walter Ziffer, Holocaust Survivor
Tues. Robert Katz, artist and HHRC board member
Wed. Rochelle and Jerry Slivka, Holocaust Survivors
Thurs. Charles Rotmil, Hidden Child during the
Holocaust

Bates College August 8-13 7–9 pm
Mon. Elisabeth Kalnz, discusses *Poisen in my roots:
Nazi Germany remembered*
Tues. Judith Magyar Isaacson, Holocaust Survivor
and author of *Seed of Sarah*
Wed. Robert Katz, artist and HHRC
board member
Thurs. Charles Rotmil, Hidden Child during the
Holocaust

For information call: Laura Petovello, 287-5620

Here's a portion of the finished product, ready to be labeled and mailed. Sharon is happy, and we can look forward to sharing another pot of coffee in 3 months.

Annual Meeting

Rebecca Hershey

The Eighth Annual Meeting of the Holocaust Human Rights Center of Maine took place on May 2 with Dr. Marion P. Pritchard as the keynote speaker. Pritchard vividly described her life under Nazi rule and her work in the underground to save Jews during World War II.

Michael Messerschmidt presented the Take a Stand Award to Peter E. O'Donnell, Portland City Councilor, for his courage in sponsoring and fighting for Portland's Human Rights Ordinance despite intense and sometimes violent opposition to equal rights for lesbians and gay men

Patty Gordon and Pat Stanton received the Volunteer of the Year Awards for their many hours working with the Multi-Cultural Group to Combat Bias and the Diversity Leadership Institute participants.

Sally Lerman reported on her participation in the Diversity Leadership Institute and recent programs.

Martin Luther King Day breakfast in Portland, and a workshop with Students Organized Against Racism (SOAR) — a college organization with members who share many of our goals.

Those of us who have carried the message in this way have received more than we have given. Some of us have made new contacts with our own ethnic origins. Others have become less passive about accepting the victimization that often accompanies extreme minority status in a state like Maine.

This is not substantial progress, but it is progress. It's a beginning. Because it is very important to all of us to understand that the prejudice and insensitivity some of us face on a daily basis is our problem only if we come to accept it or let it defeat us. It is inherently a problem of those in the majority who act out their prejudices.

To say that diversity is not a factor in one's life is ignore the very principles on which this country was founded and continues to thrive. Our growth as a nation has been enriched by many cultures and with our cooperation it will continue to do so. We must learn to *value* our differences, not just tolerate or deal with them.

Some families transmit their attitudes of the majority being better than the minority through misinformation, hostile comments or total omission. Young people are sometimes taught, intentionally or unintentionally, that anything or anyone foreign is a threat, or inferior to what is American. Students, teachers, and parents, have often filtered out any positive information about the said minority. For example, except for a mention of slavery, Martin Luther King day and sometimes the Civil Rights marches, little information is available on the necessary parts which people of color play throughout American history, and in every part of American life today.

Some people may wonder why an organization with Holocaust in its name would bother worrying about the plight of oppressed people who are not Jewish. As someone who is Jewish, African-American, Mexican, and Native American, and who identifies with her friends who might be oppressed because they are homosexual, Asian, or Franco-American, I can tell you, I have never wondered this. I know that so long as a single individual is oppressed we have not, as compassionate human beings, concluded the fight against all which we denounce.

see Hershey page 14

Diversity Leadership Institute

My name is Rebecca Hershey. I'm a junior at Maranacook Community School. My background includes African-American, Jewish, Hispanic, Native American and Creole. I identify with all of these, and I believe that these and many other cultures are what make up America, and that anyone who lives within its boundaries is indeed American.

Our organization was first established last August with a three day conference held at the University of Maine's Farmington campus. There were about 35 students from a number of high schools in Maine.

It was a weekend of discovery and exploration. We went to workshops, had discussions, and generally sought to explain our own backgrounds while learning about the backgrounds of others. We shared our reasons for attending and intentions for the future; reaching the conclusion that we had come together as a result of a common interest; to not only battle racism but find out what we had to offer — within ourselves as well as to those around us.

We resolved at the end of the weekend to make it just a start. We said that we would continue to talk to each other and try to carry the message forward, spreading the work that our differences were not defects, but complementary to our characters. In fact, thanks to the Portland Police Department, the Multi-Cultural Group to Combat Bias, and the Holocaust Human Rights Center of Maine, about 20 of us have kept our resolution.

Since last summer we have met regularly in Portland and Augusta, and have conducted and participated in special programs, including meetings with the Brunswick and Portland Racial Harmony groups, the NAACP

Creating a Brochure or Booklet

Chapter Three
More Good Ideas

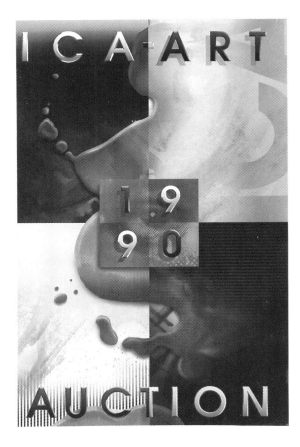

Whether you're working with black copy on white bond or four-color illustrations and fuschia text on 80-pound chartreuse coated stock, or whether you're designing a flyer for your church bake sale or a catalog for an upscale furniture company, your goal is the same—to use the right text, the right illustrations and the right amount of white space, while still communicating your message to the piece's recipient.

The pieces in this section illustrate many different ways to do this. Each one uses typeface, white space, and illustrations of one sort or another to properly pull together each client's message.

Look carefully at each piece in this section to see what makes it successful. But don't stop here—when you're perusing your mail, when you're visiting your travel agent, when you're at the mall or in a restaurant, a great brochure or booklet may cross your path. Examples of great design, examples you can learn from, are everywhere. Stay alert, and stay open. And pretty soon, you'll be creating printed pieces that will stop somebody in their tracks—and maybe inspire them too.

See what other designers are doing with brochures and booklets.

 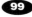

More Good Ideas

This brochure uses gray-purple and pale yellow ink, with forest green accents, to showcase the work of the illustrators included. These muted colors don't compete with the illustrations showcased, the way bright ink colors, or even standard black, would. Notice how balanced the layout is, with the headlines on each page perfectly counterpointing each other and with none of the illustrations overpowering the others.

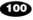

SCRAPBOOK

MIDLAND
100
IRON & STEEL

This booklet, printed in brown ink on light tan recycled paper, details the history of an iron and steel company. What could have been a dry subject is made more accessible by the use of these warm colors of ink and paper; these, along with the use of old photographs, script captions and woodcut illustrations, make the scrapbook concept come to life. Large typeface and wide leading make the text inviting and easy to read; balanced layouts with just the right amount of white space make the booklet flow smoothly.

1 9 4

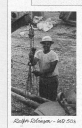

Ralph Robinson – late 50's

Midland also became involved with scrapping 26,000 machine guns for the Arsenal. It took about two weeks to get permission from the government to bring one gun to the Midland yard as an experiment. After proving their machine could cut the weapon effectively, a Midland crew went to the Arsenal to cut up the other guns. Each morning the Midland crew would wait for the Captain and his Arsenal crew to arrive and hand the guns over to be cut.

Besides tanks and machine guns, Midland disassembled all the street cars in the Tri-City area, as well as over 1,000 Rock Island Line rail cars. For the latter, a burning track was created which burned off the wood, allowing the crews to cut up the entire car. One of the presses was used to take the wheels off the axles. Then the wheels, axles and iron were all sold separately.

In the early 50's both Louis and Irving passed away. Al became president and Hank Davis, Louis' grandson, became vice president.

1950: The Korean War began.

Wages were up 130% from 1939. Buying was up only 35%.

1951: The first commercial color TV broadcast was presented by CBS.

1952: Rocky Marciano knocked out Joe Walcott.

1953: U.S. steel production was up 117,500,000 short tons a year.

General Electric Company announced that all communist employees would be discharged.

1954: U.S.S. Nautilus, the first atomic powered submarine was commissioned.

Macomb bridge demolition – early 50's

W W I I

1940: The Centennial Bridge opens.

Franklin D. Roosevelt was elected president.

The PGA golf tournament was won by Byron Nelson.

1941: Japanese attacked Pearl Harbor.

An embargo on shipments of scrap iron to Japan was ordered by President Roosevelt.

Germany and Italy declared war against the U.S.

Joe DiMaggio's hitting streak ended at 56 consecutive games.

1942: The World heavyweight boxing champion was Joe Louis.

The War Production Board was established.

1943: Over 26,000,000 tons of iron and steel scrap were collected for industries.

1944: D-Day. The invasion of Normandy.

Guam fell to the U.S. forces.

Paris was liberated.

The NFL championship was won by the Green Bay Packers.

1945: Germany and Japan were forced to accept unconditional surrender.

Hiroshima was destroyed by the first atomic bomb used in war.

Rationing of shoes, tires and meat were ended.

On December 7, 1941 the Japanese bombed Pearl Harbor, and the next day the United States declared war. During those early days President Roosevelt asked all the implement dealers in the country to hold a scrap drive to support the war effort. As Farmall's scrap supplier, Midland became involved.

Irving along with Connie Schadt, Midland's yard foreman at the time, visited the farmers and International Harvester dealers in six towns on the Burlington Railroad line to talk about how to organize the drive. It was decided a two-day scrap drive was necessary. Midland ordered railroad cars in all the participating towns, while Connie and another Midland employee directed the loading of the rail cars. The farmers were instructed to bring their scrap to the towns' grain elevators for loading. Since Midland would be paying for the scrap, it was decided a central checking account should be established at a Monmouth bank with the grain elevator operators in each town writing checks off the account.

The drive was a success with about 80 rail cars full of scrap being collected and no cheating on the communal checking account.

THE GREAT SCRAP DRIVE

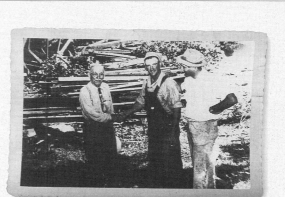

Louis Livingston, demolition contractor, Hank Davis – Blowing up a Macomb, Il bridge – early 50's

 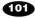

More Good Ideas

Beef

Veal

T.F. Kinnealey & Co.

T.F. Kinnealey's clean, modern plant houses the entire fabricating operation under one roof. Since 1950, we've had continuous, on-site government inspection (Establishment No. 272) to insure the highest standards throughout the manufacturing process. We take pride in fulfilling custom orders with care and consistency. At the portioning bench, 15 skilled butchers fabricate exactly to specification, portioning all cuts to within a tolerance of one-half ounce.

1. Steak Ready Tenderloin—Side Runner On
Prepared from MBG #189A by removing all ridge fat, all loose tissue on the back and all silver skin.

2. Tenderloin Steaks—Side Runner On
Portion steak cut to within a ½ oz. tolerance and a diameter of not less than 2⅜".

3. Steak Ready Tenderloin—Side Runner Off
Prepared from MBG #190A. The same final preparation as above except the side runner is removed from the entire length of the tenderloin.

4. Tenderloin Steaks—Side Runner Off
The ultimate hand cut steak (filet mignon) is cut to within a ½ oz. tolerance and a diameter of not less than 2⅜". Completely fat free.

At the main bench, we break and prepare the primal cuts of beef and lamb to roast ready products, then vacuum pack and inventory them prior to shipping. State-of-the-art equipment and straight-line production techniques provide for accurate and consistent orders throughout the fabrication provide yield figures for customers determine exact food

1. Chop Re
Produced from "Cla removing the blade and removing the chine bone and the rack to 2" from

2. Rib Ve
Regular portion cut or (with all the rib meat

3. Rib
"Classic" eye cut from trimmed of all bone and left intact. Unique for

4. Veal M

5. Top Round Trimmed
Produced by deveining, as in Sc

6. Center Cu

Full-page photos, each opposite an explanatory page with lots of white space, do well to let prospective customers know what they can order. The red rules on the text pages echo the heads on the photo pages, providing balance and continuity, as does the alternating of sides for each type of page.

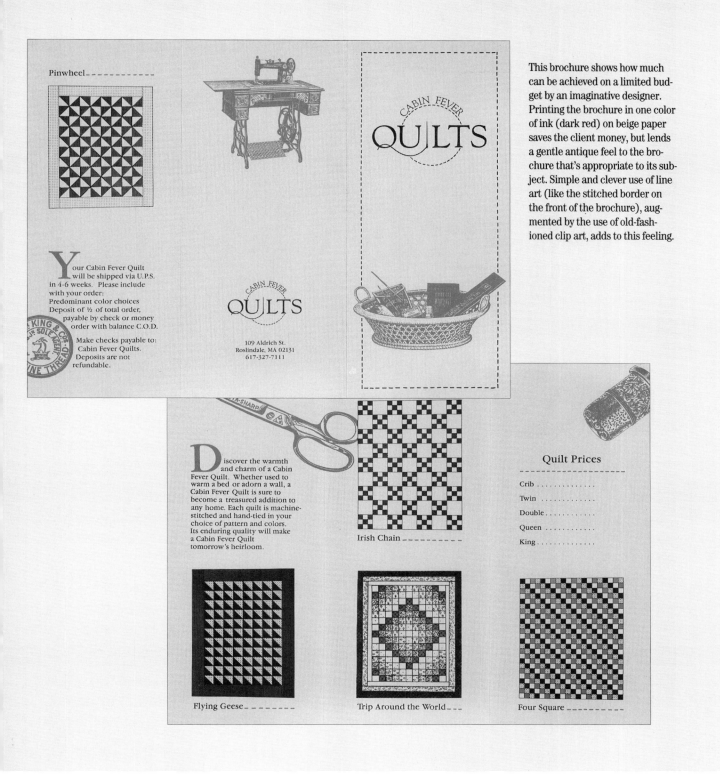

This brochure shows how much can be achieved on a limited budget by an imaginative designer. Printing the brochure in one color of ink (dark red) on beige paper saves the client money, but lends a gentle antique feel to the brochure that's appropriate to its subject. Simple and clever use of line art (like the stitched border on the front of the brochure), augmented by the use of old-fashioned clip art, adds to this feeling.

More Good Ideas

This booklet, a very simple and straightforward piece, is designed to disseminate investment information internally as opposed to convincing clients to invest more. The statistics regarding the various funds are charted on the page with a narrative surrounding it. The typefaces used for the body and the heads are consistent throughout.

PaineWebber

MUTUAL FUNDS

Portfolio Managers' MESSAGE

Winter 1992

PW Dividend Growth Fund—up 35.34% in 1991 vs. 30.40% for the S&P

PW U.S. Government Income Fund—an 11.16% average annual return since inception

PW Short-Term Global Income Fund—rates on average are 135% higher overseas

For Internal Use Only

Mitchell Hutchins

NEW YORK TAX-FREE INCOME FUND

The New York market came under year-end pressure with a heavy calendar of New York issues, which came at the same time as a heavy general municipal calendar. In addition to this supply pressure, nagging credit concerns about New York State and its budget further stressed the market. On the other hand, these distressed levels have been viewed by many national funds as presenting buying opportunities. The credits are paying attractive interest rates and the opportunity for relative price appreciation is strong. The rela-

OBJECTIVE: High current income exempt from Federal, New York State and New York City taxes

INFO:	PWMF	Weekly Notes: PWMF.PERFORM
Quotron Symbol:	Class A: PNYAX.Q	Billing Symbol: Class A: MFNYTA
	Class B: PNYBX.Q	Class B: MFNYTB

| NAV (Class A): | 12/31/91: $10.22 | Net Assets: | 12/31/91: $40.3 million |
| NAV (Class B): | 12/31/91: $10.22 | | |

TOTAL RETURNS THROUGH 12/31/91*

	Class A	Lipper** NY Muni	Lipper Rank
Latest 12 months	12.77%	12.97%	30/47
Since inception (9/23/88)***	33.25		

	Class A	Class B		Class A	Class B
SEC Yield (12/91):	6.50%	6.01%	Dist. Rate (12/91):	5.81%	
Last Div. Paid (12/91):	$0.0515	$0.0456	Last Cap. Gain Paid:	N/A	N/A
Total Div. 1990:	$0.6806	N/A	Total Cap. Gain Paid 1990:	N/A	N/A

 * Performance calculated by Lipper method, which differs from returns investors may receive.
 ** Data for the 12-month period is for the Fund's specific peer group, as defined by Lipper.
 *** Since inception total return is calculated by PaineWebber, not by Lipper.

PORTFOLIO RATINGS MIX (12/31/91)

Cash & AAA	26%
AA	31
A1, A+	10
A	28
BBB	5
TOTAL	100%

INDUSTRY DIVERSIFICATION (12/31/91)

University	23%
Power	12
Water	13
Sales Tax	9
G.O.	10
Tolls	8
Health	8
Resource Recovery	7
Other	10
TOTAL	100%

APPROXIMATE WTD. MATURITY: 22 YEARS

, although at the time of this assured.

...king at projected deficits as it city has been more successful ...dget gaps. It has balanced its

books every year since 1980. It is looking at budget shortfalls totalling $7 billion over the next five years. The details of how the administration plans to close these gaps are still in the formative stage. It is expected that vigorous action will be necessary to continue balancing the annual budgets.
—Greg Serbe

ATLAS GLOBAL GROWTH FUND

While we may be near the trough in short rates in the United States, that is not the case overseas. The Bank of Japan eased monetary policy twice during the fourth quarter. However, we expect further monetary easing in 1992 as well as fiscal stimulation to keep that economy growing. Similarly, German rates are at historically high levels and should fall in 1992 as that economy slows from last year's vigorous growth to a more sustainable growth rate. This should allow the other members of the European Monetary System to lower their rates further and accelerate their economic growth rates in 1992.

The Fund's portfolio strategy follows from our analysis of monetary policies around the world. We have raised the Fund's allocation to Japanese equities to roughly 20% of assets. Recently, the Bank of Japan eased bank reserve requirements. We expect them to follow this step with additional easing measures in the near future. Lower interest rates should sustain higher valuations and economic activity in Japan.

We increased the Fund's weight in German equities to 11% of assets late in autumn of 1991. Along with Japan, we think that Germany has the most room to reduce interest rates over the medium term. We believe that, by the middle of next year, German interest rates will be substantially lower than they are now. This should help the economy maintain a more sustainable pace of growth

OBJECTIVE: Long term capital appreciation

INFO:	PWMF	Weekly Notes: PWMF.PERFORM
Quotron Symbol:	Class A: PAGAX.Q	Billing Symbol: Class A: MFAGGA
	Class B: PAGBX.Q	Class B: MFAGGB

| NAV (Class A): | 12/31/91: $13.93 | S&P 500: | 12/31/91: 417.09 |
| NAV (Class B): | 12/31/91: $13.91 | Net Assets: | 12/31/91: $215.3 million |

TOTAL RETURNS THROUGH 12/31/91*

	Class A	Lipper** Global Avg.	CWI	Lipper Rank
Latest 12 months	9.42%	19.54%	18.29%	9/10
Latest 5 years	52.74	60.49	63.92	4/7
Since inception (12/30/83)***	237.72			

	Class A	Class B		Class A	Class B
Last Div. Paid (12/91):	$0.1982	$0.1659	Last Cap. Gain Paid:	$0.636 (10/90)	N/A
Total Div. 1990:	$0.8052	N/A	Total Cap. Gain Paid 1990:	$0.636	N/A

 * Performance calculated by Lipper method, which differs from returns investors may receive.
 ** Data for the 12-month period is for the Fund's specific peer group, as defined by Lipper.
 *** Since inception total return is calculated by PaineWebber, not by Lipper.

COUNTRY ALLOCATION (12/31/91)

U.S.	24.2%
Europe	29.4
Japan	20.1
Other	17.0
Foreign Bonds	0.8
Cash	8.5
TOTAL	100.0%

TOP TEN PORTFOLIO HOLDINGS (in alphabetical order as of 12/31/91)

1. Allianz AG (Germany)	6. Federal National Mortgage Assoc. (U.S.)
2. Chambers Development (U.S.)	7. Seven-Eleven (Japan)
3. Comcast Corp. (U.S.)	8. Wal-Mart Stores (U.S.)
4. Daiwa House IND (Japan)	9. Waste Management Inc. (U.S.)
5. Deutsche Bank AG (Germany)	10. Waterford Wedgewood (Ireland)

APPROXIMATE NUMBER OF SECURITIES IN PORTFOLIO: 123

after the initial burst of activity generated by reunification has passed.
—Nimrod Fachler/Ellen R. Harris

FUND

...of the growth...and cumul-
...ues to focus on companies that can show growth, either in earnings or cash flow or asset value. The portfolio mix is determined by the investment merits of the individual companies, with little regard to industry weightings or market capitalization. As a result, the Fund tends to own stocks of companies of all sizes and in several different industries.

1991 was a good year for the Fund, with almost all investments contributing to the outstanding performance at one time or another. Based on our overall economic outlook, we see little reason to change the strategy at this juncture. However, there will continue to be some changes in the individual securities that are owned.

With the rash of new issues in 1991, there were several interesting companies that are now in the hands of the public. Our strategy with regard to new issues is fairly basic—we meet with management and make an assessment of their capabilities; we analyze products or services; and we do as much as we can with the financials. From this, we make an estimate of when we think the next several years and when we set valuation targets. If a new issue is reasonably priced, we are likely to buy it. If not, we will let it go by, even though it may work out well. During 1991, we added several new names to the portfolio on new issues — Genelabs, Immunomedics, Rogers Cantel, Right

OBJECTIVE: Long term capital appreciation

INFO:	PWMF	Weekly Notes: PWMF.PERFORM
Quotron Symbol:	Class A: PGRAX.Q	Billing Symbol: Class A: MFGROA
	Class B: PGRBX.Q	Class B: MFGROB

| NAV (Class A): | 12/31/91: $18.53 | S&P 500: | 12/31/91: 417.09 |
| NAV (Class B): | 12/31/91: $18.47 | Net Assets: | 12/31/91: $131.3 million |

TOTAL RETURNS THROUGH 12/31/91*

	Class B	Lipper** Growth Avg.	S&P 500	Lipper Rank
Latest 12 months	47.76%	36.01%	30.40%	10/43
Latest 5 years	129.50	89.16	104.48	7/27
Since inception (3/18/85)***	192.99			

	Class A	Class B		Class A	Class B
Last Div. Paid (12/91):	$0.0072	$0.0037	Last Cap. Gain Paid:	$0.6003 (12/91)	N/A
Total Div. 1990:	$0.1650	N/A	Total Cap. Gain Paid 1990:	$0.6003	N/A

 * Performance calculated by Lipper method, which differs from returns investors may receive.
 ** Data for the 12-month period is for the Fund's specific peer group, as defined by Lipper.
 *** Since inception total return is calculated by PaineWebber, not by Lipper.

PORTFOLIO WEIGHTINGS (12/31/91)

Equities	84.3%
Cash	15.7
TOTAL	100.0%

TOP TEN PORTFOLIO HOLDINGS (in alphabetical order as of 12/31/91)

1. Centex Telemanagement Inc.	6. Staples Inc.
2. Chiron Corp.	7. TeleCommunications Inc.
3. Duty Free International Inc.	8. Time Warner
4. Elan Corp. (ADS)	9. Wal-Mart Stores Inc.
5. Federal National Mortgage Assoc.	10. Waste Management Inc.

APPROXIMATE NUMBER OF SECURITIES IN PORTFOLIO: 68

Start— to name a few.

Our objective is to provide above-average capital appreciation, but not at the expense of extreme volatility. As a result, we do have an eclectic mix of names, but over the long run, they help us achieve our goals.
—Ellen R. Harris

REGIONAL FINANCIAL GROWTH FUND

During the past quarter, performance of stocks in the financial sector has been mixed. That is, though investors have been enthusiastic about the potential benefits of continued consolidation in the banking industry, the worrisome economic outlook has dampened investor sentiment toward the group.

The Fund benefited directly from the announced combination of two Michigan banks, Comerica and Manufacturer's National, a transaction that offers considerable cost-saving potential due to the banks' overlapping markets. Other, smaller combinations in the Midwest indirectly contributed to the Fund's performance, due to its substantial exposure in the region.

Looking forward, we foresee two trends unfolding. First, we expect the consolidation among financial institutions to continue into 1992. The broad implications are for enhanced productivity for the institutions that remain. Second, our belief is that as 1992 unfolds, asset quality trends should continue to improve at a gradual pace and loan demand should slowly reaccelerate. Hence, we see opportunities for earnings growth in the sector and will look for such investments at attractive values.
—Karen L. Finkel

OBJECTIVE: Long term capital appreciation

INFO:	PWMF	Weekly Notes: PWMF.PERFORM
Quotron Symbol:	Class A: PREAX.Q	Billing Symbol: Class A: MFRFGA
	Class B: PREBX.Q	Class B: MFRFGB

| NAV (Class A): | 12/31/91: $12.55 | S&P 500: | 12/31/91: 417.09 |
| NAV (Class B): | 12/31/91: $12.56 | Net Assets: | 12/31/91: $45.7 million |

TOTAL RETURNS THROUGH 12/31/91*

	Class A	Lipper** Financial	Lipper Rank
Latest 12 months	65.46%	60.64%	3/6
Latest 5 years	81.28	78.15	5/6
Since inception (5/22/86)***	62.71		

	Class A	Class B		Class A	Class B
Last Div. Paid (12/91):	$0.1120	$0.0640	Last Cap. Gain Paid:	$0.2265 (6/87)	N/A
Total Div. 1990:	$0.2410	N/A	Total Cap. Gain Paid 1990:	N/A	N/A

 * Performance calculated by Lipper method, which differs from returns investors may receive.
 ** Data for the 12-month period is for the Fund's specific peer group, as defined by Lipper.
 *** Since inception total return is calculated by PaineWebber, not by Lipper.

PORTFOLIO WEIGHTINGS (12/31/91)

Eastern	20.0%
Southern	7.3
Midwest	30.1
Western	21.6
Finance	14.2
Financial Service	2.1
Money Center	2.7
Cash	2.0
TOTAL	100.0%

TOP TEN PORTFOLIO HOLDINGS (in alphabetical order as of 12/31/91)

1. Bancorp Hawaii, Inc.	6. Mercury Finance Co.
2. Charter One Financial, Inc.	7. Republic New York Corp.
3. Federal Home Loan Mortgage Corp.	8. Student Loan Marketing Assoc.
4. Federal National Mortgage Assoc.	9. U.S. Bancorp (of Oregon)
5. Mercantile Bancorporation Inc.	10. Wilmington Trust

APPROXIMATE NUMBER OF SECURITIES IN PORTFOLIO: 54

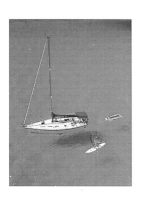

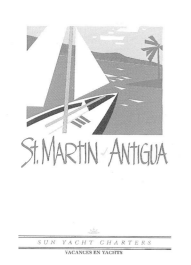

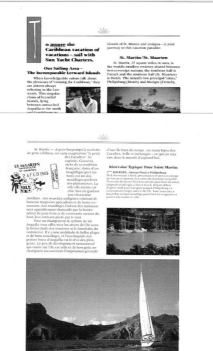

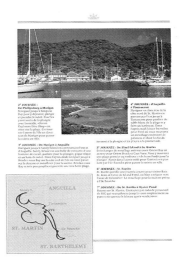

These booklets, one version in English and one in French, contain a lot of information. The text is very nicely balanced with well-chosen photographs and just the right amount of text and white space, and the consistent use of double rules, the rising sun logo and the hand-lettered decorative caps reversed out of various colors keep the pages "going with the flow." The inside cover is printed with a light-yellow palm-tree pattern, which subtly warms up the otherwise white pages without cluttering them too much. A pocket in the back can be used for application materials and for pricing information, which is always subject to change.

More Good Ideas

Although the photographs and information on these pages may range from mutant mice to financial reports, the borders, shapes and heads provide continuity. The diamond-shaped device is used on nearly every page in one form or another. The heads are all reversed out of various and sundry colors and the borders all contain text either referring to a facet of The Jackson Laboratory or listing the diseases they research. The use of an electron micrograph of blood cells as a background for the inside cover provides visual interest to the otherwise dry list of corporation members.

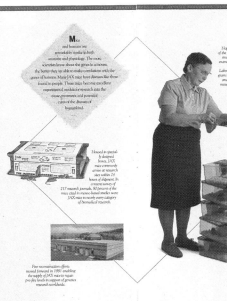

John A. Salvato, M.D.
Pediatrician

This brochure is light, colorful and fun. Inside, it contains a note from the doctor regarding his practice, as well as billing and insurance information. The age range of the folks he treats is depicted by showing three of his patients. White space is used to great advantage, providing a break between text, photo and decorative devices. (I think that the adhesive bandage speaks volumes about pediatric patients.) These devices and the border provide a continuous path to the information contained in the panels on the other side of the brochure. The overall color scheme of yellow and orange-red, which is even picked up in the clothes the children wear, keeps the tone of this brochure lively and accessible.

I would like to take this opportunity to tell you about my practice of pediatric and adolescent medicine and how I may be of service to you.

Pediatrics is the primary medical care of a child from birth to adulthood. This type of medical care is particularly important for the infant and the growing child. A pediatrician is a specialist in diagnosing and treating diseases affecting children. I am not only a trained pediatrician who deals with normal primary care, I am also a Developmental Pediatrician. A Developmental Pediatrician is specially trained to identify and treat abnormal development, as well as such things as behavior or learning disorders, autism, epilepsy and mental retardation.

I prefer to see my patients by appointment whenever possible, so I can schedule enough time to examine each patient and be able to answer any and all questions a parent may have. Occasionally an emergency will create unforeseen schedule delays. We will do our best to notify you of any delay or

change in your appointment. To make an appointment please call 872-0806 Monday through Friday from 8:30 a.m. to 5:00 p.m. In the event of an emergency during office hours, call 872-0806. My staff will get the message to me and relay my response if I am unable to speak with you directly.

For medical problems after hours, call 872-0806. When the office is closed, my phone is forwarded to the hospital answering service operator who will page me. If I am out of town, the operator will contact the doctor who is taking care of my patients in my absence. Emergencies should proceed directly to the emergency room at the Thayer Unit of Mid-Maine Medical Center.

Billing and Insurance. I ask that you pay for your office visit at the time of your visit. My staff will be happy to assist you in filling out your insurance forms so you can be reimbursed for your payment to me. I accept cash, check, Visa and MasterCard. I am also a WellCare provider.

More Good Ideas

Simplicity, continuity and readability make this report pleasing to the eye. The same typeface is used throughout with generous leading and ample white space. Each page is actually printed in two colors with the background color printed either as a solid or as a bordered screen. Section headers are consistently reversed out of black, and we won't forget that this is the 140th report since the dates are used as a decorative device on nearly every page, as well as on each cover. The vellum used for the opening mission statement gives this straightforward brochure a touch of luxury that's appropriate for a bank.

RAG RIGHT. OFFICIAL [ILLUSTRATED] NEWSLETTER OF THE ART DIRECTORS CLUB. FALL [1991] COLOR ISSUE

A IS FOR ART DIRECTOR
JACK BARRETT

Fall comes rolling our way again. The nights have already become colder and the days shorter. I love the fall... the smell of wood stoves and the rustle of bright leaves under my feet.

Fall brings back wonderful memories of Halloween & the first day of school. Not that the first day of school was all so wonderful, but the fact that my routine was changing and things were going to be different. I miss that now. After 25 years, the yearly change is a hard habit to shake.

Nine years into "real life" and the fall still makes me think of school. After sitting through many a class at two different art schools, I now have a different perspective on things. For now I am the instructor.

I teach illustration and air brush courses. These are continuing education courses that meet at night. Since there are few classes of this type in the area, enrollment is high. The students range in age from 19 to 60, and I'm fortunate that they are all hard workers.

There are many questions asked by the students, but the most frequent are, "How do I find work?" "How much should I charge for this piece?" And, "Should I have a contract?" There aren't any business courses offered at the local college tailored to the graphic arts profession, these are logical questions. I've had graduates at local colleges in my class that didn't know anything about reproduction rights, sales tax, or interstate commerce. That's why I tell them about the Art Directors Club.

The Club offers reduced rates for students. Education is one of the main reasons the club exists. It also offers creatives an informal atmosphere in which they can share common concerns and problems. And yes, you can even find work...sometimes. It doesn't matter whether you're an illustrator, designer, copywriter, photographer, potter, painter, sculptor, printmaker, jewelry maker, or even a wood burner, you still have to deal with clients, contracts, sales tax, income tax forms and slow times — when it looks as though you'll never have another job again.

So to all of those art students out there, come on, join us! The Art Directors Club is here to help provide you with knowledge and resources you'll need after you get out into the "real world." Believe me, it can't hurt ... but it sure can help.

Jack Barrett is a freelance illustrator and instructor at PortLand School of Art and the Portland Adult Community Education program.

PRESIDENTS' MESSAGE
SUE GOODRIDGE

No, it's not a typo. Both Jan Bonjour and I are happy to be co-presidents of the Art Directors Club for the upcoming year. We are looking forward to having a great year with YOUR help. Please consider serving on one of the many committees that are the life blood of the organization. We need your input and enthusiasm.

I'd like to thank Dave Mishkin for the great job he's done the past year. Jon and I have been picking his brain for help and ideas during the past several months and he has promised to continue being active and supportive this coming year.

If you ever have any questions or concerns about the Club, a committee, or an idea, feel free to call me at 549-7057.

THE 1991 FROSTIES
At 8:00 am on Thursday, August 15th a distinguished panel of Portland advertising professional's convened at Frostie headquarters on Fore Street and began the rigorous task of selecting the 1991 Frostie winners. The judges immediately commented not only on the huge number of entries, but on the quality of work displayed. The judges were given one time, three nickels, and five pennies with which to cast their votes. The entry with the most money in the cup beside it would win. After much careful reviewing and notetaking, the judges left, and an independent firm was left to the task of tallying the votes.

And in the end, Designsense walked away with the Best of Show. First Place was awarded to Christopher Hidden Design (who apparently had Robert Frost assist in copywriting). Second Place was captured by Bobby & Co. (rumored to be the upstart design firm of Bob Perkins), and third place was awarded to Kevin Fahmura's innovative "Doormat" design. A merit award was given to Nancy McBride (who noted Milli Vanilli as her copier of choice).

The revelry that ensued at Griffin McDuff's on September 9th, after the awards [A] were distributed was, in the words of one of the event's organizers, "more fun than we've had all week."

A special thanks to all those participated ... and a big boring, yawn to those that didn't. See you next year!

PORTFOLIO UPDATE
PORTFOLIO COMMITTEE

We want to thank all of you for your enthusiastic response to PORTFOLIO. We would also like to bring you up to date on what's happening with the book.

The past couple of months have been busy ones for the committee. We have taken considerable time determining the printer of the book, working closely with several of the area's top printers to get the best quality for the best price. Penmor Lithographers in Lewiston was finally chosen. The press has an excellent reputation, and will be able to create the separations and bind the book in-house.

We have also begun putting together the mailing list. As a result of further planning and research, we have decided to reduce the scope of the mailing to 5,000 very qualified prospects throughout Maine, New Hampshire, Northern Massachusetts and Vermont.

Because this is the first time we have put together a book of this scope, the committee

has not been able to meet our original publication date of late June. The decision was made to delay publication until mid-September rather than this summer when many people are out of their offices. The book is now scheduled to be published on September 30th.

A representative from the PORTFOLIO Committee will be in touch with those that purchased a full page for input on the mailing list. If you didn't buy a full page, a limited number of books will be available for sale to club members and others for $30. If you'd like a copy, send $30 to PORTFOLIO, c/o Art Directors Club, P.O. Box 7441, Portland, ME 04112.

Again, our thanks for your participation and patience.

COPYRIGHT 1991
Ever wonder what's really copyrighted? Does the piece you've created belong to you ... or have you sold the rights?

To make things perfectly clear, the Art Directors Club will be sponsoring a panel discussion, moderated by George Hughes, to unravel the copyright issue. Bob Mittel, a copyright, trademark, and patent attorney in Portland, will be on-hand to establish definitions and distinctions on an issue that always seems to have more than a few questions confused.

Topics and issues to be discussed include the distinction between the sale of copyright and the sale or ownership in artwork, protecting the controversial work-made-for-hire clause. The discussion is open to everyone, but will have particular importance to the creators of works, as well as the buyers and production managers (who must answer to clients).

The panel will be comprised of an agency owner, agency creative director, photographer, illustrator, printer, designer/owner

Mittel. Questions to be presented to the panel for discussion will address the role of art directors in creative ownership, digitization of artwork and its implications, the ownership of printer films, usage fees and rights, and the all important question, "why don't writers receive residuals similar to photographers and illustrators?"

The discussion will be held in the Rines Room, at the Portland Public Library, Tuesday, October 22, 1991.

NEW SPACE / NEW FACE / OUTER SPACE

NICHOLS LANDIS has been selected as agency of record for several new clients: Ski Maine Association, Maine Energy of Biddeford (a waste to energy management facility) and The Leen Co. (an industrial supplier for the New England area).

LYNDA LITCHFIELD and DAN HOWARD, of Designsense, were recently commissioned to redesign the typography of the Broderson Award. The awards, which are now free-standing, will still be silkscreened, but will feature a new, more elegant [D1], Broderson B.

CETACEA PRODUCTIONS of Falmouth recently produced a series of television public service announcements for Allied Whale, promoting their Adopt-a-Finback-Whale program. Allied Whale is a research group based at the College of the Atlantic, in Bar Harbor.

In July, Portland photographer RUSSELL FRENCH [D2] traveled to Newport Maine, Virginia, to take photographs of an airfoil being tested in a wind tunnel for the Virginia Air & Space Museum.

FREELANCE
JULIE FERGUSON

Start pulling your wildest costumes together [C] The Great Pumpkin Halloween Masquerade Ball has upped its first prize to a whopping $700! There's also a $100 prize for the best carved pumpkin, and several great second-prizes. The party is scheduled for Thursday, October 31 at the Sonesta Hotel's Ballroom, with music by Papa Loves Mambo.

The Halloween bash is co-sponsored by the Art Directors Club of Greater Portland, with the proceeds benefiting the People With AIDS Coalition (PWAC) of Maine.

Last year's event was one very hot party ... the costumes were stupendous! This year many people have already volunteered their time and services. Gary Symington is designing this year's poster, B & W Typesetting will be providing type, and Goodridges Screen Printing will be donating their services. PR efforts will be boosted by photos that Arthur Fink snapped at last year's party. Barbara Wolf, Sue Ryen and Julie

from 9:30 to 9:00. For more information, call Barbara Wolf at 772-8948, or George Hughes at 772-0651.

Start pulling your wildest costumes together [C] The costumes were during poor economic times, it seems freelancers seem to flourish. Why? According to Communications Arts, its for several reasons.

Primarily because people who are "between jobs" often consider themselves freelancers for lack of a better word ... like "unemployed." And as the number of agency cutbacks grow, there appear to be more freelancers hitting the streets in search of work. Meanwhile more and more individuals are choosing the path of self-employment. They too are freelancers, but they're usually in it for the long haul, and not until something better comes along.

Several months ago Ruth Gorton a local freelance designer (of the softer variety) compiled a list of tips and ideas that other freelancers may find useful ... regardless of whether they're in for the short term, or life. In this issue of Rag Right we've included some of her ideas on invoicing and billing, but look for other topics in upcoming issues.

Before beginning work for a new client, show there a copy

FOUR TIPS TO GET THE BEST FOUR-COLOR PROCESS PRINTING / MARK GOODRIDGE

We print four color process work on posters and t-shirts regularly. Some jobs turn out better than others. Same press, same ink, same printer, but some customers get better printing than others for the same price.

In four-color process printing, the difference between a good job and a great job is often due to factors outside the printer's control. Decisions made by the designer before the job ever gets to the printer greatly affect the quality of the finished piece. And let's face it, four-color process printing is expensive enough! Why pay all that money for a printing job that's only "o.k."?

What can the designer do to get the best four-color process printing possible?

Start the job with the original art. If the original is a painting or an air-brush work, give the original to the printer to make the separations from. The best photograph in the world is not as good as the original work.

Avoid fluorescent pigment. Fluorescent pigments are popular with designers and artists because they are bright and intense. They make the picture really pop, but fluorescent colors are completely unobtainable with normal four color process printing. To create a good match for a picture with fluorescent dyes or pigments at least a fifth color will be necessary with all the attendant complications and expense. By the way, avoiding fluorescent pigments is not always easy because some air brush and paint media that have fluorescent pigments in their formulations are not always so labeled.

If your original picture is a photograph, provide the printer with the largest, sharpest, most perfect transparency you can obtain. 4 x 5 transparencies are preferable to 35mm slides. Inspect the photo with a magnifying glass

At first glance, this appears to be a mild-mannered, albeit nicely designed, newsletter. It contains a lot of information on neat six-column pages with small but effective heads, legible sans serif typeface and a little color. The fun starts when the piece is opened completely and becomes a wildly colorful and exuberantly illustrated calendar/poster informing the reader of coming club events. These two cleverly contrasted parts of the newsletter are tied together by the use of color-coded letters within the copy that refer readers to the calendar inside—a useful device for avoiding repetition of information when you've got little space at hand.

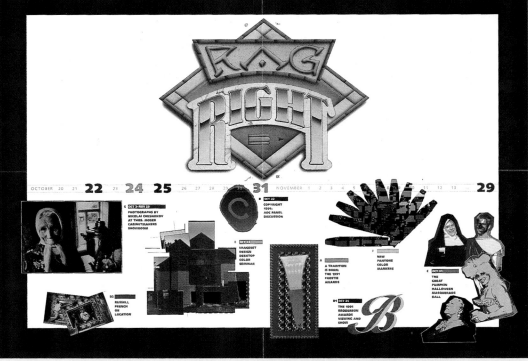

More Good Ideas

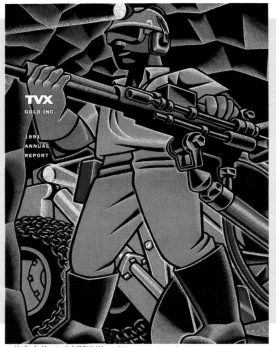

This perfect-bound annual report for a producer of precious metals uses full-page, mural-like illustrations to add vitality to the design. Note the small photographs that break up the large blocks of text on the pages that face the illustrations; a more common choice would have been to make the photographs full-page and to make the illustrations small, but that wouldn't have made the same graphic impact. The text is printed in gray ink but, owing to a legible typeface and generous leading, is still quite readable.

The Brasília Mine, in which TVX Gold has a 23% interest, is a unique surface mining operation which involves no waste stripping and a minimum amount of drilling and blasting. This large tonnage, low grade gold mine is located near the town of Paracatu, some 190 kilometres southeast of Brasília, the capital of Brazil, and is operated by a Brazilian subsidiary of RTZ.) The mine established another production record in 1991 producing a total of 165,500 ounces of gold, some 3% above the previous level of 160,000 ounces achieved in 1990. The cash cost of production continued to improve in 1991, averaging $207 per ounce compared to $256 per ounce in 1990.) For the second consecutive year, the Brasília Mine was the recipient of a five star award from the International Loss Control Institute. One of the most coveted awards in the worldwide mining industry, the achievement is recognition of the exceptional safety and environmental attainments of the operation.) The orebody lies within a sandstone-shale succession known as the Paracatu formation, and consists of a flat lying formation of phyllites and siltstones contain-

BRASÍLIA

ing varying amounts of quartz. The material is strongly weathered to a depth of 40 metres and the gold is present as native metal. This weath-ered phyllite package is

LOADING ORE AT BRASÍLIA

the subject of the current mining plan and has been sub-divided from top to bottom into three ore types.) Mining at Brasília is carried out by contractor using front-end loaders, shovels and a fleet of 25 ton trucks. Processing is by means of a conventional cyanidation, floatation and carbon-in-pulp circuit which was originally designed for an annual throughput of six million tons. A number of process modifications enabled the plant to process 11.1 million tons grading 0.018 ounces per ton in 1991 compared to 10.2 million tons grading 0.019 ounces per ton in 1990.) An optimization program is currently underway, which will supplement the existing plant grinding capacity to process the harder ore found at depth, and to permit further incremental increases in throughput. The $14.1 million program, is expected to be completed in 1992.) The Company's share of reserves at December 31, 1991 totalled 67,636,000 tons grading 0.015 ounces per ton, compared to 70,138,000 tons grading 0.015 ounces per ton for the prior year.

Mammography

Answers and Information
The Women's Center at Eastern Maine
Eastern Maine Medical Center

Physician Referral

The Obstetrics and Gynecology Service
The Women's Center at Eastern Maine
Eastern Maine Medical Center

What is an ultrasound?

A diagnostic ultrasound works on the same principle as the sonar which is used by submarines to locate distant objects. Like sonar, high frequency sound waves that can't be detected by the human ear are sent into the body through a "transducer" shaped like a microphone. When those waves reach interior organs they bounce back, creating an "echo" that forms a picture on a television monitor. The picture can then be recorded on x-ray film, Polaroid film, heat sensitive film or videotape. An ultrasound does not use ionizing radiation. Most examinations take between 30 and 60 minutes. Occasionally an exam will take longer.

What is the examination like?

The sonographer or ultrasound technologist will apply a water-soluble gel to the skin of the area to be examined. The gel creates good contact between the transducer and the skin and it allows the transducer to slide easily across the skin. Usually the exam does not hurt, but if you are tender in an area then the exam may be somewhat uncomfortable.

For example, during an abdominal or pelvic ultrasound, the sonographer will scan your abdomen and pelvis by moving the handheld transducer back and forth across the skin surface. During the examination you may be asked to hold your breath, turn on your side or onto your stomach. At the end of the examination the gel is wiped off.

The Doppler ultrasound is used to look at blood vessels and listen to the blood flowing through them to detect any narrowing of the vessel.

Are there any special preparations for an abdominal exam?

For an ultrasound of the abdomen which includes examinations of the liver, gallbladder, biliary tree and pancreas, you should have nothing to eat or drink after midnight. Try to avoid gas-producing foods, such as beans and carbonated beverages for one to two days prior to the exam. Ultrasound does not penetrate well through air, gas or bone.

Are there any special preparations for a pelvic exam?

For a pelvic ultrasound, or if you are pregnant, you should have a full bladder. One and one-half hours before the exam, empty your bladder. Then drink 4 or 5 eight-ounce glasses of fluid. Do not drink milk. Do not empty your bladder again until your exam is finished. If your bladder is not full at the time of your exam, you will be delayed in the Ultrasound Department while you drink enough fluids to sufficiently fill it, or you may have to reschedule your exam for another day. A full bladder is a sound conducting window which allows structures in the pelvis to be seen.

Are there any ultrasounds that don't require special preparation?

There are no special preparations for ultrasound examinations of the aorta, carotids, cranial, kidneys, renal glands, thyroid or parathyroid.

When will my doctor have the results?

Your ultrasound will be interpreted by a physician who specializes in reading these examinations. Your doctor should receive a typewritten report 2 to 3 days after your exam is completed.

How much will the exam cost?

The cost of an ultrasound examination varies depending on the length and complexity of the examination. You will receive a bill from Eastern Maine Medical Center for your exam. You will also receive a separate bill from the radiologists for their supervision and interpretation of the exam.

Most insurance companies cover the cost of the ultrasound examinations. If you have a question about billing, please call the EMMC billing office at 945-7780.

Subtle colors and the use of ragged right margins help this series of brochures to disseminate important health care information in a relaxed, nonthreatening way. The typeface is gently rounded and the graphics relaxing. No sharp edges here. Costs are held down by the use of only two colors of ink for most of the brochures, as well as the brochure's second use as a place for the physician to write appointment information.

More Good Ideas

This brochure doubles as a folder. The discussion and illustration of the product on the inside of the piece work together with the photograph and logo on the cover to present a crisp, clean, hardworking, businesslike image. Although the design of the brochure is straightforward, the use of black marble as a background for the cover and the borders of the inside flaps gives the brochure an upscale feel. The folder's flap is die-cut so that either a horizontal or vertical business card can be inserted.

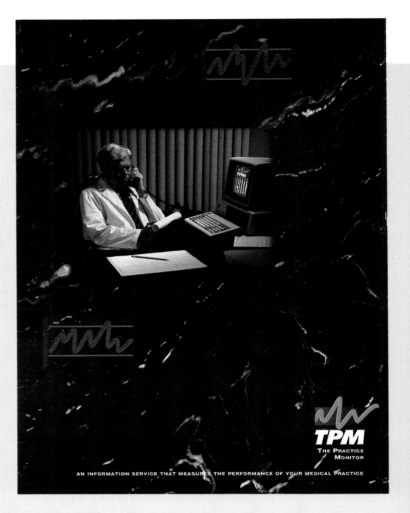

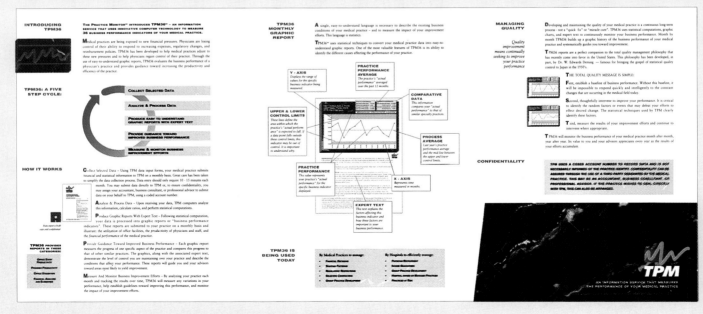

staff will be happy to fill out your insurance claims forms for you.

Because patient understanding and expectations are such important aspects of plastic surgery, I am always interested in speaking to groups about plastic surgery in general or about any of the wide range of individual procedures I perform. If your group or organization would like a presentation, please call my office staff during business hours. We'll do our best to accommodate your request.

Donald L. Schassberger, M.D.
Plastic, Reconstructive, and Hand Surgeon

College:
Purdue University School of Pharmacy, B.S.

Medical School:
Indiana University Medical School, M.D.

General Surgery Residency:
Maine Medical Center, Portland, ME

hester, NY

r, NY

Y

COSMETIC SURGERY

Not only does our physical appearance affect our sexuality and self-perception, but it can also have a profound effect on interpersonal relationships. The man or woman who about his or her who has a ph surgery ca improv

HAND SURGERY

The hand is an intricate, mechanical and sensory organ. It is an extension of the body that can accomplish with speed and precision an endless number of gestures, pinches, strokes and other movements. The hand is capable of conveying feeling through nuances of motion and touch that surpass the abilities of language. In fact, the whole reason for the shoulder, upper limb, elbow, forearm and wrist is to position the hand for its many functions.

Unfortunately, 10% to 20% of all bodily injuries are injuries to the hand. The types of injuries are many and varied, and because of the hand's intricacy, both plastic surgeons and orthopedic surgeons are normally involved in hand surgery. Some of the more common injuries and procedures are:

Rheumatoid arthritis (progres-

This booklet is an effective mixture of beauty and functionality, much like plastic surgery itself. The elegance of the script on the cover is countered by the practical text inside. The booklet, which contains general information about each type of surgery performed, is given to patients with one of four inserts (two are shown), depending on the type of surgery to be performed on the patient (a clever cost-saving device). The inserts echo the booklet's design with the photograph and the decorative initial cap.

More Good Ideas

The cover of this brochure manages to convey, clearly yet provocatively, the difficult abstract idea of the variety of art that The Institute of Contemporary Art in Boston displays. The inside of the brochure displays pictures of all the art to be auctioned by the ICA; the checkerboard background unifies and balances the wildly disparate pieces of art displayed in the catalog, creating a well-balanced layout despite the variety of art shown.

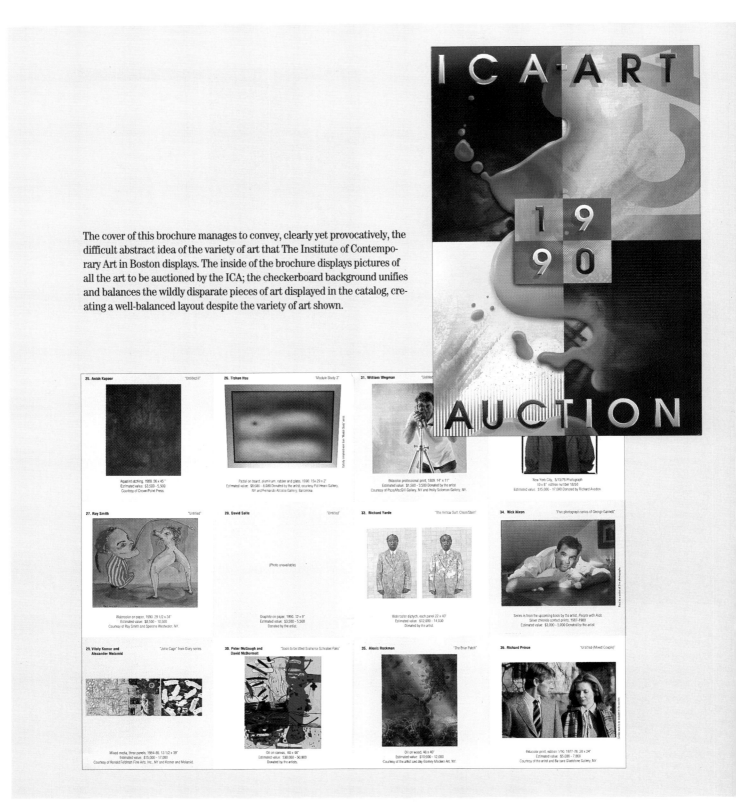

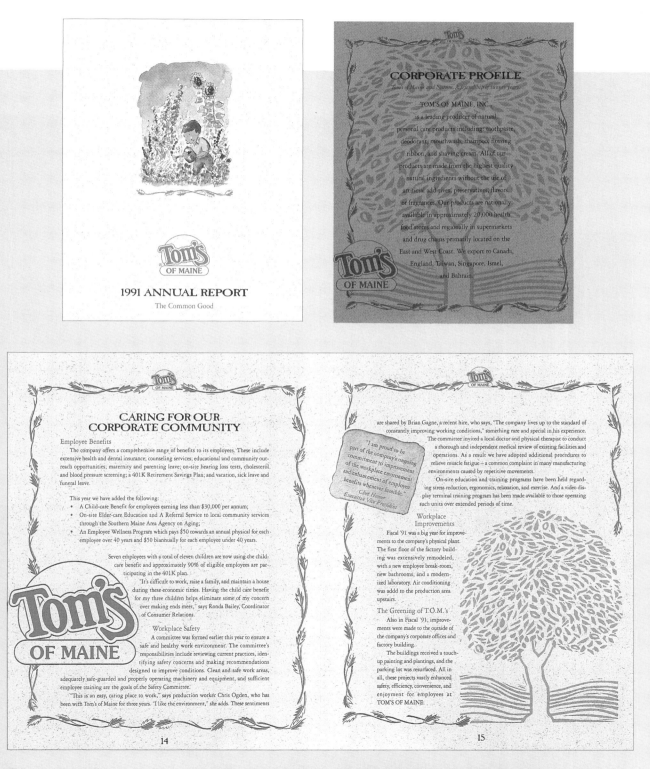

This company manufactures a well-known line of all-natural personal care products. Therefore, it is only right that the brochure should be printed on recycled paper. The leaf border, suggestive of nature, carries the eye comfortably through the pages. The balanced use of screens and solids serves to keep the reader focused on each piece of the design in its turn. The almost woodcut feel of most of the graphics maintains the brochure's low-tech, down-to-earth tone.

More Good Ideas

This clever booklet uses the unusual method of extending patterns or motifs found in the illustrations on the right-hand page into the white space on the facing page. Copy columns are wide, but are made readable by the use of generous leading and by breaking up the copy with black initial caps.

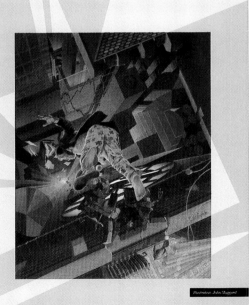

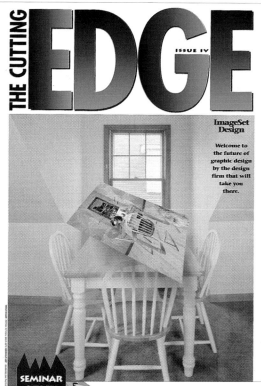

THE CUTTING EDGE

ISSUE IV

ImageSet Design

Welcome to the future of graphic design by the design firm that will take you there.

SEMINAR
OCT. 24TH
DESKTOP
COLOR
HAS
ARRIVED!

This piece is sort of a "periodical brochure" used to keep ImageSet's clients abreast of all the new options and possibilities offered by this design/service bureau. Its large size (11" x 17") allows for comfortable leading and plenty of white space. The border on the left-hand page is echoed by the head on the right, with each set printed in a different color—continuity and eye-pleasing variety, all in one shot; other borders throughout cleverly play off of the name of the brochure, The Cutting Edge. To demonstrate the color separation capabilities of their firm, the designers of this brochure have packed it with beautifully reproduced color photographs. Overall, this brochure is as much a portfolio of the design and color separation abilities of ImageSet as it is a newsletter about the firm itself.

DESIGN PERSPECTIVE

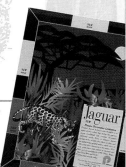

More Good Ideas

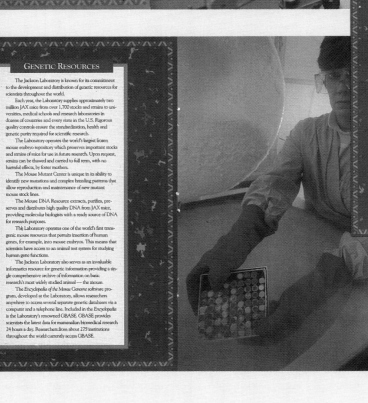

This colorful brochure illustrates the client's work quite powerfully by word and deed, so to speak. Although the colors differ from page to page, the design remains the same, giving the piece a consistency almost akin to the changing seasons. The photographs, although generally explained on facing pages, remain uncluttered with captions, which appear on the last page. The pocket on the back cover can be used to hold ever-changing informational materials.

Listen

to the story of
Weatherend that began
once around a time
on the coast of Maine
where a certain
groundskeeper
designed furniture
whose graceful curves
mirrored the lines
of the sea. That was
long ago but the story
continues today as
skilled artisans use
time honored boat-
building techniques
to make Weatherend
furniture as durable
as it is beautiful.

This exceptionally lovely brochure gets its message across primarily through captioned photographs. The history of the product is related in a single column that is continued from page to page. White space is used to its greatest advantage. The eye is drawn with great precision to each product. The reproductions of the hand-colored photographs on drafting vellum at the beginning and end of the brochure suggest memories of long ago. The caption that appears to be printed in gray ink on the vellum is actually printed in black on white by itself on the following page—giving the reader two chances to read the gentle and elegantly designed introduction to the brochure.

Heistad's furniture had an undeniable presence. Everything about it seemed just as it should be: the way a table apron mirrored the slatted back of a settee, the way the arch of a crest rail repeated the curve of a table. Like Hans Heistad's originals, our furniture is of heirloom quality – classic furnishings that will be passed on from one generation to the next.

All the pieces in our collection capture the spirit of the originals; in some cases we have changed design details to increase comfort or enhance appearance. For instance, our slatted seats are gracefully contoured and scooped for comfort and function. The generous angle on the rake of seatbacks helps to avoid the rigidity too common in traditional garden seating. Our tabletops are designed for beauty and function: table rims have grooved indentations, helping water drain easily. The exquisite detailing of the slatted apron on our Weatherend tables was slightly modified from the original for ease of dining. And, of course, every design in the Weatherend collection is generously and elegantly proportioned.

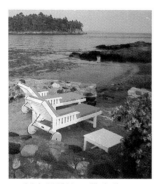

Our Southern Harbor™ Chaise Lounge, available with or without arms, has an adjustable back and wooden wheels and is featured with a square Lasalle™ Occasional Table.

All our seating pieces are made for comfort and function. The Weatherend™ Chair, with its curved back and scooped seatboards, is comfortable at a dining or occasional chair. Our Southport™ Planter is available in different sizes and has a removable liner with a detachable saucer.

Penobscot Chairs complement the Islesboro™ Dining Table, which is available in different sizes. Perfect for dining because of their high curved backs, the Penobscot Chairs are offered with and without arms. The Weatherend™ Console Table is generously proportioned for serving and storage.

Weatherend's elegantly curved armrest. Jackson™ crest rail with its signature end wing. Weatherend's crest rail and generous rake enhance appearance and increase comfort.

 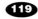

Index

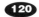